FOREW

GW00361552

The Hidden Places series is a collection of easy to use travel guides taking you, in this instance, on a relaxed but informative tour of Gloucestershire and Wiltshire, two adjoining rural counties of outstanding beauty offering the visitor the imposing chalky heights of the Marlborough downs and the gentler slopes and pretty stone villages of the Cotswolds.

Our books contain a wealth of interesting information on the history, the countryside, the towns and villages and the more established places of interest in the counties. But they also promote the more secluded and little known visitor attractions and places to stay, eat and drink many of which are easy to miss unless you know exactly where you are going.

We include hotels, inns, restaurants, public houses, teashops, various types of accommodation, historic houses, museums, gardens, garden centres, craft centres and many other attractions throughout Gloucestershire and Wiltshire, all of which are comprehensively indexed. Most places have an attractive line drawing and are cross-referenced to coloured maps found at the rear of the book. We do not award merit marks or rankings but concentrate on describing the more interesting, unusual or unique features of each place with the aim of making the reader's stay in the local area an enjoyable and stimulating experience.

Whether you are visiting the area for business or pleasure or in fact are living in the counties we do hope that you enjoy reading and using this book. We are always interested in what readers think of places covered (or not covered) in our guides so please do not hesitate to use the reader reaction forms provided to give us your considered comments. We also welcome any general comments which will help us improve the guides themselves. Finally if you are planning to visit any other corner of the British Isles we would like to refer you to the list of other *Hidden Places* titles to be found at the rear of the book.

The

HIDDEN PLACES

of

GLOUCESTERSHIRE AND WILTSHIRE

Edited by
Peter Long

© Travel Publishing Ltd.

Published by:
Travel Publishing Ltd
7a Apollo House, Calleva Park
Aldermaston, Berks, RG7 8TN

ISBN 1-902-00740-9

© Travel Publishing Ltd 1999

First Published:	*1990*	*Fourth Edition:*	*1999*
Second Edition:	*1993*		
Third Edition:	*1997*		

Regional Titles in the Hidden Places Series:

Cambridgeshire & Lincolnshire	Channel Islands
Cheshire	Chilterns
Cornwall	Devon
Dorset, Hants & Isle of Wight	Essex
Gloucestershire & Wiltshire	Heart of England
Hereford, Worcs & Shropshire	Highlands & Islands
Kent	Lake District & Cumbria
Lancashire	Norfolk
Northeast Yorkshire	Northumberland & Durham
North Wales	Nottinghamshire
Peak District	Potteries
Somerset	South Wales
Suffolk	Surrey
Sussex	Thames Valley
Warwickshire & W Midlands	Yorkshire Dales

National Titles in the Hidden Places Series:

England	Ireland
Scotland	Wales

Printing by: Ashford Press, Gosport
Maps by: © MAPS IN MINUTES ™ (1998)
Line Drawings: Sarah Bird
Editor: Peter Long
Cover Design: Lines & Words, Aldermaston

Cover Photographs: Castle Combe, Wiltshire; Tewkesbury Abbey, Gloucestershire;
Upper Slaughter, Gloucestershire. © Britain on View/Stockwave.

All information is included by the publishers in good faith and is believed to be correct at the time of going to press. No responsibility can be accepted for errors.

This book is sold subject to the condition that it shall not by way of trade or otherwise be lent, re-sold, hired out, or otherwise circulated without the publisher's prior consent in any form of binding or cover other than that which it is published and without similar condition including this condition being imposed on the subsequent purchase.

CONTENTS

Royal Forest of Dean

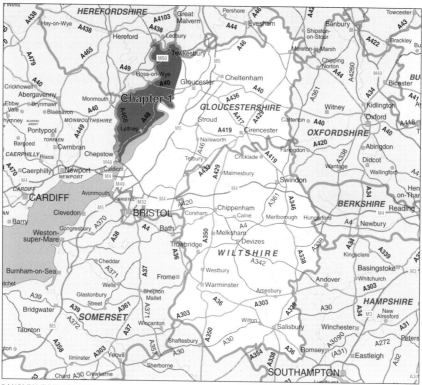

© MAPS IN MINUTES ™ (1998)

Wild wood, royal hunting ground, naval timber reserve, important mining and industrial area. **The Royal Forest of Dean**, one of England's few remaining ancient forests, has been all these, and today its rich and varied landscape provides endless interest for walkers, historians and nature-lovers. Its geographical location in an area bordered by the Severn Estuary to the south and the Wye Valley to the west has effectively isolated it from the rest of England and Wales and as a result it has developed a character all its own. To the playwright Dennis Potter it was "This heart-shaped land". Following the last Ice Age an area of some 120,000 acres between the Rivers Severn, Wye and Leadon became covered with deciduous forest and remained so until around 4000BC, when the farmers of the New Stone Age began clearing the land with their state-of-the-art flint axes,

felling vast numbers of trees. Coppicing was started about this time, and the new shoots growing from the bases of the felled trees provided the timber of the future.

The Forest has long been home to a wide variety of wildlife, and it was the presence of deer that led Edmund Ironside to designate it a royal hunting forest in the 11th century. In the same century King Canute established the Court of Verderers with responsibility for everything that grew or lived in the Forest. Iron ore deposits were first discovered in the Forest 2,500 years ago; they were exploited by the Romans, but it was not until the 1600s that mineral began to be extracted on a grand scale.

The most ruinous development in the Forest was the demand for timber for the process of iron-smelting; at one time 72 furnaces were operating in the area, feeding on such enormous quantities of timber that by the 1660s only a few hundred trees remained. The severity of the situation was realised by the government, which in 1668 cancelled all the permits for extracting minerals and set about an extensive replanting programme that was accelerated a long time later during the Napoleonic Wars.

The Victorians exploited another of the Forest's natural resources, coal, and at one time up to a million tons were removed each year, mostly from open-cast workings. This industry came more or less to an end in the 1930s, although a few seams are still worked to this day. The centuries of mining inevitably left their mark, the Forest has gradually reclaimed the workings (known as *scowles*), often hiding them in a dense covering of moss, trees and lime-loving plants.

Today, the wooded area covers some 24,000 acres and has a large number of attractions for the visitor, including Dean Heritage Centre, Puzzlewood, Clearwell Caves, Hopewell Colliery and Dean Forest Railway. The Forest is a marvellous place for walking, whether it's a gentle stroll or an energetic hike. There are numerous waymarked walks in and around the forest, most of which are detailed in leaflets available at the visitor centres and Tourist Information Centres. Among them are the **Wye Valley Walk; Offa's Dyke Path**, which covers the Wye Valley between Chepstow and Ross-on-Wye; the **Wysis Way**, passing west to east; and the Gloucestershire Way, covering a route from Chepstow to Symonds Yat and then taking in the spectacular May Hill to the north.

This chapter proposes a tour in and around the Royal Forest, starting and ending at Longhope, and then a trip north to Newent and the Vale of Leadon.

LONGHOPE

MAP 1 REF B2

8 miles W of Gloucester off the A40

An attractive settlement south of the A40 Gloucester-Ross-on-Wye road. Longhope is the location of the **Harts Barn Crafts Centre**, situated in a medieval hunting lodge built by William Duke of Normandy as a place to keep his hounds when he came to hunt the hart. Crafts include quilting, picture-framing, glassware, pottery and a smithy. Open Tuesday to Sunday.

Built in 1400 and extended down the centuries, the **Glasshouse Inn** is a real 'Hidden Place' on the north edge of the Forest of Dean near the Birds of Prey Centre. Two bars, with the original double-oven grate and cast-iron fireplace, beams, tiled floors, planked ceilings, old oak benches and chairs, ancient photo-

**The Glasshouse Inn, May Hill, Longhope, Gloucestershire GL17 0NN
Tel: 01452 830529**

graphs of locals and many old prints and drawings cram an acre of atmosphere into charming surroundings, while outside, a lawned garden, with tables and chairs under parasols, has access to a third bar. Real ales are on tap to enjoy by themselves or with a selection of home-cooked dishes from the menu that include fresh fish choices. Specials appear on Friday and Saturday; food is available on Sunday during summer months.

MITCHELDEAN
2 miles W of Longhope on the A4136

MAP 1 REF B2

A peaceful community on the northern fringe of the forest. A mile or so south of the village is **St Anthony's Well**, one of many throughout the land said to have magical curative powers. The water at this well is invariably icy cold and bathing in it is said to provide a cure for skin disease (St Anthony's Fire was the medieval name for a rampant itching disease). The monks at nearby Flaxley Abbey swore by it.

DRYBROOK Map 1 ref B2
4 miles W of Longhope off the A4136

Hidden away at Hawthorn's Cross on the edge of the forest is a unique collection of mechanical music spanning the last 150 years. **The Forest of Dean Mechanical Organ Museum** is open Tuesday and Thursday afternoons in April, May, July and August. Drybrook has a very unusual black-and-white building with a five-storey square tower. This was once the **Euroclydon Hotel** (the name is still on the tower) and was originally built, in 1876, for a wealthy mine-owner to provide a look-out over his domain and his workers.

RUARDEAN Map 1 ref B2
2 miles W of Drybrook on the A4136

A lovely old village whose **Church of St John the Baptist**, one of many on the fringe of the forest, has many interesting features. A tympanum depicting St George and the Dragon is a great rarity, and on a stone plaque in the nave is a curious carving of two fishes. These are thought to have been carved by craftsmen from the Herefordshire School of Norman Architecture during the Romanesque period around 1150. It is part of a frieze removed with rubble when the south porch was being built in the 13th century. The frieze was considered lost until 1956, when an inspection of a bread oven in a cottage at nearby Turner's Tump revealed the two fish set into its lining. They were rescued and returned to their rightful place in the church.

From Ruardean, country roads lead westward to the sister villages of **Upper** and **Lower Lydbrook**. These tranquil villages were once major producers of pig iron, rivals even for Sheffield, and when the extraction of iron ore and coal was at its height their position on the northwest edge of the forest made then ideally suited for the processing of the ore. The first commercially viable blast furnace in the area was sited here at the beginning of the 17th century. For several centuries flat-bottomed barges were loaded at Lower Lydbrook with coal bound for Hereford, 25 miles upstream; this river trade continued until the 1840s, when it was superseded, first by the Gloucester-Hereford Canal and then by the Severn and Wye Railway. The actress Sarah Siddons lived in Lydbrook as a child.

ENGLISH BICKNOR Map 1 ref B2
3 miles N of Coleford off the A4136

The Church of St Mary, high above the Wye Valley, boasts some intriguing 14th century stone figures of females, one of them holding a round object that is thought by some to be a heart, by others an egg. Just by the church can be seen the earthworks of a **Norman motte and bailey castle**. Welsh Bicknor is, naturally, on the other side of the Wye.

Dryslade Farm is a 185-acre, mainly Beef Suckler farm with 20 acres of woodland. Self-catering accommodation - with assisted wheelchair access - is offered in the ground-floor flat of the farmhouse, which dates from 1780. The flat is spacious, homely and well equipped, with two bedrooms, a bathroom, lounge and fitted kitchen. Alternatively, B&B accommodation is available in two upstairs rooms, both en suite. All rooms are non-smoking. The owners, Philip and Daphne Gwilliam, live on the premises and offer personal, friendly service and

**Dryslade Farm, English Bicknor, Near Coleford,
Gloucestershire GL16 7PA Tel/Fax: 01594 860259 Mobile: 0780 1732778**

advice on the area; although they are kept busy with farm work, they are always happy to stop for a chat. Breakfasts are a real treat, with the good honest farmhouse fare guaranteed to set you up for a hard day's walking or cycling - or just a prelude to relaxing in the wonderful peace and tranquillity. Guests and their children are most welcome to watch or help milk the Guernsey cows, feed the calves or wander around the adjoining fields and woodland. A large lawn is ideal for a game of football, and there's a patio with tables, chairs and a barbecue. A lock-up shed can be used for storing bikes - the area is great for cycling through the woods. Dogs are welcome, as long as they don't chase the farm animals! Tourist Board ratings: Self-Catering 4 Keys approved plus accessible Category 3; B&B 3 Diamonds.

HILLERSLAND
Map 1 ref B2

1½ miles S of English Bicknor off the B4432

The **Symonds Yat Rock Lodge** is a small, friendly hotel offering modern, comfortable accommodation in a single-storey building on the edge of the beautiful Forest of Dean. The four letting bedrooms are all en suite and have TV and tea/coffee-making facilities. One room has a four-poster bed and two are family rooms. Pets are welcome and everything is at ground level so there are no steps, and the rooms are well away from the road - there's ample parking space outside

Symonds Yat Rock Lodge, Hillersland, Coleford,
Gloucestershire GL16 7NY Tel: 01594 836191 Fax: 01594 836626

the rooms. The Lodge has a licensed restaurant serving full English breakfast and evening meals, including vegetarian options and children's meals.

The location of the Lodge is delightful, with forest tracks leading off directly opposite, and the stunning views over the Wye Valley from **Symonds Yat Rock** only a short stroll away. Wildlife is in abundance here and the Yat Rock is one of the few places where peregrine falcons can be observed in their nest sites - an RSPB observation point is manned here during the spring and summer months.

COLEFORD

A former mining centre which received its royal charter from Charles 1 in the 17th century in recognition of its loyalty to the Crown. It was by then already an important iron processing centre, partly because of the availability of local ore

deposits and partly because of the ready local supply of timber for converting into charcoal for use in the smelting process. It was in Coleford that the Mushet family helped to revolutionise the iron and steel industry. Robert Forester Mushet, a freeminer, discovered how spiegeleisen, an alloy of iron, manganese, silicon and carbon, could be used in the reprocessing of 'burnt iron' and went on to develop a system for turning molten pig iron directly into steel, a process which predated the more familiar one developed later by Bessemer.

Coleford is lucky indeed to have a restaurant like **Muffins**, where the menu's assertion that "home cooking means home-made" is borne out by the excellent results on the plate. Owner Janet Marrott is a leading figure in Coleford life, She is also a superb cook, producing a wonderful array of goodies to keep a smile on the faces of her loyal regular customers as well as the stream of visitors to this lovely market town and the sights and scenery all around. Her restaurant, which she runs with her husband Bryan, is the quintessence of a traditional English tea room, with a warm, welcoming ambience, pretty flowers, proper linen on the tables and a menu that sets out to tempt the discerning eater - that means healthy, wholesome food with not a chip in sight. There are muffins, of course, the genuine home-made English version, served plain with butter or with mouthwatering fillings like cottage cheese, tuna mayonnaise or country paté. Look for your favourite snack on the menu and you'll probably find it, from scones and cakes and pastries to jacket potatoes, made-to-order

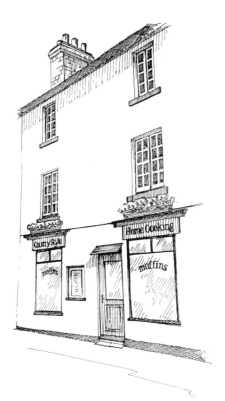

**Muffins, 12 St John Street, Coleford,
Gloucestershire GL16 8AR
Tel: 01594 834841**

sandwiches, salads and bar snacks - "ploughman's with a difference". Breakfast is served until 11, and lunchtime specials include pie of the day and roast of the day. Opening times are 9-3 (Thursday till 2, Saturday till 4). Closed Sunday.

Coleford, still regarded as the capital of the Royal Forest of Dean, is a busy commercial centre with an interesting church and a number of notable indus-

trial relics. It is home to the **Great Western Railway Museum**, housed in an 1883 GWR goods station next to the central car park. Exhibits include several large-scale steam locomotives, railway relics and memorabilia, an engine shed and a miniature locomotive for children. Call 01594 833569 for opening times. Another treat for railway fans is the **Perrygrove Railway** on the B4228 just south of town. Designed as a family attraction, it offers unlimited trips on its narrow-gauge steam train, a village with secret passages and a treasure hunt in the woods. Tel: 01594 834991.

The mother-and-son team of Angela and Barney Rowe greet visitors by the thousand to **Beechenhurst Lodge** picnic site, a perfect spot to pause on a walking or cycling trail through the great Forest of Dean. The Lodge is a low modern building on the B4226 between Coleford and Cinderford on the site of what was formerly Speech House Colliery. A Forestry Commission franchise, it provides picnic tables, barbecues, play areas and parking, as well as refreshments from a menu that includes cakes and scones, pies and tarts, rolls and sandwiches, jacket potatoes, lasagne (meat or vegetarian) and a hearty brunch. This

**Beechenhurst Lodge, Speech Hill House, Coleford,
Gloucestershire GL16 7EG Tel: 01594 827357 Fax: 01594 837433**

is walking and cycling territory par excellence, with many trails marked, and the Lodge is the start of the famous Sculpture Trail. In 1984 sculptors were invited to visit the Forest to create works of art inspired by the surroundings. Most of the sculptures are constructed from natural local materials - wood, iron and stone. The 3½ mile trail opened in 1986, following a route through majestic oaks and pines, allowing visitors to enjoy the wonders of the Forest while discovering the sculptures along the way. Lots of other events start at the Lodge: orienteering, mushroom-hunting, deer safari, bat-watching. There's always something to do, and it's always fun!

Clearwell Caves are set in an area of special landscape value, just on the outskirts of the historic village of Clearwell, which boasts a castle, pretty church, chapel and several good pubs. This is the only remaining working iron mine in the Forest of Dean out of the very many that once worked here. The mine produces ochres for use as paint pigments by artists or those wishing to decorate their homes using natural paints.

Before the 19th century only Free Miners were allowed to enter Forest of Dean mines; any Free Miner allowing access to non-members of the fellowship would be brought before the mine law court, their fellowship withdrawn, their tools broken or confiscated and the Miner never allowed to mine within the Forest of Dean again. Today such punishment is frowned upon and at Clearwell Caves

Clearwell Caves, Near Coleford, Royal Forest of Dean,
Gloucestershire GL16 8JR Tel: 01594 832535

nine impressive caverns have been opened to visitors, allowing you to descend over 100 feet underground, although the mine itself goes down over 600 feet. The Cave shop is a treat in itself with unusual gift ideas and a wide range of spectacular minerals and crystals to buy from all around the world.

Don't miss visiting the Tearoom, which contains some very interesting artefacts but particularly some exceptional paintings of local Free Miners; the two paintings of iron miners have been done using the ochres that they used to mine!

Complete a memorable visit by wandering down to see **Clearwell** village and the pretty surrounding countryside; there are several walks from the Caves that explore surface mining remains, some with spectacular views over the Welsh mountains and the Wye Valley.

Half a mile from Coleford, on the B4228 Chepstow road, **Puzzle Wood** is nearly 14 acres of pre-Roman open-cast iron ore mines (known locally as scowles) which have been left over the course of 2,700 years to slip back into the healing hands of nature. The result is a magical outdoor grotto of trailing vines, moss-covered rocks, fern and wild flowers. The paths were laid nearly 200 years ago and there are many dead-ends, circles, wooden bridges and passageways through the rocks, taking visitors through a most unusual maze of unique and spectacular scenery. The wood and the farmland that surrounds it were acquired in 1998 by Philip and Debbie Prosser, who, at Lower Perrygrove Farm, offer bed and

Puzzle Wood and Lower Perrygrove Farm, Perrygrove Road, Coleford, Gloucestershire GL16 8QB Tel: 01594 833187

breakfast accommodation in three tastefully refurbished en suite bedrooms - a double, a twin and a family room - with TVs, radio-alarms and tea/coffee-makers. A traditional farmhouse breakfast is served in the cosy dining room overlooking the garden and the fields beyond. Because of the large number of steps, Puzzle Wood is not suitable for the less able or for pushchairs - or for the congenitally lazy.

AROUND COLEFORD

NEWLAND Map 1 ref B3
1 mile SW of Coleford off the A466

Newland's Church of All Saints is often known as the **Cathedral of the Forest** because of its impressive size. Its aisle is almost as wide as its nave and its huge pinnacled tower is supported by flying buttresses. Like many churches in the

county, it was built during the 13ᵗʰ and 14ᵗʰ centuries and remodelled by the Victorians. Inside, it has a number of interesting effigies, including an unusual brass relief of a medieval miner with a pick and hod in his hand and a candlestick in his mouth. Other effigies depict a forester in 15ᵗʰ century hunting gear with a hunting horn, a sword and knife; and, from the 17ᵗʰ century, an archer with wide-brimmed hat, bow, horn and dagger.

COALWAY Map 1 ref B3
On the eastern edge of Coleford

One mile from Coleford, in the beautiful Forest of Dean, the 200-year-old **Crown Inn** has a very friendly, welcoming tenant in Dianne Worrall. The food is good, the drinks are good, and there's always a lively, cheerful atmosphere. Young and

old, regulars and first-timers meet for a chat, a drink, a game of skittles or pool, or something to eat from the extensive bar and restaurant menus. The front of the pub is dominated by a magnificent old sycamore tree, while in the garden tables and chairs are set out and there are swings to keep the children happy. Inside, the lounge is really cosy and inviting - you could almost be in your front

The Crown Inn, Parkend Road, Coalway, Nr Coleford, Gloucestershire GL16 7HX Tel: 01594 836620

room! The pub opens at 7am, serving breakfast to early starters, and tea and coffee are available from 10. The local tourist attractions are many and varied, including the Clearwell Caves, the Dean Heritage Centre, the National Bird of Prey Centre, the Forest Railway and, most splendidly, the Forest itself.

BROADWELL Map 1 ref B3
2 miles E of Coleford off the B4226

Mike and Jan Tutty have a cheery greeting for visitors to the **Bird-in-Hand**, a free house which has built up quite a reputation for the quality of its cooking.

**The Bird-in-Hand, North Road, Broadwell, Near Coleford,
Gloucestershire GL16 7BX Tel: 01594 832383**

Local residents and tourists taking in the delights of the Forest of Dean can be sure of a top-notch bar or restaurant meal any lunchtime and any evening. Quick snacks and daily specials are listed on a blackboard in the bar, supplementing a menu that includes excellent versions of classic pub dishes, from potato skins with dips to steaks, curries, lasagne and savoury pies. There's a children's menu and a good choice for vegetarians. The Bird-in-Hand is a popular venue for functions (up to 200 can be accommodated) and other attractions include a beer garden and skittle alley.

CANNOP
MAP 1 REF B3

4 miles E of Coleford on the B4226

Cannop Valley has many forest trails and picnic site; one of the sites is at **Cannop Ponds**, picturesque ponds created in the 1820s to provide a regular supply of water for the local iron-smelting works. At Speech House Road, near Cannop, is **Hopewell Colliery**, a true Forest of Dean free mine where visitors can see mine workings dating back to the 1820s and some of the old tools of the trade. Open daily March to October.

STAUNTON
MAP 1 REF B3

3 miles NW of Coleford on the A4136

Lots to see here, including a Norman church with two stone fonts and an unusual corkscrew staircase leading up past the pulpit to the belfry door. Not far from the village are two enormous mystical stones, the **Buckstone** and the **Suck Stone**. The former, looking like some great monster, used to buck, or rock, on its

base but is now firmly fixed in place. The Suck Stone is a real giant, weighing in at many thousands of tons. There are several other stones in the vicinity, including the **Near Harkening** and **Far Harkening** down among the trees, and the **Long Stone** by the A4136 at Marion's Cross.

Jennifer and Derek Hockey welcome bed and breakfast guests to their family home of **Assisi, The Buckstone**, tucked away up a quiet country lane on the edge of the Royal Forest of Dean. The atmosphere in the brick-built house is very warm and welcoming, and the furnishings, the objects and the family portraits all help to generate a real home-from-home feeling. The accommodation comprises three bedrooms - a double, a twin and a single - which share a

**Assisi, The Buckstone, Staunton, Near Coleford,
Gloucestershire GL16 8PD Tel: 01594 836900 Fax: 01594 836991**

bathroom and separate shower room. The double and the twin have spectacular panoramic views of the Wye Valley and Forest of Dean. Symonds Yat and the Welsh Border are also close by, and there are wonderful views over an Area of Outstanding Natural Beauty. The locality offers superb walking, cycling, canoeing, rock-climbing and caving possibilities, and riders who bring their own horses will find stabling and grazing facilities (Jennifer and Derek are keen riders and own several horses). The main attractions in the immediate vicinity are the extraordinary sandstone and quartz conglomerate monoliths described above. A superb breakfast sets guests up for an energetic day. Assisi is open all year round.

SLING MAP 1 REF B3
2 miles S of Coleford on the B4228

Di and Alan Jeynes assure customers old and new of a warm welcome at **The Miners Arms**, a grand old pub that's the heartbeat of the village - if it's happening in Sling, the pub knows about it! The setting in the Forest of Dean naturally attracts the tourists, and once they enter the pub, with its exposed stone walls

**The Miners Arms, Chepstow Road, Sling, Near Coleford,
Gloucestershire GL16 8LH Tel: 01594 836632**

and wooden floors, they know they've made the right choice. In this atmospheric ambience real ale quenches real thirsts, and there's also a good cider or two and some fruit-based brews. Traditional beer from the wood is produced at the Freeminer Brewery in the village. Good bar food is available all day at very reasonable prices to eat in or take away. The Big Breakfast is served at all times, and Friday night is curry night.

Elizabeth and Gareth Cole run the **Woodland View Caravan & Camping Site**, welcoming all ages of visitors seeking a close, friendly community in this most pleasant of surroundings. The site is in the heart of the Forest of Dean and is an ideal location to set base and start out on the driving, walking and cycling trails, or just relax and admire the lovely verdant scenery. Outdoor pursuits are very much the thing here, with walking, mountain biking, canoeing and caving among the options. The amenities are all that could be needed for a comfortable stay: pitches for tents, caravans and camper vans, toilets, hot showers, a chemical disposal point, fresh water taps, washing-up facilities, four hardstanding

**Woodland View Caravan & Camping Site, Sling, Near Coleford,
Gloucestershire GL16 8JA Tel: 01594 835127**

serviced pitches, 20 electric hook-up points and a small shop well stocked with
provisions. From Coleford take the B4228 towards Chepstow. After 2 miles Puz-
zle Wood is on the right. Woodland View is signposted ¼ mile further on the
left.

PARKEND MAP 1 REF B3
3 miles SE of Coleford off the B4234

A community once based, like so many others in the area, on the extraction of
minerals. New Fancy Colliery is now a delightful picnic area, with a nearby hill
affording breathtaking views over the forestscape. Parkend is to be the northern
terminus of Dean Forest Railway (see under Lydney). The track is there, the
signal box has been renovated and a replica station built. Off the B4431, just
west of Parkend, is the RSPB's **Nagshead Nature Reserve**, with hundreds of nest
boxes in a woodland site with footpaths, waymarked trails and a summer infor-
mation centre.

Comfortable en suite accommodation at the heart of the Forest of Dean is
offered at **Edale House**, an elegant Georgian building facing the cricket green in
the village of Parkend. Alan and Christine Parkes' house provides a quiet, civi-
lised home from home in an area of outstanding natural beauty and history:
the Royal Forest of Dean and the Wye Valley form one of Britain's most se-
cluded and tranquil National Parks, and another local attraction is the RSPB's
Nagshead Nature Reserve. The five guest bedrooms, all with en suite or private
facilities, are tastefully furnished to a high standard; two rooms on the ground
floor are suitable for less mobile guests. Local country produce is used for the
splendid evening meals served on Friday, Saturday and Sunday. Alan, a real

**Edale House, Folly Road, Parkend, Royal Forest of Dean, Gloucestershire
GL15 4JF Tel: 01594 562835 Fax: 01594 564488 e-mail: edale@lineone.net**

enthusiast in the kitchen, does all the cooking, regaling diners with such delights as trout rösti fishcakes, spinach-stuffed medallions of pork, and a cinnamon, date and banana pudding with toffee sauce. The wine list is a personal selection from around the world.

ST BRIAVELS
5 miles S of Coleford on minor roads

Map 1 ref B3

A historic village named after a 5th century Welsh bishop whose name appears in various forms throughout Celtic Wales, Cornwall and Brittany, but nowhere else in England. In the Middle Ages St Briavels was an important administrative centre and also a leading manufacturer of armaments, supplying weapons and ammunition to the Crown. In 1223 it is believed that Henry lll ordered 6,000 crossbow bolts (called quarrels) from here. The ample Church of St Mary the Virgin, Norman in origin, enlarged in the 12th and 13th centuries and remodelled by the Victorians, is the scene of a curious and very English annual custom, the St Briavels **Bread and Cheese Ceremony**. After evensong a local forester stands on the Pound Wall and throws small pieces of bread and cheese to the villagers, accompanied by the chant "St Briavels water and Whyrl's wheat are the best bread and water King John can ever eat". This ceremony is thought to have originated more than 700 years ago when the villagers successfully defended their rights of estover (collecting wood from common land) in nearby Hudnalls Wood. In gratitude each villager paid one penny to the churchwarden to help feed the poor, and that act led to the founding of the ceremony. Small pieces of bread and cheese were considered to bring good luck, and the Dean Forest miners would keep the pieces in order to ward off harm.

St Briavels Castle, which stands in an almost impregnable position on a high promontory, was founded by Henry l and enlarged by King John, who used it as a hunting lodge. Two sturdy gatehouses are among the parts that survive and they, like some of the actual castle buildings, are now in use as a youth hostel.

Andrew Richards has an effervescent, outgoing personality that guarantees a great atmosphere at **The Travellers Rest**. All ages and all types come here, from local regulars and family groups to passing traffic to the Wye Valley, and at the back is a parking area for caravans, with hook-up facilities. There's a neat garden, also at the back, and lawns and flower beds at the front, where rustic tables

**The Travellers Rest, Stowe Green, St Briavels, Near Lydney,
Gloucestershire GL15 6QW Tel: 01594 530678**

and chairs are set out. Inside, the scene is set by beams, a copper-hooded log fire, cane-backed chairs and some splendid oil paintings by Andrew's mother. Adorning the firebreast is a brass ship's bell from the old *Empress of England*. Andrew's wife Maureen is in charge of the cooking side, producing anything from snacks and salads to grills, pies, lasagne and vegetarian dishes. The real ales are good thirst-quenchers.

BREM

Map 1 ref B3

5 miles S of Coleford on the B4231

One of the gateways to the Forest, with traces of ancient iron workings and an imposing stone war memorial.

The Rising Sun is the fourth pub for experienced caterers Julie and Peter Hicks, who have made great strides in their first year here. The 200-year-old slate-roofed stone building has been totally refurbished while carefully preserving the stone walls and exposed beams that give the place such character. Julie's menus offer something for everyone, from baguettes and light snacks to a full à

**The Rising Sun, The High Street, Bream, Gloucestershire GL15 6JF
Tel/Fax: 01594 564555**

la carte menu served in the new 36-cover Stables Restaurant and 100-cover Forest View bar and dining area. From the grill come succulent steaks and a mighty mixed grill, and other main-course choices could be chicken tikka masala, venison steak in a red wine and mushroom sauce and the fresh fish of the day - consult the Catch of the Day board. There's always plenty for vegetarians and some naughty but delicious desserts, with liqueur coffees to round things off in style. Four real ales are on tap at any one time, and Peter's aim to have offered 100 different brews in his first year should be a doddle. There's a beer garden behind the pub, and ample parking at the side.

LYDNEY

The harbour and the canal at Lydney, once an important centre of the iron and coal industries and the largest settlement between Chepstow and Gloucester, are well worth exploring, and no visit to the town should end without a trip on the **Dean Forest Railway**. A regular service of steam and diesel trains operates between Lydney Junction, St Mary's Halt and Norchard. At **Norchard Railway Centre**, headquarters of the line, are a railway museum, souvenir shop and details of restoration projects, including the imminent extension of the line to Parkend. Air-conditioned classic coaches in the platform serve light snacks on steam days. The backbone of the locomotive fleet (this is for real railway buffs!) are 5541, a Churchwood-designed Prairie tank engine, and 9681, an 0-6-0 pannier tank built in 1948, when GWR was becoming BR. Call 01594 845840 for details of services and events.

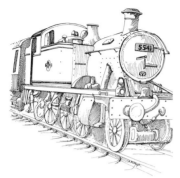

Dean Forest Railway

One of the chief attractions in the vicinity is **Lydney Park Gardens and Museum**. The gardens, which lie beside the A48 on the western outskirts, are a riot of colour, particularly in May and June, and the grounds also contain the site of an Iron Age hill fort and the remains of a late-Roman temple excavated by Sir Mortimer Wheeler in the 1920s. The builders of this unusual temple were probably wealthy Romanised Celts; the mosaic floor, now lost, depicted fish and sea monsters and was dedicated to Nodens, the Roman-Celtic god of healing whose emblem was a reclining dog with curative powers. The nearby museum houses a number of Roman artefacts from the site, including the famous 'Lydney Dog' and a number of interesting items brought back from New Zealand in the 1930s by the first Viscount Bledisloe after his term there as Governor General. Also in the park are traces of Roman iron-mine workings and Roman earth workings.

Highbury House, the former coach house for Lydney Park, provides high-quality self-contained accommodation in three modern apartments with all the amenities on hand for a self-catering holiday. An acre of mature gardens of great interest to plant-lovers, including ponds and pathways, overlooks a valley that reaches to the Forest of Dean, so the setting combines the best of both worlds - the sights and the shopping in Lydney and the outstanding beauty of the sur-

Highbury House, Lydney, Gloucestershire GL15 5JH
Tel: 01594 842339 Fax: 01594 844948

rounding countryside. Owner Inez Midgley can provide dinner in her adjoining Georgian house in addition to or as an alternative to self-catering, and a relaxed meal with quiet conversation is a great way to spend an evening. Inez is Portuguese, and the influence of her native land is present in her excellent cooking.

Taurus Crafts is located on the beautiful Lydney Park Estate on the southern border of the Forest of Dean just off the A48 between Lydney and Aylburton. The overall aim of Taurus is to open up life's chances and choices to a broad range of individuals with various difficulties and problems, offering work expe-

**Taurus Crafts, The Old Park, Lydney, Gloucestershire GL15 6BU
Tel: 01594 844841 Fax: 845636 e-mail: enquire@taurus.newnet.co.uk**

rience and training in a real work environment. The complex is an exciting place to browse, with a wide spectrum of attractions both inside and out. The enclosed Farm Yard contains the workshops of local crafts people, and throughout the year on-site demonstrations and exhibitions display their skills. In the beautifully restored oak-beamed barn are the Gallery, whose walls are hung with the work of talented local artists, and a café serving delicious cakes, snacks and wholesome lunches. All the crockery in the café is made on site, and visitors can watch the potters at work and even have a go themselves. The Taurus Gift Shop has become widely known for its selection of unusual gifts, quality home accessories and exquisite crafts. Taurus Crafts is open every day from 10 to 5.30.

AROUND LYDNEY

ALVINGTON
MAP 1 REF B3

2 miles SW of Lydney on the A48

In the churchyard at Alvington are the graves of the illustrious Wintour family, protagonists in the defeat of the Spanish Armada. Half a century after that event came Sir John Wintour's remarkable escape from Cromwell's man at **Wintour's Leap**. Captain John Wintour (or Winter), adventurer, Keeper of the Forest of Dean and sometime secretary to Queen Maria Henrietta of the Netherlands, was at the head of a Royalist force when defeated at Blockley, near Chepstow, by Parliamentary troops. Wintour is said to have escaped the battle, which took place in 1644, by riding up the Wye and hurling himself and his horse into the river from the cliffs at Lancaut.

A prominent location in a pleasant village on the A48 southwest of Lydney makes for easy access to **The Globe Inn**, a large 17th century building, said to be a coaching inn in the past, with a lawned garden and an ornamental pond with koi carp. Inside, darkwood tables and chairs provide space and comfort in the front bar and restaurant area; in the back bar, the locals like to get together for a pint and a game of darts, pool or quoits. Tony and Kath Kirkham have been here since the mid-1980s; Tony is in charge of the kitchen, producing tasty bar snacks and a full menu that includes 12oz gammon, 10oz sirloin steak, home-made steak & kidney pie and an excellent Sunday roast lunch for which it is advisable to book.

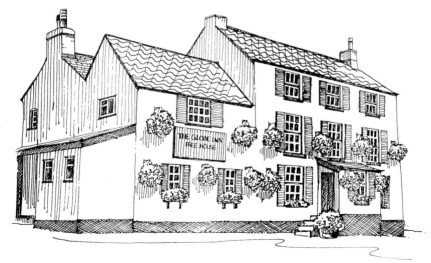

The Globe Inn, Alvington, Near Lydney, Gloucestershire GL15 6BD
Tel: 01594 529284

YORKLEY

MAP 1 REF B3

3 miles N of Lydney off the B4234

The Nags Head has a really outstanding tenant in Myra Byett, a friendly and very popular lady who has been at the helm for 17 years. The building is about 200 years old, smartly whitewashed over stone, with a pretty little front garden with white tables and chairs set outside in summer. Inside, the open-plan bar attracts a very cheerful group of locals as well as walkers, weekenders and tourists enjoying the region's superb countryside. The local football and cricket teams

The Nags Head, Yorkley, Near Lydney, Gloucestershire GL15 4RX
Tel: 01594 562592

are regular visitors, and there are pub teams for darts, quoits, cribbage and skittles (the skittle alley upstairs is occasionally visited by a female ghost). There's live entertainment at the weekend, with occasional bursts at any time on the resident electric organ. Food, all home-prepared and home-cooked, spans snacks, sandwiches, pies and steaks, with Sunday lunches particularly popular.

BLAKENEY

MAP 1 REF B3

4 miles NE of Lydney on the A48

An attractive little village and a convenient base for exploring the heart of the Forest. Bed and Breakfast accommodation is available in two large, well-furnished rooms at **The Old Tump House**, a stone-built former inn and cider mill at the end of a charming little valley on the edge of the forest. Originally a two-up, two-down cottage with an adjacent brewhouse, it served as a hostelry for the local iron-smelters. A large function room was later added, and that room

The Old Tump House, New Road, Blakeney, Gloucestershire GL15 4DG
Tel/Fax: 01594 510608

and the old brewhouse now contain the B&B accommodation, where cooking facilities are available for self-catering. A separate cider mill was built, and the horse-driven crushing wheel and press exist unchanged to this day. The Old Tump House, which enjoys stunning views down the valley, is owned and run by a retired professional couple, June and Terry Noble.

On the edge of the village, on the main A48, **The Cock Inn** is a free house that attracts both local and passing trade, as well as tourists wanting a base for

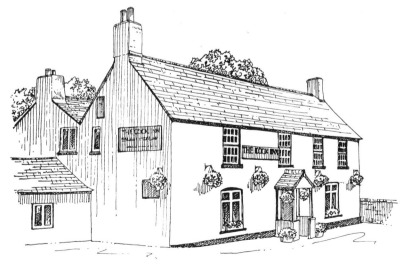

The Cock Inn, Nibley Hill, Blakeney, Gloucestershire GL15 4DG
Tel: 01594 510239

exploring the marvellous Forest of Dean. Drivers can join the Forestry Commission's circular drive through the central part of the forest on a road that follows the twists and turns of the river. The letting bedrooms are singles, doubles and a family room, all with en suite facilities, TVs and tea/coffee-makers. There are two bars, one mainly for drinking, the other mainly for dining. The walls are covered with interesting old prints and photographs. Good-quality food, prepared and cooked on the premises, spans a decent choice, from sandwiches and baguettes to chicken pie and steaks. There's ample parking at the side of the pub, and a lawned beer garden secure and secluded behind a hedge and a fence. Owner Gordon Bowkett had the local corner shop for many years and together with April is now putting time and energy into running the pub and overseeing a refurbishment programme.

Take the B4227 up from Blakeney to visit the **Dean Heritage Centre** at **Soudley**. The centre, open throughout the year, tells the story of the unique landscape of the Forest and its fiercely independent people. Attractions include

Dean Heritage Centre

displays of natural, industrial and social history, a Victorian cottage, a smallholding with animals, millpond and waterwheel, a charcoal stack, crafts shop and café.

At nearby **Awre**, an ancient crossing place of the Severn, is the Church of St Andrew, not much changed in the 700 years since it was built. Its most remarkable possession is the massive **Mortuary Chest**, carved from a single trunk and used down the years as a laying out place for bodies recovered from the river. In the churchyard are several examples of headstones depicting the local speciality of cherubs.

NEWNHAM-ON-SEVERN
MAP 1 REF B3
3 miles N of Blakeney on the A48

One of the gateways to the Forest, and formerly a port, Newnham lies on a great bend in the river. It is one of the best places for viewing the famous **Severn Bore**, the wave that is created when the incoming tide from the Bristol Channel is funnelled into the narrow Severn estuary. Small-scale bores occur throughout the year, but at certain times, usually in early spring or late autumn, tidal conditions can generate a wave up to nine feet in height - a great challenge to surfers and canoeists.

Newnham's heyday was at the beginning of the 19th century, when a quay was built and an old tramway tunnel converted into what was perhaps the world's first railway tunnel. The churchyard of St Peter's has more examples of the cherub headstones.

Joanne Mathews, who counts dogs and ballooning among her loves, offers superb accommodation at **Swan House**, her 17th century stone-and-slate merchant's house in the main street. The six bedrooms, all en suite, are individually decorated and furnished, with either antique pine or four-poster beds. Thoughtful touches abound, and one ground floor room has grab rails in the bathroom for less mobile guests. The south-facing garden is a perfect spot to relax in the summer, while inside is a comfortable sitting room where complimentary sherry is offered before a candlelit dinner. The evening meal is served in the Georgian extension, and a regularly changing menu makes excellent use of local, often organic produce in such dishes as warm chicken liver mousse with bacon, bay leaf and crab apple jelly, wine-braised venison sausages and traditional apple pie with a Lancashire cheese crust and mascarpone and nutmeg ice cream. A full English

Swan House, High Street, Newnham-on-Severn, Glocs
GL14 1BY Tel: 01594 516504 Fax: 01594 516177
e-mail: joanne@swanhouse_newnham.freeserve.co.uk
Website: www.swanhouse_newnham.freeserve.co.uk

breakfast with plenty of choice starts the day, and for trips out into the country-side picnic hampers or packed lunches can be provided. Smoking is allowed in the bedrooms but not in the restaurant.

WESTBURY-ON-SEVERN
MAP 1 REF C3

3 miles NW of Newnham on the A48

The village is best known for the National Trust's **Westbury Court Garden**, a formal Dutch water garden laid out between 1696 and 1705. Historic varieties of apple, pear and plum, along with many other species introduced to England before 1700, make this a must for any enthusiastic gardener. The house was long ago demolished, and the only building to survive is an elegant two-storey redbrick pavilion with a tower and weather vane. Tel: 01452 760461.

Also worth a visit in Westbury is the Church of Saints Peter, Paul and Mary with its detached tower and wooden spire.

LITTLEDEAN
MAP 1 REF B2

2 miles NW of Newnham on the road to Cinderford

Places of interest here include the 13th century church, the 18th century prison and, just south of the village, **Littledean Hall**, reputedly the oldest inhabited house in England. The house has Saxon and Celtic remains in the cellars and is thought to have originated in the 6th century. Highlights in the grounds, from which balloon flights launch, include a Roman temple site, a Victorian walled garden and a number of ancient chestnut trees. Open 11-5 every day.

On a corner in the centre of the village, **The Kings Head** is a 200-year-old building in traditional stone and slate. The local trade is returning with a will

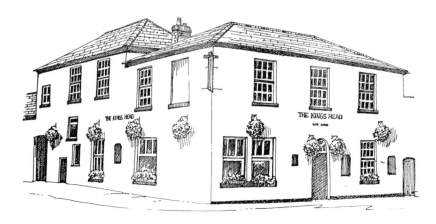

The Kings Head, Broad Street, Littledean, Gloucestershire GL14 3NH
Tel: 01594 825648

since the pub was taken over by Julie Murrell, an astute, enthusiastic and friendly young manager who has lived in the village for several years. The open-plan bar is light, comfortable and appealing, with curtained windows, old beams, photographs and old books on the area to browse through while enjoying a glass of real ale or waiting for a meal. Home cooking produces simple, wholesome fare, from well-filled sandwiches to omelettes, chicken dishes and steaks. Coffee is available throughout the day. Car parking 150 yards away.

CINDERFORD
MAP 1 REF B2

3 miles NW of Newnham on the A4151

A former coal-mining community with evidence of the mines visible among the trees.

And so back to Longhope, where the round trip started, for an excursion north to Newent and the vale of Leadon.

NEWENT
MAP 1 REF C2

5 miles N of Longhope on the B4216

Capital of the area of northwest Gloucestershire known as the Ryelands, and the most important town in the Vale of Leadon, Newent stands in the broad triangle of land called Daffodil Crescent. The rich Leadon Valley soil was traditionally used for growing rye and raising the renowned Ryelands sheep, an ancient breed famed for the quality of its wool. The town was one of the county's principal wool-trading centres, and the wealth produced from that trade accounts for the large number of grand merchants' houses to be seen here. The most distinctive house in Newent is the splendid timber-framed **Market House**, built as a butter market in the middle of the 16th century, its upper floors supported on 16 oak pillars that form a unique open colonnade. The medieval **Church of St Mary** has many outstanding features, including the shaft of a 9th century Saxon cross, the 11th century 'Newent Stone' and the 17th century nave. Royalist troops had removed the lead from the roof to make bullets, an act which caused the roof to collapse during a snowstorm in 1674. A new nave was started after Charles ll agreed to donate 60 tons of timber from the Forest of Dean.

Janet Turpie front of house and Simon Eastwood in charge of the kitchen make an excellent team at **The Singing Kettle**. The 100 year-old building, once a winery, with a grain store above, is now a super restaurant and tea room. The two parts, seating about 50 in all, are separated by the kitchen, where Simon and his two chefs prepare a mouthwatering variety of dishes for the various menus. Chilli, steaks, pasta and grilled haddock appear on both main menus, while the evening à la carte goes to town with the likes of crispy prawn brochettes, grilled salmon with rosemary hollandaise and sautéed pork with apricots. A menu of snacks and lighter dishes is available all day, but this is a place where

The Singing Kettle, 1-2 Cheapside, Church Street, Newent, Gloucestershire GL18 1PU Tel: 01531 822941

you should linger over a proper meal! The walls of The Singing Kettle are adorned with the work of local artists and when the weather is kind, tables and chairs are set out under parasols in a paved area at the front. Summer opening hours are 10-4.30 Tuesday -Sunday plus Friday and Saturday evenings (open all day Saturday). Phone for winter variations. Closed January

The Shambles Museum of Victorian Life is virtually a little Victorian town, a jumble of cobbled streets, alleyways and squares, with shops and trades tucked away in all corners, and even a mission chapel and a Victorian conservatory. Tel: 01531 822144. At Nicholson House (Tel: 01531 821888) is the private collection Crime Through Time, often called the Black Museum of Gloucestershire.

There aren't too many windmills in Gloucestershire, but at **Castle Hill Farm** just outside town is a working wooden mill with great views from a balcony at the top.

AROUND NEWENT

A mile south of Newent is the **National Bird of Prey Centre** housing one of the largest and best collections of birds of prey in the world. Over 110 aviaries are home to eagles, falcons, owls, vultures, kites, hawks and buzzards. Between 20 and 40 birds are flown daily. Open every day from February to November.

On the road north towards Dymock, set in 65 acres of rolling countryside, the **Three Choirs Vineyard** is the country's largest wine producer.

DYMOCK
MAP 1 REF C1
3 miles N of Newent on the B4216

At the heart of the village is the early Norman Church of St Mary, whose unusual collection of artefacts and memorabilia includes the last ticket issued at Dymock station, in 1959. Dymock boasts some fine old brick buildings, including the White House and the Old Rectory near the church, and outside the village, the Old Grange, which incorporates the remains of the Cistercian Flaxley Abbey. In the years before World War 1 Dymock became the base for a group of writers who became known as the **Dymock Poets**. The group, which included Rupert Brooke, Wilfred Gibson, Edward Thomas and Lascelles Abercrombie, and was later joined by Robert Frost, sent out its *New Numbers* poetry magazine from Dymock's tiny post office, and it was also from here that Brooke published his *War Sonnets*, including *The Soldier* (*If I should die, think only this of me.....*). Brooke and Thomas died in the War, which led to the dissolution of the group. Two circular walks from Dymock take in places associated with the poets.

UPLEADON
MAP 1 REF C2
2 miles N of Newent off the B4215

The **Church of St Mary the Virgin** features some fine Norman and Tudor work but is best known for its unique tower, half-timbered from bottom to top; even the mullion windows are of wood. The church has a great treasure in its Bible, an early example of the Authorised Version printed by the King's printer Robert Barker. This was the unfortunate who later issued an edition with a small but rather important word missing. The so-called Wicked Bible of 1631 renders Exodus 20.14 as *"Thou shalt commit adultery"*.

KEMPLEY
MAP 1 REF C2
1 mile S of Newent on a minor road

A village famous for its cider and also for having two churches, of very different age and significance. The Church of St Mary, easily the most popular church in the area, dates from the end of the 11th century and would be a gem even without its greatest treasure. That treasure, in the chancel, is an almost complete set of 12th century frescoes, the most renowned in the region and among the finest in the land. Their subjects include St Peter and the Apostles, Christ with his feet resting on a globe, and the de Lacy family, local lords of the manor. The red sandstone Church of St Edward the Confessor was built in 1903 by the 7th Earl Beauchamp in the style of the Arts and Crafts Movement using exclusively local materials.

This is the area of **Dymock Woods**, an area of Forestry Commission woodland famous for its daffodils.

Three miles south of Newent, on National Trust land, stands **May Hill**. It rises to nearly 1,000 feet and its domed summit is planted with trees commemo-

rating Queen Victoria's Golden Jubilee (1887), Queen Elizabeth ll's Silver Jubilee (1977) and the Queen Mother's 80th birthday (1980). The reward for climbing to the top is a quite magnificent view that stretches over Gloucestershire, and, on a clear day, as far as Bristol.

2 South Gloucestershire & the Vale of Berkeley

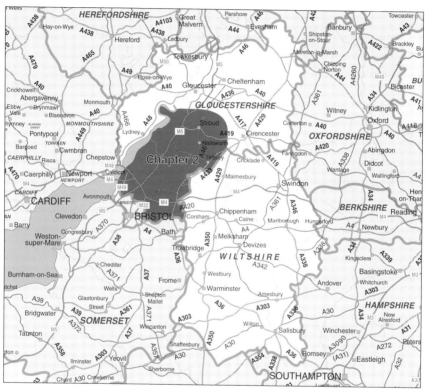

© MAPS IN MINUTES ™ (1998)

A tour down the eastern bank of the great River Severn, taking in the meanderings of the river, the great tidal ranges of the estuary, the old and new bridges; natural history at Slimbridge, bricks and mortar history at Berkeley, industrial archaeology, glorious gardens and the charming towns of Tetbury and Stroud.

FRAMPTON-ON-SEVERN
8 miles SW of Gloucester off the A38

MAP 1 REF C3

The 22-acre Rosamund Green, incorporating a cricket ground and three ponds, is one of the largest village greens in England, formed when the marshy ground outside the gates of **Frampton Court** was drained in the 18th century. The court is an outstanding example of a Georgian country house, built in the Palladian

style in the 1730s and the seat of the Clifford family ever since. Fine porcelain, furniture and paintings grace the interior, and in the peacock-strutted grounds an ornamental canal reflects a superb Orangery in Dutch-influenced strawberry gothic. A unique octagonal tower was built in the 17th century as a dovecote. The Court is open by appointment only. Tel: 01452 740267.

On the other side of the green is **Frampton Manor**, the Clifford family's former home, built between the 12th and 16th centuries. This handsome timber-framed house is thought to be the birthplace of Jane Clifford, who was the mistress of Henry ll and bore him two children. The manor, which has a lovely old walled garden with some rare plants, is open by written appointment. At the southern edge of the village stands the restored 14th century Church of St Mary with its rare Norman lead font. The church stands beside the **Sharpness Canal**, which was built to allow ships to travel up the Severn Valley as far as Gloucester without being at the mercy of the estuary tides. The canal has several swing bridges and at some of these, as at Splatt Bridge and Saul Bridge at Frampton, there are splendid little bridge-keeper's cottages with Doric columns.

To the west of Frampton, on a great bend in the river, is the Arlingham Peninsula, part of the **Severn Way Shepperdine-Tewkesbury long-distance walk**. The trail passes close to Wick Court, a 13th century moated manor house. The land on which the village of **Arlingham** stands once belonged to the monks of St Augustine's Abbey in Bristol who believed it to be the point where St Augustine crossed the Severn on his way to converting the heathen Welsh tribes. Nearby is **St Augustine's Farm** on the site of a monastic house. It is a 110-acre working farm and a popular venue for family outings, but as we went to press (October 1999) farm alterations were under way and the farm was not open for individual visits. Call 01452 740277 for the latest information about re-opening.

The Severn naturally dominated life hereabouts and at **Saul**, a small village on the peninsula, the inhabitants decorated their houses with carvings of sailors, some of which, in bright, cheerful colours, can be seen today. The village lies at the point where two canals cross. Continuing round the bend in the river, **Epney** is the point from which thousands of baby eels are exported each year to the Netherlands and elsewhere to replenish their own stocks. A mile or so inland from Epney is the historic hamlet of **Moreton Valence**, whose 15th century church has an impressive Norman doorway with a depiction of the Archangel Michael thrusting a spear into a dragon's mouth. Also to be seen here are the ramparts of a 14th century castle, once the property of the De Valence family.

SLIMBRIDGE
4 miles S of Frampton on the A38

MAP 1 REF C3

The Wildfowl and Wetlands Trust was founded on the banks of the Severn in 1946 by the distinguished naturalist, artist, broadcaster and sailor Peter (later

**Slimbridge Wildfowl
and Wetlands Trust**

Sir Peter) Scott. He believed in bringing wildlife and people together for the benefit of both, and the Trust's work continues with exciting plans for the Millennium. Slimbridge has the world's largest collection of exotic wildfowl, with up to 8,000 wild winter birds on the 800-acre reserve. Viewing facilities are first-class, and there's a tropical house, pond zone, children's play area, restaurant and gift shop. Tel: 01453 890333. Also in the long, rambling village is a fine 13th century church whose 18th century windows incorporate fragments of the original medieval glass.

BERKELEY

MAP 1 REF B3

6 miles S of Frampton off the A38

The fertile strip that is the Vale of Berkeley, bounded on the north by the Severn and on the south by the M5, takes its name from the small town of Berkeley, whose largely Georgian centre is dominated by the Norman **Berkeley Castle**. Said to be the oldest inhabited castle in Britain, and home to 24 generations of the Berkeley family, this wonderful gem in pink sandstone was built between

Berkeley Castle

1117 and 1153 on the site of a Saxon fort. It was from here that the barons of the West met before making the journey to Runnymede to witness the signing of Magna Carta by King John in 1215. Edward ll was imprisoned here for several months after being usurped from the throne by his wife and her lover, and eventually met a gruesome death in the dungeons in the year 1327. Three centuries later the castle was besieged by Cromwell's troops and played an important part in the history of the Civil War. It stands very close to the Severn and once incorporated the waters of the river in its defences so that it could, in an emergency, flood its lands. Visitors passing into the castle by way of a bridge over a moat will find a

wealth of treasures in the **Great Hall**, the circular keep, the state apartments with their fine tapestries and period furniture, the medieval kitchens and the dungeons. The Berkeley family have filled the place with objects from around the world, including painted glassware from Damascus, ebony chairs from India and a cypress chest that reputedly belonged to Sir Francis Drake. Security was always extremely important, and two remarkable signs of this are a four-poster bed with a solid wooden top (no nasty surprises from above in the night) and a set of bells once won by the castle's dray horses and now hanging in the dairy. Each horse wore bells with a distinctive chime so that if an outsider attempted to gain entrance as a carter his strange bells would betray him. The castle is surrounded by sweeping lawns

Great Hall, Berkeley Castle

and Elizabethan terraced gardens. Special features include a deer park, a medieval bowling alley, a beautiful lily pond and a butterfly farm with hundreds of exotic butterflies in free flight. Tel: 01453 810332.

The parish church of St Mary, which contains several memorials to the Berkeley family, has a fine Norman doorway, a detached tower and a striking east window depicting Christ healing the sick. A curious piece of carving in the nave shows two old gossips with a giant toad sitting on their heads. Next to the castle and church is the **Jenner Museum**, once the home of Edward Jenner, the doctor and immunologist who is best known as the man who discovered a vaccine against smallpox. The son of a local parson, Jenner was apprenticed to a surgeon in Chipping Sodbury in 1763 at the tender age of 14. His work over several decades led to the first vaccination against smallpox, a disease which had killed many thousands every year. His beautiful Georgian house in Church Lane has a state-of-the-art display showing the importance of the science of immunology, and in the grounds of the house is a rustic thatched hut where Jenner used to vaccinate the poor free of charge and which he called the Temple

of Vaccinia. The museum is open Tuesday to Sunday afternoons from April to September and on Sunday afternoons in October.

At **Sharpness**, a mile or so west of Berkeley, the world's first nuclear power station operated between 1962 and 1989. It marks the entrance to the **Sharpness Canal**. There are several interesting villages in the vicinity, including Breadstone, which has a church built entirely of tin.

Visitors to Berkeley Castle should not miss the opportunity to sample the excellent hospitality on offer at **The Elms Country House**, where Alistair and Alison Rawnsley are always on hand with a friendly welcome. The 17th century slate-roofed stone building, once the property of aviation expert Sir Stanley Hooker, is decorated and furnished with great style and taste, and the eight en suite letting bedrooms, including some of family size, provide a very comfortable base for touring the area or just relaxing. Alison runs the catering side of

The Elms Country House, Stone, Vale of Berkeley, Gloucestershire GL13 9JX Tel: 01454 260279

the business, and in the two dining rooms - 30 covers in all - good eating is to be had throughout the day, with anything from jacket potatoes and a slap-up breakfast to fish pie, steaks and vegetable Wellington. At weekends a fixed-price three-course menu is another option. The residents' lounge, with log fire and inviting armchairs, is a good place to while away an hour or two, and tables and chairs are set out under parasols on the lawn. The castle is a major local attraction, but there are also some lovely walks hereabouts, notably along the banks of the Little Severn. The Elms is located on the A38 very close to J14 of the M5.

OLDBURY-ON-SEVERN Map 1 ref B4
15 miles SW of Frampton off the A38

The parish is dedicated to St Arilda, a virgin who was beheaded at nearby Kington because she refused to give in to the advances of an evil local baron. Much of the church was rebuilt after being destroyed by fire in 1897, but there are some interesting monuments from the 17th and 18th centuries. There are marvellous views from the churchyard across the river to Chepstow and the Forest of Dean.

THORNBURY

A bustling market town between the Severn and the M5, with a number of interesting buildings from both Georgian and Victorian times. The woollen industry was important in late medieval times, and the church, set away from the centre near the site of the old manor house, reflects the prosperity of those days. The side chapel is dedicated to the Stafford family, the local lords of the manor whose emblem, the Staffordshire knot, is much in evidence. Edward Stafford, 3rd Duke of Buckingham, was responsible for starting work on **Thornbury Castle** in 1511 but did not live to see its completion. Charged with high treason by Henry Vlll, he was beheaded in London on Tower Hill in 1522. The building was completed by Anthony Salvin in the 1850s and for many years has been run as a restaurant.

AROUND THORNBURY

AUST Map 1 ref B4
3 miles W of Thornbury on the B4461

The English end of the original **Severn Suspension Bridge** lies here. Completed in 1966, it replaced the ferry service which had plied this unreliable stretch of water since Roman times. The bridge carries the M4 motorway across the wide river mouth into South Wales. A second crossing was more recently developed at the little resort of **Severn Beach**, three miles downstream from Aust. The rail tunnel also passes under the estuary at this point.

ALMONDSBURY Map 1 ref B4
6 miles S of Thornbury on the A38

Four miles to the east of Severn Beach, the sprawling community of Almondsbury is home to more than its fair share of ghosts. The Church of St Mary has some notable features, including a Norman font and a rare lead-covered broach spire, one of only three in southern England. It also has some fine windows, one of them a memorial to Charles Richardson, the 19th century engineer who designed

the original Severn Tunnel. A curious event took place in 1817 at nearby **Knole Park** when a young woman arrived at the door of the local squire saying that she was an Oriental princess who had been kidnapped and taken on board a ship, from which she had escaped by jumping overboard. The squire was taken in, and so was 'Princess Caraboo', who rapidly became the toast of Bath. Her fame spread far enough to come to the attention of her former Bristol landlady, who identified the fake princess as one Mary Baker, a penniless woman from Devon. The embarrassed squire raised the money to send the impostor to Philadelphia, from whence she returned some years later to live in Bristol, where she died in 1865.

Our journey skirts the northern suburbs of Bristol to visit more of the hidden delights of South Gloucestershire.

MARSHFIELD
10 miles E of Bristol on the A420

MAP 1 REF C5

This old market town was once the fourth wealthiest town in Gloucestershire, after Bristol, Gloucester and Cirencester, its prosperity based on the malt and wool industries. Its long main street has many handsome buildings dating from the good old days of the 17th and 18th centuries, but not many of the coaching inns remain that were here in abundance when the town was an important stop on the London-Bristol run. Among the many notable buildings are the **Tolzey market hall** and the imposing Church of St Mary, which boasts a fine Jacobean pulpit and several impressive monuments from the 17th and 18th centuries. Each Boxing Day brings out the **Marshfield Mummers**, who take to the streets to perform a number of time-honoured set pieces wearing costumes made from newspapers and accompanied by a town crier. On the northern edge of town is a folk museum at Castle Farm.

A lane leads south through a pretty valley to the delightful hamlet of **St Catherine's**, whose church contains a splendid 15th century stained-glass window with four lights depicting the Virgin Mary, the Crucifixion, St John and St Peter. The great manor house, St Catherine's Court, now privately owned, once belonged to the Benedictine priory at Bath.

Three miles northwest of Marshfield, on the A46, the National Trust-owned **Dyrham Park** stands on the slope of the Cotswold ridge, a little way south of the site of a famous 6th century battle between Britons and Saxons. This striking baroque mansion, the setting for the film *Remains of the Day*, houses a wonderful collection of artefacts accumulated by the original owner William Blathwayt during diplomatic tours of duty in Holland and North America (he later became Secretary of State to William lll). Among the most notable are several Dutch paintings and some magnificent Delft porcelain. The west front of the house looks out across a terrace to lawns laid out in formal Dutch style; much of the estate is a deer park, which perhaps it was originally, as the word Dyrham means 'deer enclosure' in Saxon. A charming little church in the grounds has a Nor-

man font, a fine 15ᵗʰ century memorial brass and several memorials to the Winter and Blathwayt families.

CHIPPING SODBURY

A pleasant market town that was one of the earliest examples of post-Roman town planning, its settlement being arranged in strips on either side of the main street in the 12ᵗʰ century. The town once enjoyed prosperity as a market and weaving centre, and it was during that period that the large parish church was built.

Moda Hotel is a listed 17ᵗʰ century building with a Georgian facade. It has a unique position overlooking the High Street and the Cotswolds. The hotel, owned by Pauline and Jeff Pullin, has ten letting bedrooms, including a family room; all have en suite facilities, central heating, hospitality trays, Sky TV and direct-

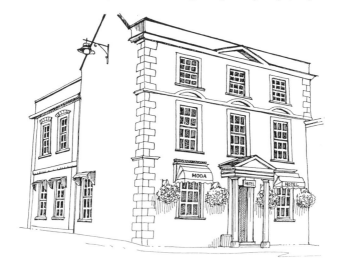

Moda Hotel, 1 High Street, Chipping Sodbury, Bristol BS37 6BA
Tel: 01454 312135 Fax: 01454 850090

dial phones. Guests can relax with a drink in the cocktail lounge bar, and table d'hote meals (by arrangement) are served in the well-appointed dining room. The owners project a warm, friendly image, providing a genuinely warm welcome for their wide range of guests, from business people to weekend visitors and families on holiday. The hotel is ideally situated for the Cotswolds, Bristol and Bath.

A mile or so to the east, on a loop off the A432, is **Old Sodbury**, whose part-Norman church contains some exceptional tombs and monuments. One of these is a carved stone effigy of a 13ᵗʰ century knight whose shield is a very rare wooden

carving of a knight. Also in the church is the tomb of David Harley, the Georgian diplomat who negotiated the treaty which ended the American War of Independence. A tower just to the east of the church marks a vertical shaft, one of a series sunk to ventilate the long tunnel that carried the London-South Wales railway through the Cotswold escarpment. Opened in 1903, the 2½ mile tunnel required its own brickworks and took five years to complete.

A lane leads south from Old Sodbury to **Dodington House**, built between 1796 and 1816 where previously an Elizabethan house stood. It was designed in lavish neo-Roman style by the classical architect James Wyatt, who was killed in a carriage accident before seeing his work completed. The house, whose interior is even more ornate than the facade, is open daily in the summer. Connected to the house by an elegant conservatory is the private Church of St Mary, also designed by Wyatt, in the shape of a Greek cross.

AROUND CHIPPING SODBURY

TORMARTON MAP 1 REF C5
3 miles SE of Chipping Sodbury off the A46

The Compass Inn, which started life in the 18th century as a coaching inn, has kept much of its old-world appeal while providing up-to-date amenities for today's visitors. Paul and Penny Monyard continue a family tradition built up

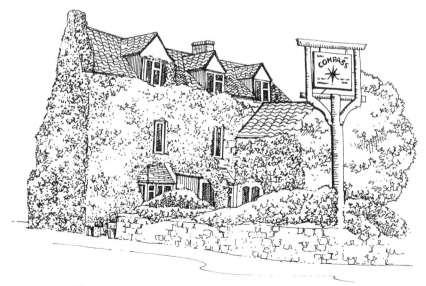

The Compass Inn, Tormarton, Near Badminton,
South Gloucestershire GL9 1JB Tel: 01454 218242 Fax: 01454 218741

over 48 years, and their guests are drawn from all ages and all walks of life. Behind a frontage almost hidden by luxuriant creeper are several bars, all sporting old wooden beams, five conference rooms and 26 guest bedrooms decorated and furnished to a very high standard and all with en suite facilities. In the restaurant, open all day every day, the Vittles Menu lists an extensive bill of fare from sandwiches and jacket potatoes to grills, pasta, 'chips with everything' and home-made specialities such as shepherd's pie or beef curry. The à la carte menu offers more esoteric choices like paté of roasted peppers and onion, Oriental stir-fry and chargrilled venison with a redcurrant and rosemary sauce. The inn, which stands on the B4465 in six acres of lawns and gardens, is in the heart of the country but has easy access to the motorway network. Local activities which can be arranged for guests include clay pigeon shooting, hot-air ballooning and riding.

BADMINTON
4 miles E of Chipping Sodbury off the B4040

MAP 1 REF C4

The **Badminton Park** estate was founded by Edward Somerset, the son of the Marquis of Worcester, whose 25-foot monument stands in the little church next to the main house. The central section of the house dates from the 1680s and contains some marvellous carvings in lime wood by Grinling Gibbons. The rest of the house, along with the grounds and the many follies and gateways, is the work of the mid-18th century architect William Kent. The house contains an important collection of Italian, English and Dutch paintings. The game of badminton is said to have started here during a weekend party in the 1860s. The Duke of Beaufort and his guests wanted to play tennis in the entrance hall but were worried about damaging the paintings; someone came up with the bright idea of using a cork studded with feathers instead of a ball. In such a moment of inspiration was the game born, and it was one of the guests at that weekend bash who later took the game to Pakistan, where the first rules were formalised.

Many of the buildings on the estate, including the parish church and the estate villages of Great and Little Badminton, were designed in an ornate castellated style by Thomas Wright. The park is perhaps best known as the venue of the **Badminton Horse Trials**, which annually attract the best of the international riders, and spectators in their thousands.

DIDMARTON
7 miles NE of Chipping Sodbury on the A433

MAP 1 REF C4

Plenty to see here, notably the medieval Church of St Lawrence, left alone by the serial remodellers of Victorian times and retaining its original three-storey pulpit and antique box pews. A row of hat pegs standing 16 feet off the ground suggests that the church once had a gallery. Next to the church, behind a giant Wellingtonia, are the remains of a 17th century manor house, while across the

road a semicircle of stones marks the site of **St Lawrence's Well**, which the saint himself, after a personal visit, promised would never run dry. In the centre of the village, **Kingsmead House** has two oddities in its garden: an octagonal gazebo from which the owner could get the first of the stagecoaches arriving from Bath, and a Gothic hermit's house constructed of yew.

WESTONBIRT
9 miles NE of Chipping Sodbury on the A433

MAP 1 REF C4

Westonbirt Arboretum, three miles south of Tetbury, contains one of the finest collections of trees and shrubs in Europe - 18,000 of them spread over 600 acres of glorious Cotswold countryside. Wealthy landowner Robert Stayner Holford founded this tree wonderland by planting trees for his own interest and pleasure. His son, Sir George Holford, was equally enthusiastic about trees and continued his father's work until his death in 1926, when he was succeeded by his nephew, the 4th Earl of Morley. Opened to the public in 1956 and now managed by the Forestry Commission, the arboretum has something to offer all year round: a crisp white wonderland after winter snows, flowering shrubs and rhododendrons in spring, tranquil glades in summer, glorious reds and oranges and golds in the autumn. The grounds provide endless delightful walks, including 17 miles of footpaths, and there's a visitor centre, plant centre, café and picnic areas. Open all year.

TETBURY
11 miles NE of Chipping Sodbury on the A433

MAP 1 REF D4

A really charming Elizabethan market town, another to have prospered from the wool trade. Its most famous building is the stone-pillared 17th century **Market House** in the heart of town, but a visit should also take in the ancient **Chipping Steps** connecting the market house to the old trading centre, and the Church of St Mary, an 18th century period piece with high-backed pews, huge windows made from recovered medieval glass and slender timber columns hiding sturdy iron uprights. **Tetbury Police Museum**, housed in the original cells of the old police station, has a fascinating collection of artefacts, memorabilia and uniforms from the Gloucestershire Constabulary. Open Monday to Friday 9 till 3 and by appointment (Tel: 01666 504670).

One of the very best reasons for lingering awhile in Tetbury is to visit **Tetbury Gallery & Tea Room**, situated near the old Market House. The elegant Georgian building, which Jane Maile runs with her daughter Gemma Williams, holds, as the name suggests, a double delight. The gallery offers a selection of original paintings and prints and unusual giftware which is carefully chosen by the owners. Beyond the Fine Art gallery, visitors will discover a wonderful traditional English tea room with linen tablecloths and sparkling white china. The food is exceptional and features a mouthwatering variety of home-made soups,

Tetbury Gallery & Tea Room, 18 Market Place, Tetbury,
Gloucestershire GL8 8DD Tel: 01666 503412

salads, hot savouries, scones and cakes. The quality of the cooking led to its
becoming a founder member of the Tea Council's Guild of Tea Shops and it
featured in a prestigious American book listing the 22 'Great Tea Rooms of Brit-
ain'. Seating in the walled courtyard when the weather permits. Open seven
days a week.

Patrick, Sandra and Luke Bate extend a warm welcome to their cosy Cots-
wold free house **The Royal Oak**. Just away from the town centre on the route of
a popular walk, this fine Cotswold slate-roofed pub has a sizeable outside seat-
ing area with lawned garden, which is a mass of colourful blooms in season,
while inside, an attractive bar is the centrepiece of the open-plan main room.
Beautifully furnished, with prints, paintings, jugs and copper ornaments, the
whole place has a very comfortable, inviting feel. A separate building houses a
skittle alley and function room. Back in the bar area there are seats for 40 or so
hungry souls, who take their pick from Luke's menu, which tempts with the
likes of chicken, mango and pepper salad, bangers and champ, four-cheese ra-
violi, lamb roghan josh and the renowned fisherman's pie plus full à la carte
and specials board. At lunchtime the full menu is supplemented by a selection

**The Royal Oak, Cirencester Road, Tetbury, Gloucestershire GL8 8EY
Tel: 01666 502570**

of baguettes and sandwiches. As we went to press (summer 1999) there was a possibility of guest accommodation, due to come on stream sometime in the year 2000.

Two miles northwest of Tetbury, west of the B4104, stands **Chavenage House**, a beautiful Elizabethan mansion built of grey Cotswold stone on earlier monastic foundations in the characteristic E shape of the period. The elegant front aspect has remained virtually unchanged down the years, and the present owners, the Lowsley-Williams family, can trace their lineage back to the original

Chavenage House

owners. Two rooms are covered with rare 17th century tapestries, and the house contains many relics from the Cromwellian period. Cromwell is known to have stayed at the house, and during the Civil War he persuaded the owner, Colonel Nathaniel Stephens, a relative by marriage, to vote for the King's impeachment. According to the Legend of Chavenage the owner died after being cursed by his daughter and was taken away in a black coach driven by a headless horseman. The present owner, who conducts tours round the property, welcomes visitors to "Gloucestershire's second most haunted house" (Berkeley Castle is the most haunted!). In 1970 an astonishing find was made in the attic - a portfolio of watercolours by George IV of plans for the restoration of Windsor Castle. Tel: 01666 502329.

BEVERSTON
MAP 1 REF C4

2 miles W of Tetbury on the A4135

The same Robert Stayner Holford who started the Westonbirt Arboretum built the model village of Beverston in conjunction with the architect Lewis Vulliamy. Their aim was to combine rural practicality with improved standards of accommodation, and the limestone terraces, cottages and model farms can clearly be seen from the main road. Holford lived at Westonbirt House, two miles to the south. Westonbirt Gardens, which run down to the Arboretum, are open to the public on special days each year under the National Gardens Scheme. Beverston's church contains a superb sculpture of the Resurrection dating from before the Norman Conquest. The village had an important castle, once occupied by Earl Godwin, father of King Harold. The Saxon earthworks are still visible.

HORTON
MAP 1 REF C4

3 miles N of Chipping Sodbury off the A46

On high ground northeast of the long, narrow village stands the National Trust's **Horton Court**, a part-Norman manor house rebuilt for William Knight, the man given the task of presenting Henry VIII's case to the Pope when the King was trying to divorce Catherine of Aragon. Among the many interesting features is a covered walkway, or ambulatory, which seems to have been modelled on a Roman cloister. The 12th century Great Hall survives from its earlier incarnation, and both the walkway and the hall can be visited. Next to the Court stands the little Church of St James, built between the 14th and 16th centuries and retaining many original features in spite of a Victorian makeover. It also holds memorials to the Paston family, lords of the manor in Jacobean times.

HAWKESBURY
MAP 1 REF C4

5 miles N of Chipping Sodbury off the A46

A village in two parts, one at the top, the other at the foot of the Cotswold Ridge. Dominating the lower part is the **Church of St Mary the Virgin**, built on

a grand scale in Norman and Gothic styles. A quaint notice near the Norman south doorway reads : "It is desired that all persons that come to this church would be careful to leave their dogs at home and that the women would not walk in with their pattens on". Pattens were wooden clogs with raised metal under-soles to keep the wearer's feet clear of mud. A pair of them hangs in the church, which contains several monuments to the Jenkins family, the earls of Liverpool. Their nearby home of **Hawkesbury Manor** was the setting of a tragic 17th century love story when a Protestant Jenkins girl fell in love with a Catholic Paston from Horton Court. The couple were forced to part, and as her lover rode away the lovelorn Miss Jenkins threw herself to her death from a top-floor window.

WICKWAR
MAP 1 REF C4

5 miles N of Chipping Sodbury on the B4060

A market town of some importance in days gone by, with its own mayor and corporation and two breweries. In the 1890s it became the first town in the west to install electric street lighting. The church, a Victorian restoration job apart from the 15th century tower, contains an interesting medieval sculpture of St John the Baptist. A round tower near the church marks a vertical shaft sunk in 1841 to ventilate the railway tunnel that runs below. Wickwar boasts a number of handsome Georgian buildings, notably the town hall with its distinctive bell tower and arches. To the east, across South Moon Ridings and up on to the ridge, stands the **Hawkesbury Monument**, designed by Vulliamy in Chinese style and erected in 1846 as a memorial to Lord Robert Somerset of Badminton, a general at the Battle of Waterloo. It has 145 steps, and the reward for climbing to the top is great views along the Cotswold escarpment and across the Severn to the Welsh mountains.

WOTTON-UNDER-EDGE

Jubilee Clock, Wotton

A hillside former wool town with a number of interesting buildings: Berkeley House with its stone Jacobean front; the terraced house that was the family home of Isaac Pitman and where he devised his renowned method of shorthand; the Perry and Dawes almshouses around a quadrangle with a small chapel; and Tolsey House, an early brick structure that was once a tollhouse for the market. The Church of St Mary (13th to 15th centuries) contains memorials to Lord Berkeley, who fought at Agincourt, and his wife Margaret. In a con-

verted fire station, the **Heritage Centre** incorporates a museum with an intriguing collection of artefacts from Wotton's crafts and industries.

The Coach House is the latest name of an attractive old high-street hostelry which was called The Goate in coaching days and more recently was The White Lion. The tenants are a delightfully friendly and positive couple Melanie and Andrew Goodwin, who have a cheery welcome for all who pass beyond the

The Coach House, 51 Long Street, Wotton-under-Edge, Gloucestershire GL12 7BX Tel: 01453 842054

redbrick frontage and into a lounge bar in Victorian style, with lots of bric-a-brac. In the 30-cover restaurant traditional English pub food is served, from snacks to a full à la carte, with coffee in between sessions. There were once three dozen pubs in Wotton, suggesting either an unusually sociable or an unusually thirsty local population. The Coach House has the oldest functioning cellar in town.

AROUND WOTTON-UNDER-EDGE

CHARFIELD MAP 1 REF C4
2 miles W of Wotton on the B4058

Starting life in the late 17th century as a pair of cottages, **The Pear Tree Inn** is delightfully traditional in style. Behind its smart white-painted facade the two cosy little bars are very much in the style of a village local, with exposed beams

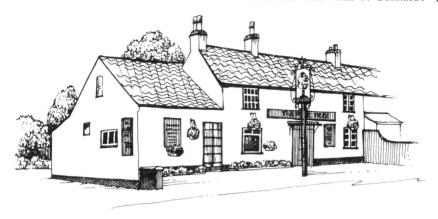

**The Pear Tree Inn, 6 Wotton Road, Charfield, Gloucestershire GL12 8TP
Tel: 01454 260663**

and a wealth of bric-a-brac; at the back is a quiet beer garden. Anne Marie and Les Marsh greet allcomers with a smile and cater for all appetites with a fine menu that is given even more variety by a daily specials board. Snacks come in the shape of baguettes, chip butties and jacket potatoes, while one of the most popular main dishes is Anne Marie's home-made Dicky Pearce pie - steak, mushrooms and Dicky Pearce real ale topped with puff pastry. Meals are served both sessions Tuesday to Sunday (extended Sunday lunch hours) and Monday lunchtime. A late-night curry supper is a special attraction on Fridays. Darts, crib and dominoes are popular pastimes at this cheerful little place, and the local theatre club holds regular meetings here.

TORTWORTH
MAP 1 REF C4

3 miles W of Wotton off the B4509

Overlooking the village green stands the Church of St Leonard, which contains some fine 15th century stained glass and a pair of canopied tombs of the Throckmorton family, former owners of the Tortworth Park estate. In a field over the church wall are several interesting trees, including an American hickory, a huge silver-leafed linden and two Locust trees. Nearby, and the most famous of all, is the famous **Tortworth Chestnut**, a massive Spanish chestnut which the diarist John Evelyn called "the great chestnut of King Stephen's time". Certainly it was well established by Stephen's time (1130s), and a fence was put up to protect it in 1800. At that time a brass plaque was put up with this inscription:

> *"May man still guard thy venerable form*
> *From the rude blasts and tempestuous storms.*
> *Still mayest thou flourish through succeeding time*
> *And last long last the wonder of the clime."*

And last it has; its lower branches have bent to the ground and rooted in the soil, giving the impression of a small copse rather than a single tree.

WORTLEY MAP 1 REF C4
On the southern edge of Wotton

Wortley boasts some impressive Roman remains. Parts of a mosaic floor of a Roman villa were unearthed by chance in 1981, and further excavation revealed a large bath house, a 3rd century paved courtyard and some massive stone drain-blocks.

ALDERLEY MAP 1 REF C4
1 mile S of Wotton on a minor road

An agreeable village with a castellated church and a handsome Elizabethan manor house that is now a school. At nearby **Alderley Grange**, birthplace of the famous judge Sir Matthew Hale, the gardens, occasionally open under the National Gardens Scheme, are noted for their old-fashioned roses, aromatic plants and herbs.

HILLESLEY MAP 1 REF C4
2 miles S of Wotton on minor roads

Ramblers on the nearby Cotswold Way Walk are among the varied clientele who regularly drop in at **The Fleece Inn** for a drink, a meal or a comfortable bed

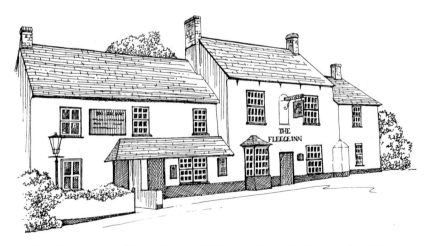

The Fleece Inn, Chapel Lane, Hillesley, Near Wotton-under-Edge,
Gloucestershire GL12 7RD Tel: 01453 843189

for the night. Clare Poole spent ten years at this delightful one-time coaching inn before taking over the reins in 1998, and her experience and expertise show in the excellent all-round attractions of the place. The bars have an invitingly old-fashioned look, with exposed beams and a wood-burning stove. Prints, photographs and plaques hang on the half-panelled walls, and in the public bar is a collection of American car number plates. Food is served daily, both lunchtime and evening, and runs from light snacks to speciality steaks and home-made fruit pie. Tables and chairs are set out in a large garden to the rear of the pub, and children have a safe area in which to play. A small patio area was added at the front in the summer of 1999. Inside activities include pool and quiz nights. For guests staying overnight there are three bedrooms - two doubles and a twin - which share a bathroom.

OZLEWORTH MAP 1 REF C4
2 miles E of Wotton on minor roads

A secluded hamlet with a very unusual circular churchyard, one of only two in England. The church itself has a rare feature in a six-sided Norman tower. Also at Ozleworth is the National Trust's **Newark Park**, built as a hunting lodge by the Poyntz family in Elizabethan times. James Wyatt later converted it into a castellated country house. Open by appointment only.

This is great walking country, and one of the finest walks takes in the **Midger Wood Nature Reserve** on its way up to **Nan Tow's Tump**, a huge round barrow whose tomb is said to contain the remains of Nan Tow, a local witch.

DURSLEY

A small town on the Cotswold Way that prospered as a cloth-making centre. It still has something of the feel of a 'working town', and one of the old mills still operates at Cam. One of the notable buildings is the 18th century Market Hall standing on 12 pillars at a busy town-centre junction. It has a bell turret on its roof and a statue of Queen Anne facing the fine parish church. The Priory is a large 16th century house built for a family of Flemish weavers who settled here and, it is said, taught the people of Dursley how to weave. William Shakespeare reputedly spent some time in Dursley in hiding after being spotted poaching. There is a reference to a bailiff from Dursley in *Henry IV*.

Cloth is still produced in the mill at Cam on the northern edge of Dursley, continuing a tradition started in the 16th century. Local legend is rich in stories about **Cam Long Down**, a small, isolated peak on the edge of Cam. One story concerns the Devil, who decided one day to cart away the Cotswolds and dam the Severn. On setting out with his first cartload he met a cobbler and asked him how far it was to the river. The cobbler showed him one of the shoes he was

taking home to mend and replied, "Do you see this sole? Well, I've worn it out walking from the Severn." This persuaded the Devil, who was obviously a lazy devil, to abandon his task; he tipped out his cartload, creating the unusual hill to be seen today. The hill is also one of several sites claimed for King Arthur's last battle.

AROUND DURSLEY

STINCHCOMBE MAP 1 REF C3
3 miles W of Dursley off the A4135

A picturesque village with several notable buildings, including 17th century **Melksham House**, seat of the Tyndale family for 300 years, and the 18th century **Piers Court**, home of the writer Evelyn Waugh. **Stancombe Park**, on the southern edge, is a handsome country house built in 1880 on the site of a Roman villa. The gardens are open occasionally under the National Gardens Scheme. The mosaic floor from the villa was recovered and moved to Gloucester Museum.

NORTH NIBLEY MAP 1 REF C4
2 miles SW of Dursley on the B4060

This village is the birthplace, around 1494, of William Tyndale, who was the first to translate and print the Old and New Testaments. He used the original Greek and Roman sources instead of the approved Latin, as a result of which he was accused of heresy and burnt at the stake at Vivolde near Brussels in 1536. 350 years later the imposing **Tyndale Monument**, paid for by public subscription, was erected on the ridge above the village to commemorate his life and work. Standing 111 feet high on the 700' escarpment, it offers amazing views and is itself one of the most prominent landmarks on the Cotswold Way. Tucked away near the village, **Hunts Court** is a mecca for serious gardeners, a two-acre maze of exciting rare shrubs, frothy borders and a marvellous collection of old roses. North Nibley is also the site of the last 'private' battle in England, which took place in 1471 between the rival barons William Lord Berkeley and Viscount de Lisle.

The Cartigny family - Jackie, Jacky and their four children - recently returned from a long spell in France to take over **The New Inn**. The ivy-clad pub enjoys the most peaceful setting deep in the countryside and attracts walkers and nature-lovers as well as a friendly local trade. Inside are two bars, one with a cabinet full of unopened beer bottles, many of them with obscure, long-forgotten names on their labels. The lounge bar opens on to the New Inn's crowning glory - a ½ acre country garden with lovely lawns and superb rose bushes. There's a terrace to the rear, and children have hours of fun on the swings, slides and climbing

**The New Inn, Waterley Bottom, North Nibley, Near Dursley,
Gloucestershire GL11 6EF Tel: 01453 543659**

frames in the play area. The locals have hours of fun with darts and dominoes in the drinkers' bar.

LOWER WICK Map 1 ref C4
4 miles SW of Dursley on minor roads

Set in open countryside in perfect peace and tranquillity, **Hogsdown Farm Caravan & Camping** provides an ideal base for discovering the beauty of the Cotswold Edge scenery. The M5 and A38 are within very easy reach, and the picturesque villages, the hills and vales and the River Severn are all waiting to be explored.

**Hogsdown Farm Caravan & Camping, Lower Wick, Near Dursley,
Gloucestershire Tel: 01453 810224**

Jenny Smith has built up the business over the past 25 years and now has 45 caravans to let, plus tents and facilities for campers. B&B is also available in three letting double/twin bedrooms. The level caravan site has toilets, showers, electric hook-up, a disposal point and a shop; there's a children's pony, and golf and fishing can be enjoyed nearby. Covered accommodation can be arranged for functions. Several pubs in the neighbourhood provide good food.

ULEY MAP 1 REF C3
3 miles E of Dursley on the B4066

Calm and quiet now, Uley was once a busy centre of commerce, mainly in the cloth-making industry. The most distinguished house in the area is **Owlpen Manor**, a handsome Tudor country house set in formal Queen Anne terraced yew gardens. Inside, contrasting with the ancient polished flagstones and the putty-coloured plaster, are fine pieces of William Morris-inspired Arts and Crafts furniture; there's also a rare beadwork collection and some unique 17th-century wall hangings. Tel: 01453 860261.

The village lies in the shadow of **Uley Bury**, a massive Iron Age hill fort which has thrown up evidence of habitation by a prosperous community of warrior farmers during the 1st century BC. Another prehistoric site, a mile along the ridge, is Uley Long Barrow, known locally as **Hetty Pegler's Tump**. This chambered long barrow, 180 feet in length, takes its name from Hester Pegler, who came from a family of local land-owners. Adventurous spirits can crawl into this Neolithic tomb on all fours, braving the dark and the dank smell to reach the burial chambers, where they will no longer be scared by the skeletons that terrified earlier visitors. The walls and ceilings of the chamber are made of huge stone slabs infilled with drystone material.

A little further north, at the popular picnic site of **Coaley Peak** with its adjoining National Trust nature reserve, is another spectacular chambered tomb, **Nympsfield Long Barrow**.

NAILSWORTH

This small residential and commercial town was once, like so many of its neighbours, a centre of the wool trade. Several of the old mills have been modernised, some playing new roles, others plying their original trades. **Ruskin Mill** is a thriving Arts & Crafts Centre (see below). **Stokescroft** is an unusual 17th century building on Cossack Square. During restoration work in 1972 scribblings found on an attic wall suggested that soldiers had been billeted there in 1812 and 1815. Perhaps this is why it is known locally as 'the Barracks'. It is thought to have housed Russian prisoners during the Crimean War, which accounts for the name of the square.

Ruskin Mill is a craft, education and community centre. The main site was built in the 1820s for the manufacture of woollen cloth and served as a home for other artisan industries before falling into disrepair. New life came in the 1960s, when it became both a family home and a conference centre dedicated to working within the insights of John Ruskin, William Morris and Rudolf Steiner. Independent craft workshops were developed in the 1980s, and at this time young people from a nearby special school were invited to help in restoration work. Their enthusiasm and interest sparked the beginning of the Ruskin Mill

Ruskin Mill, Old Bristol Road, Nailsworth, Gloucestershire GL6 0LA
Tel: 01453 837500 Fax: 01453 837512

Further Education Centre, and soon students from all over the country were being referred. Today, the opportunities for developing skills are enormous, from land projects (market garden, fish farm, charcoal production) to craft work-shops (stained glass, leatherwork, Iron Age forge, willow construction), car mechanics, photography and the performing arts. There is a coffee shop, a veg-etable shop selling organic produce (their own, of course!),and a gallery with exhibitions of painting, photography, sculpture and furniture; the students also stage regular drama events and produce a news magazine. Visitors can walk alongside the mill pond, through the flourishing market garden down to one of England's oldest fish farms, where trout have been reared for over 100 years.

AROUND NAILSWORTH

AVENING

Map 1 ref D4

2 miles SE of Nailsworth on the B4014

History aplenty in this ancient village. Each September it celebrates 'Pig Face Sunday', a festival harking back to the days when wild boar roamed the Cotswolds causing damage to crops, livestock and even human beings. One rogue animal caused such havoc that when it was caught it was hung from an oak tree before being roasted and eaten. The custom continues in a modified form to this day. In the village church is a memorial to a human rogue, the Honourable Henry Bridge, who in his youth carried out "deeds of lawlessness and robbery almost unsurpassed". In Hampton Fields to the northeast of the village is the extraordinary **Avening Long Stone**, standing eight feet high and pierced with holes. This prehistoric standing stone is said in local legend to move on Midsummer's Eve.

The Bell at Avening is a substantial old building occupying a corner site on the main street, with parking at the front and side. Melissa Bovey's practised eye saw the potential of the place, and a refurbishment programme has seen its revival as a really friendly, welcoming place to tarry awhile - or overnight. The three bedrooms, one with en suite facilities, are in a renovated granary at the back of the pub. Cotswold stone features in the two bars, where darkwood furnishings and upholstered bench seats, a log fire and lots of brass and copper ornaments paint a splendidly traditional picture. There's also a traditional look

The Bell at Avening, 29 High Street, Avening, Near Tetbury, Gloucestershire GL8 8NF Tel: 01453 836422

to much of the blackboard menu, whose dishes are all home-prepared from fresh ingredients. From the grill come steaks, gammon and lamb chops, while other choices might include ham (served hot or cold with a fried egg), breaded haddock, spaghetti bolognese and an excellent steak, kidney and ale pie. But the list also tempts with some less familiar dishes such as pan-fried sea bass or Thai-style cod fillet. Beyond the lounge is a natural sun trap in the shape of a secluded patio with tables and chairs.

STROUD

The capital of the Cotswold woollen industry, an ideal centre on the River Frome at a point where five valleys converge. The surrounding hill farms provided a constant supply of wool, and the Cotswold streams supplied the water-power. By the 1820s there were over 150 textile mills in the vicinity; six survive, one of them specialising in green baize for snooker tables. A stroll round the centre of town reveals some interesting buildings, notably the **Old Town Hall** dating from 1594 and the **Subscription Rooms** in neo-classical style. An easy walk from the centre is **Stratford Park**, a large park containing dozens of trees both ordinary and exotic. Lots of ducks on the pond.

The 18th century **Clothiers Arms**, which clings to a steep stretch of the A46 just beyond the bustle of the town centre, is one of the very best dual-purpose pubs in the area, thanks to the energy and commitment of owner Luciano

The Clothiers Arms, 1 Bath Road, Stroud, Gloucestershire GL5 3JJ
Tel: 01453 763801 Fax: 01453 757161 net:www.clothiersarms.co.uk
e-mail: luciano@clothiersarms.demon.co.uk

Magalotti. Taking over what was "just a pub" in the early 1980s, he has never stopped making improvements, the most notable being the addition of five superb en suite bedrooms with handsome polished pine furniture. The main bar is a particularly popular place at weekends, and its decor includes the work of local artists, a scene of Luciano's home town of Rimini, a penny-farthing bicycle hanging from a wall, and a rare Stroud Beer Company logo in glass and crushed glass, mounted in a canopy over the bar counter. Outside are a beer garden, children's play area and large car park. The food here is top-class, and the menu in the leafy restaurant is full of tempting things, from seafood pancakes and chicken liver paté to walnut-stuffed breast of chicken, grilled Brixham plaice, West Country gammon and pasta with a choice of sauces - napolitano, bolognese, carbonara or seafood.

AROUND STROUD

SELSLEY MAP 1 REF C3
2 miles S of Stroud off the A46

All Saints Church was built in the 1860s by Sir Samuel Marling, one of a family of wealthy Stroud mill-owners. A distinctive landmark with its saddleback tower, it is modelled on a church seen by Sir Samuel on his travels around Europe and is notable for its exceptional stained glass. The glass was commissioned from William Morris and Company and the designers included Morris himself, Dante Gabriel Rossetti, Ford Madox Brown and Edward Burne-Jones.

Selsley Herb Farm is a small nursery specialising in herbs and selected garden plants, with a barn shop and plant sales area. Open Tuesday-Sunday in summer.

WOODCHESTER MAP 1 REF C3
2 miles S of Stroud off the A46

The mysteriously unfinished **Woodchester Mansion** is one of Britain's most intriguing Victorian country houses. It's like a Victorian building site caught in a time warp, having been started in 1854 and suddenly abandoned in 1868, three-quarters finished and with the scaffolding in place and the workmen's tools left behind. What stands now, as in 1868, is a vast shell with gargoyles and flying buttresses on the Gothic facade, and all the props and stays and tools exposed inside. This incomplete masterpiece is now used as a training ground for stonemasons. Tel: 01453 860661/750455.

AMBERLEY MAP 1 REF C3
3 miles S of Stroud off the A46

Sights to see here include a church built in the year Victoria came to the throne and dsecribed by a former Bishop of Gloucester as "the ugliest in Gloucester-

shire". In the churchyard is the grave of PC Wren, author of *Beau Geste*. At Rose Cottage Mrs Craik wrote her Cotswold novel *John Halifax, Gentleman*.

KING'S STANLEY MAP 1 REF C3
2 miles W of Stroud on the A419

The parish church is Norman in origin but was remodelled in 1876. The Baptist church dates back to 1640, making it one of the earliest non-conformist churches in the country. On the outskirts stands Stanley Mill, built as Britain's first fire-proof industrial building and still in use for the manufacture of cloth.

LEONARD STANLEY MAP 1 REF C3
3 miles W of Stroud off the A419

Henry Vlll and Anne Boleyn reputedly visited Leonard Stanley in 1535, when it was a flourishing wool-trading village. They may well have visited the Saxon chapel and the 12th century priory. The former, used as a barn for generations, contains an early clock and some fine medieval carvings.

FROCESTER MAP 1 REF C3
4 miles W of Stroud off the A419

The chapel in the centre of the village was built in 1680 using materials from nearby Frocester Court. In the grounds are a superb timber-framed gatehouse and the wonderful **Frocester Tithe Barn**, a massive 186 feet in length and sub-stantially as it was when built on the instructions of Abbot John de Gamages between 1284 and 1306.

EASTINGTON MAP 1 REF C3
6 miles W of Stroud on the A419

Two gems here. One is an extraordinary early Georgian garden house with an ornate stone-dressed brick facade; the other a very handsome and elaborate finger-post road sign on a tall stone base. The arms indicating the directions (but not the mileage) are set high up, presumably for easy reading by a stage-coach driver.

MINCHINHAMPTON MAP 1 REF D3
4 miles SE of Stroud off the A419

A scattered community on the ridge between Golden Valley and Nailsworth Valley, Minchinhampton acquired its market charter as far back as 1213. Fol-lowing the Dissolution of the Monasteries, Henry Vlll presented Minchinhampton Manor to the 1st Baron Windsor in return for the baron's family estate near Windsor. The estate was later acquired by Samuel Sheppard, whose family was responsible for the building of Gatcombe Park and of

Minchinhampton's **Market House**. There's good walking and good exploring hereabouts, with the old stone quarries at Ball's Green, the National Trust woodland and grassland at Minchinhampton and Rodborough Commons, the Iron Age defences of Minchinhampton Bulwarks and the Neolithic long barrow known as **Whitfield's Tump**, from whose summit the Methodist preacher George Whitfield gave a famous public address in 1743.

On the attractive main street of Minchinhampton stands **The Crown Inn**, base for many community activities and a favourite meeting place for a pleasant drink and a chat, or a quiet game of darts or bar billiards. Beyond the splendid 17th century frontage, the lounge and bar have the look of a family home, with lots of prints and photographs, plates and ornaments. Rosemary and Richard extend a warm and friendly welcome both to their regulars and to the many visitors who pause in their part of the world. Rosemary runs the food side of the

**The Crown Inn, High Street, Minchinhampton, Near Stroud,
Gloucestershire GL6 9BN Tel: 01453 882357**

business, offering both bar snacks and a more extensive menu that runs from garlic mushrooms and hot smoked mackerel to grilled plaice, scampi, roast chicken, steaks and home-made steak & kidney pie. Senior citizens enjoy a special deal on weekday lunchtimes. Behind the inn are a beer garden and car park. The Crown provides comfortable overnight accommodation in four en suite bedrooms.

CHALFORD
MAP 1 REF D3

3 miles SE of Stroud on the A419

Steep wooded hillsides protect this marvellous village, for long a hideaway for artists and craftsmen. Its tight little streets are filled with interesting shops, and the parish church contains furniture made by Norman Jewson and Peter van der Waals. Below the church is a section of the old Thames and Severn Canal, last used in 1933, and one of the distinctive round tower houses the company built for its workers.

FRANCE LYNCH
MAP 1 REF D3

Northern outskirts of Chalford

A short walk north of Chalford lies the little village of France Lynch. In this picturesque and peaceful hamlet in the Golden Valley, **The Kings Head** enjoys a superb setting among high-banked fields and mature English oaks. The beer garden is the perfect place for enjoying the views, with a real feeling of being in

**The Kings Head, France Lynch, Near Stroud, Gloucestershire GL6 8LT
Tel: 01453 882225**

the midst of nature, but when the wind blows and the rain falls the bars, with their exposed ceiling beams and open fires, provide a snug and cosy alternative. The building dates from 1744 and saw long service as a pub before a period of closure. The current tenants, Pat and Mike Duff, have revived its appeal over the past few years, restoring a centre of community life to the local residents and attracting visitors from further afield - it is on the Huguenot Trail and brings

many visitors from France. The annual music and dance festival is very popular. Appetites are taken care of by a lunchtime menu that includes filled baguettes, jacket potatoes, dishes with chips and pot meals, with a roast on Sunday. In the evening, Monday to Saturday, ribeye and sirloin steaks are a popular choice, along with moules marinière, salmon steak with herb butter and pasta main courses. Children have their own menu.

OAKRIDGE LYNCH MAP 1 REF D3
6 miles E of Stroud off the A419

The **Oakridge Village Museum** has a small collection of items of local interest.

 Overlooking the Golden Valley in the very heart of the Gloucestershire countryside, the **Butchers Arms** is a gem of a village pub that's packed with genuine old-fashioned charm. This lively 18th century Cotswold-stone inn, owned and run by Brian and Peter Coupe, has fully earned its reputation for fine food, with regulars coming from many miles around to enjoy a snack or lunch in the bar, or a full-scale evening meal or Sunday lunch in the Stable Room, where the tables are set in individual 'stalls' and the odd bridle hangs on the wall. The area

Butchers Arms, Oakridge Lynch, Near Stroud, Gloucestershire GL6 7NZ
Tel: 01285 760371

is a walker's paradise, so visitors usually bring good appetites, and the menus offer an amazing number of options for satisfying them. In the bars at lunchtime hot baguettes, burgers, omelettes and cauliflower cheese share the menu with a range of internationally-inspired dishes accompanied by chunky deep-fried potato wedges, while Sunday lunch in the restaurant always includes brunch

and a roast. In the evening the choice is even wider, and fixtures such as chicken liver paté, tiger prawn cocktail and beef & stout pie are joined by exciting specials like Turkish lamb or roast cod with spinach and a garlic buttterbean broth. A fine selection of real ales is kept in tip-top condition. Open fires keep things snug in colder weather, but when the sun shines the scene shifts to the beer garden. Skittles and darts are the favourite pub games, and the bars - all beams and exposed stone - are the setting for many local activities. The location is another major asset of this truly outstanding place: it's a real 'Hidden Place', totally unspoilt, and surrounded by quite superb natural beauty.

BISLEY
MAP 1 REF D3
4 miles E of Stroud on minor roads

Country roads lead across from Stroud or up from Oakridge Lynch to the delightful village of Bisley, which stands 780 feet above sea level and is known as 'Bisley-God-Help-Us' because of the winter winds which sweep across the hillside. Bisley's impressive All Saints Church dates from the 13th century and was restored in the early 19th by Thomas Keble, after whose poet and theologian brother John Keble College, Oxford was named. The font has two carved fish inside the bowl and a shepherd and sheep on the base. In the churchyard is the Poor Souls' Light, a stone wellhead beneath a spire dating from the 13th century. It was used to hold candles lit for souls in purgatory. Below the church are the **seven wells of Bisley** (also restored by Thomas Keble), which are blessed and decorated with flowers each year on Ascension Day. At the top of the village is a double lock-up built in 1824, with two cells beneath an ogee gable.

The village's main claim to fame is the story of the Bisley Boy. When Bisley was a rich wool town it had a royal manor, Over Court, where the young Princess Elizabeth (later Queen Elizabeth l) often stayed. The story goes that during one of those visits the princess, then aged 10, caught a fever and died. Fearing the wrath of her father Henry Vlll, her hosts looked for a substitute and found a local child with red hair and remarkably similar physical characteristics except for the rather important fact that the child was a boy called John Neville. Could this explain the Virgin Queen's reluctance to marry, her problem with hair loss and her "heart that beats like a man's", or was the story made up to fit those facts? Alas, we will never know.

3 Vale of Gloucester and the Central Cotswolds

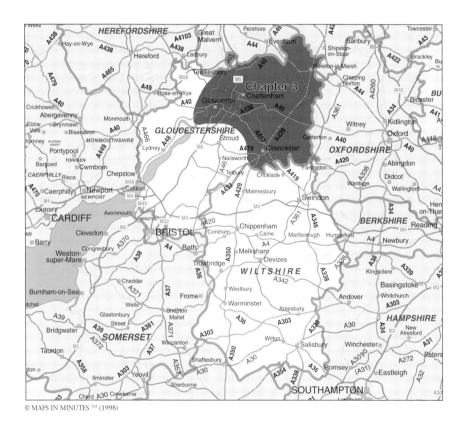

© MAPS IN MINUTES ™ (1998)

Laurie Lee's Slad Valley is just one of the many scenic delights of the Cotswolds, the limestone hills that sweep across the county from Wotton-under-Edge to Chipping Campden. In this chapter the major centres of Gloucester, Cheltenham and Cirencester reveal their historic and cultural attractions on a tour that also includes some of the most glorious scenery and the prettiest villages in the whole of Britain.

STROUD TO GLOUCESTER

SLAD MAP 2 REF D3
2 miles N of Stroud on the B4070

Immortalised by Laurie Lee in his autobiographical *Cider With Rosie*, the sprawl-
ing village of Slad in the valley of the same name was for centuries a centre for
milling and the production of fruit. A Roman villa was found in the Valley, and
the votive tablets found there - one was dedicated to Romulus in his guise of
fertility god and protector of crops - are now in Gloucester Museum.

MISERDEN MAP 2 REF D3
5 miles NE of Stroud off the B4070 or A417

Miserden Park Gardens, created as a very formal garden in the 17th century, are
known for their spectacular spring bulbs, perennial borders, roses, topiary and
an avenue of Turkish hazels. Open Tuesday to Thursday in summer. In the cen-
tre of the village stands a large sycamore tree next to a 17th century barn with a
working forge.

PAINSWICK MAP 2 REF D3
4 miles N of Stroud on the A46

This beautiful little town, known as the 'Queen of the Cotswolds', prospered
with the wool trade, which had its peak in the second half of the 18th century.
At that time 30 mills provided power within the parish, and the number of fine
houses and farms in and around the town are witness to those days. Many of
them are built of the pale grey limestone that was quarried at Painswick Hill.

St Mary's Church, which dates from around 1380, contains some rare cor-
bels thought to represent Richard ll and his queen. The church tower rises to
172 feet and can be seen for miles around. The church was the site of one of
many local skirmishes in the Civil War when a party of Parliamentary soldiers
came under cannon fire, which did considerable damage to the building. In
1643 King Charles l spent the night at Court House before the siege of Glouces-
ter. In the grounds of **Painswick House,** on the B4073 at the northern edge of
town, **Painswick Rococo Garden,** hidden away in magnificent Cotswold coun-
tryside, is a unique 18th century garden with plants from around the world and
a maze planted in 1999 with a path structure in the shape of '250' to com-
memorate the garden's 250th anniversary. Other attractions are a specialist
nursery, a children's nature trail, a gift shop and a restaurant. Call 01452 813204
for opening times.

A little further north, at Cranham, **Prinknash Abbey Park** (call it Prinnage)
comprises an active monastery, chapel, working pottery, gift shop and tearoom.
The Benedictine monks of Caldey Island moved here in 1928 when the old

house was made over to them by the 20th Earl of Rothes in accordance with the wishes of his grandfather. They no longer occupy the old house, having moved into the impressive new monastery in 1972. The abbey chapel is open daily for solitude and contemplation. Visitors can have a guided tour round the pottery and buy a hand-made Prinknash pot. Part of the abbey gardens are given over to the **Prinknash Bird & Deer Park**, where visitors can feed and stroke the fallow deer and see the waterfowl, the peacocks and the African pygmy goats. By the lake is a charming two-storey Wendy House.

EDGE MAP 2 REF C3
4 miles N of Stroud on the A473

Straddling a hilltop across the Spoonbed Valley, Edge has two delightful village greens and the mid 19th century Church of St John the Baptist with an ornate spire. To the west of the village lies **Scottsquarr Common**, an area of Special Scientific Interest with an abundance of wild flowers and butterflies and spectacular views.

 In the village of Edge - aptly named as it is lies on the fall of the Cotswold escarpment - **The Edgemoor Inn** is a fine old pub built of mellow Cotswold stone. Much extended down the 250 years of its existence, the inn caters for both local trade and visitors from outside the area, thus keeping alive the old-established tradition of hospitality that Edge boasts. Hands-on owners Chris and Jill Bayes run one of the very best dining pubs in the region, with impressively high standards in terms of both the catering itself - Jill's province - and the quality of the decor and furnishings. There are some 50 covers in the dining

**The Edgemoor Inn, Edge, Near Stroud, Gloucestershire GL6 6ND
Tel: 01452 813576**

rooms (no smoking), where the menu caters admirably for appetites both large and small. Smoked salmon paté, devilled whitebait and jalapeno peppers filled with cream cheese make excellent starters or light meals, while main courses could include anything from fried plaice to liver and bacon, Chinese-style pork steak and grilled sirloin or fillet steak. Sandwiches and ploughman's platters provide other options, and there are always plenty of blackboard specials, including vegetarian dishes, to boost the choice even further. Another big plus here is the setting, and the view looking down the valley to Painswick from the picture window or the terraced patio is something to behold. Children are welcome at this busy, friendly place, and there are facilities for disabled visitors.

SHEEPSCOMBE Map 2 ref D3
5 miles NE of Stroud on the A46

A most delightful, peaceful community of gabled Cotswold-stone cottages and farmhouses surrounded by beech woods and set on both sides of a beautiful valley twisting away to the east of Painswick. One of the first Sunday schools was established here in 1780 by a local weaver, an event which probably led Robert Raikes of Gloucester to found the **National Sunday School Movement** soon afterwards. The house called Steepways, previously Mount Pleasant, was where Uncle Charlie from *Cider With Rosie* lived.

Anne and Roy Hawkins welcome guests to **Sen Sook** to enjoy the peace and solitude of the quiet valley in which it stands. Sen Sook (it means 'The House of a Thousand Smiles') is a very attractive modern bungalow set in a tiny hamlet that is far removed from the urban bustle. The village, with its surrounding National Trust woodland, is in an Area of Outstanding Natural Beauty, ideal

Sen Sook, Far End Lane, Sheepscombe, Gloucestershire GL6 7RL
Tel: 01452 812047

walking country that will be familiar to readers of Laurie Lee's *Cider With Rosie*. The accommodation comprises two light and airy double bedrooms, one with en suite facilities and one with an adjoining private bathroom. Both afford superb views. A very substantial breakfast of home-made or locally-produced fare is served in the large dining room/lounge. On warm, sunny days breakfast can be served on the large verandah, where guests can enjoy the beautiful view while eating. Packed lunches are available on request, and good food is served in the village pub, a short walk away along a quiet country lane. No smoking in the bedrooms.

BROOKTHORPE
MAP 2 REF C3

6 miles N of Stroud on the A4173

A pleasant village whose 13th century Church of St Swithin has an unusual saddleback tower. On a cornice in the porch is a roughly carved chronogram which hides the Roman numerals for 1648, the year Charles l was executed.

UPTON ST LEONARDS
MAP 2 REF D2

8 miles N of Stroud off the B4073

A curiosity in the churchyard is a sundial with an iron pyramid on top and three faces to catch the sun from almost any direction.

GLOUCESTER

The capital city of Gloucestershire first gained prominence under the Romans, who in the 1st century AD established a fort to guard what was then the lowest crossing point on the Severn. A much larger fortress soon followed, and the settlement of Glevum became one of the most important military bases, crucial in confining the rowdy Celts to Wales. William the Conqueror held a Christmas parliament and commissioned the Domesday Book in Gloucester, and also ordered the rebuilding of the abbey, an undertaking which included the building of a magnificent church that was the forerunner of the superb Norman Cathedral. The elaborate carved tomb of Edward ll, murdered at Berkeley Castle, is just one of many historic monuments in **Gloucester Cathedral**; another, the work of the Wedgwood designer John Flaxman, remembers one Sarah Morley, who died at sea in 1784, and is shown being delivered from the waves by angels. The exquisite fan tracery in the cloisters is the earliest and among the finest in existence, and the great east window, at 72 feet by 38 feet, is the largest surviving stained-glass window in the country. It was built to celebrate the English victory at the Battle of Crécy in 1346 and depicts the coronation of the Virgin surrounded by assorted kings, popes and saints. The young King Henry lll was crowned here, with a bracelet on his little head rather than a crown.

The old area of the city around Gloucester Cross boasts some very fine early buildings, including St John's Church and the Church of St Mary de Crypt. Just behind the latter, near the house where Robert Raikes of Sunday School fame lived, stands an odd-looking tower built in the 1860s to honour Hannah, the wife of Thomas Fenn Addison, a successful solicitor. The tower was also a memorial to Raikes.

Three great inns were built in the 14th and 15th centuries to accommodate the scores of pilgrims who came to visit Edward II's tomb, and two of them survive. The galleried New Inn, founded by a monk around 1450, doubled as a theatre and still retains the cobbled courtyard. It was from this inn that Lady Jane Grey was proclaimed Queen.

Gloucester Cathedral

Equally old is The Fleece Hotel in Westgate Street, which has a 12th century stone-vaulted undercroft. In the same street is **Maverdine House**, a four-storey mansion reached by a very narrow passage. This was the residence and headquarters of Colonel Massey, Cromwell's commander, during the Civil War siege of 1643. Most of the region was in Royalist hands, but Massey survived a month-long assault by a force led by the King himself and thus turned the tide of war.

Gloucester Docks were once the gateway for waterborne traffic heading into the Midlands, and the handsome Victorian warehouses are always in demand as location sites for period films. The docks are now home to several award-winning museums. The **National Waterways**

Gloucester Docks

Museum, on three floors of a beautiful warehouse, is entered by a lock chamber with running water and tells the fascinating story of Britain's canals with films, displays and historic boats.

The **Robert Opie Collection** at the **Museum of Advertising and Packaging** takes a nostalgic look at the 40s, 50s, 60s and 70s with the aid of toys and food, fashions, packaging and a continuous screening of vintage TV commercials. **Soldiers of Gloucestershire** uses archive film, photographs and life-size reconstructions to tell the history of the county's regiments.

Elsewhere in the city **Gloucester City Museum and Art Gallery** houses treasures from all over the county to reveal its history, from dinosaur bones and Roman remains to antique furniture and the decorative arts. Among the highlights are the amazing **Birdlip Mirror**, made in bronze for a Celtic chief just before the Roman conquest, two Roman tombstones and a section of the Roman city wall revealed under the cut-away gallery floor. English landscape painting is represented by Turner, Gainsborough and Richard Wilson. Timber-framed Tudor buildings house **Gloucester Folk Museum**, where the exhibits include farming, fishing on the Severn, the port of Gloucester, the Civil War, a Victorian schoolroom, a dairy, an ironmongery and a wheelwright's workshop. **Gloucester Transport Museum** has a small collection of well-preserved vehicles and baby carriages housed in a 1913 former fire station. The **House of the Tailor of Gloucester**, in College Court, is the house sketched by Beatrix Potter in 1897 and used in her tale *The Tailor of Gloucester*. It now brings that story to life, complete with Simpkin the Cat and an army of helpful mice.

In the southwestern suburbs of Gloucester are the ruins of **Llanthony Abbey**. The explanation of its Welsh name is an interesting one. The priory of Llanthony was originally founded in the Black Mountains of Wales at the beginning of the 12th century, but the inmates were so frightened of the local Welsh that they begged the Bishop of Hereford to find them a safer place. The Bishop passed their plea to Milo, Earl of Hereford, who granted this plot of land for a second priory bearing the same name as the first. Llanthony Secunda was consecrated in 1136. On a nearby hill the monks built St Ann's Well, whose water was - is - believed to cure eye problems.

AROUND GLOUCESTER

In Hangar 7 Meteor Business Park at Gloucestershire Airport (entrance opposite Down Hatherley Road on the B4063 north of Gloucester) is the **Jet Age Museum**, whose exhibits include a Meteor and a Javelin. Visitors can sit in a Vulcan, Canberra, Buccaneer and Harrier cockpit. Two miles south of the city, off the A4173, is **Robinswood Hill Country Park**, 250 acres of pleasant walks, views and trails with a Rare Breeds farm.

TWIGWORTH
MAP 2 REF C2
2 miles N of Gloucester off the A38

Twigworth is the home of **Nature in Art**, a renowned museum of wildlife art housed in 18th century Wallsworth Hall. The collection depicts many aspects of nature in a variety of media, from life-size sculptures to Picasso, David Shepherd to ethnic art, tapestries to ceramics. Artists in residence. Changing temporary exhibitions. Art courses. Evening events.

HARTPURY
MAP 2 REF C2
5 miles NW of Gloucester on the A417

Two very unusual Grade ll listed buildings here: a rare medieval set of bee hives in an outbuilding known as a bee bole, and, in the churchyard, a Soper stone tomb with a shroud-wrapped body on the top. At nearby **Ashleworth** is a magnificent 14th century tithe barn with a stone-tiled roof, projecting porches and elaborate interlocking roof timbers.

PAUNTLEY
MAP 2 REF C2
8 miles N of Gloucester on the A417

The penniless orphan boy who in the pantomime fable was attracted by the gold-paved streets of London and who became its Lord Mayor was born at **Pauntley Court**. Richard Whittington, neither penniless nor an orphan, was born here about 1350, one of three sons of landowner Sir William de Whittington and Dame Joan. He became a mercer in London, then an important financier and was three times Mayor (not Lord Mayor - that title had not been invented). He married Alice Fitzwarren, the daughter of a wealthy landowner from Dorset. The origin of the cat connection is unclear, but an event which could have contributed to the myth was the discovery in 1862 of the carved figure of a boy holding a cat in the foundations of a house in Gloucester. The carving can be seen in Gloucester Museum.

REDMARLEY D'ABITOT
MAP 2 REF C1
9 miles NW of Gloucester on the A417

This hilltop village, built on red marle (clay) and once the property of the French d'Abitot family, was the home for a short time of the actress Lilly Langtry, mistress of the Prince of Wales, later King Edward Vll. The link with the actress is remembered in two streets in the village - Drury Lane and Hyde Park Corner.

TEWKESBURY

A town of historic and strategic importance at the confluence of the Severn and Avon rivers. Those rivers also served to restrict the lateral expansion of the

town, which accounts for the unusual number of tall buildings. Its early prosperity was based on the wool and mustard trades, and the movement of corn by river also contributed to its wealth. Tewkesbury's main thoroughfares, High Street, Church Street and Barton Street, form a Y shape, and the area between is a marvellous maze of narrow alleyways and small courtyards hiding many grand old pubs and medieval cottages. At the centre of it all is **Tewkesbury Abbey**, the cathedral-sized parish church of St Mary. One of the largest parish churches in the country, it was founded in the 8th century and completely rebuilt in the 11th. It was once the church of the Benedictine Abbey and was among the last to be dissolved by Henry VIII. In 1540, it was saved from destruction by the townspeople, who raised £453 to buy it from the Crown. Many of its features are on a grand scale - the colossal double row of Norman pillars; the six-fold arch in the west front; and the vast main tower, 132 feet in height and 46' square, the tallest surviving Norman main tower in the world. The choir windows have stained glass dating from the 14th century, and the abbey has more medieval monuments than any besides Westminster.

Among the most interesting memorials is a tomb which might be that of John Wakeman, the last abbot, who became the first Bishop of Gloucester in 1541. His tomb depicts the decaying corpse of a monk being nibbled at by vermin. A less dramatic monument by the south transept remembers Dinah Maria Mulcock, who, as Mrs Craick, wrote *John Halifax, Gentleman*, which features Tewkesbury under the name of Nortonbury. (This famous Victorian novelist visited the town in 1825 and took lunch at The Bell, as did her creation John Halifax. When Charles Dickens' Mr Pickwick came, he stayed at the Hop Pole Hotel, an occasion celebrated by a plaque outside the inn.)

Two other outstanding features in the Abbey are the high altar, a massive slab of Purbeck marble over 13 feet in length, and the renowned **Milton Organ**, built for Magdalen College, Oxford. Cromwell had it moved into the chapel of his Hampton Court residence, where the young John Milton, his Latin secretary at the time and later to become a great poet, played it to entertain the boss. It later returned to Magdalen, from where it was brought to Tewkesbury in 1737. Its 17th century pipes are thought to be among the oldest still in use. The half-timbered town is full of old and interesting buildings, among them the House of Nodding Gables on the High Street and Mythe Bridge, designed by Thomas Telford and built in a single cast-iron span in the 1820s, with a charming little tollhouse at each end.

Three museums tell the story of the town and its environs: the Little Museum, laid out like a typical old merchant's house; Tewkesbury Museum, with displays on the social history and archaeology of the area; and the **John Moore Countryside Museum**, a natural history collection displayed in a 15th century timber-framed house. The museum commemorates the work of John Moore, a well-known writer, broadcaster and naturalist, who was born in Tewkesbury in 1907.

The **Battle of Tewkesbury** was one of the fiercest in the Wars of the Roses. It took place in 1471 in a field south of the town which has ever since been known as Bloody Meadow. Following the Lancastrian defeat, those who had not been slaughtered in the battle fled to the Abbey, where the killing began again. Abbot Strensham intervened to stop the massacre, but the survivors, who included the Duke of Somerset, were handed over to the King and executed at Market Cross. The 17-year-old son of Henry VI, Edward Prince of Wales, was killed in the conflict and a plaque marking his final resting place can be seen in the Abbey. Tewkesbury was again the scene of military action almost two centuries later during the Civil War. The town changed hands several times during this period and on one occasion Charles l began his siege of Gloucester by requisitioning every pick, mattock, spade and shovel in Tewkesbury.

Lorraine Bishop and her grown-up family create a very warm and friendly ambience at **Carrant Brook**, a delightful redbrick house put up by a local builder about 100 years ago as one of ten show homes. It stands in Rope Walk, a cul-de-sac that is very peaceful and quiet yet only a few minutes' walk from the many attractions of the town. The three guest rooms all have en suite bathrooms, central heating, TVs, radio-alarms, hairdryers and tea/coffee-making facilities. One room boasts a very splendid original cast-iron and brass bed. In the cosy little dining room, where a coal fire blazes in winter, a very generous breakfast is served. Evening meals, babysitting and light laundry can be arranged with prior notice. There is also off-road parking, and a neat little garden with tables and chairs for taking the sun.

Carrant Brook, 3 Rope Walk, Tewkesbury, Gloucestershire GL20 5DS Tel: 01684 290355

AROUND TEWKESBURY

FORTHAMPTON MAP 2 REF C1

3 miles W of Tewkesbury off the A438

An unspoilt Severn Vale village dominated by the ancient Church of St Mary with a rare original stone altar, and **Forthampton Court**, sometime home to the abbots of Tewkesbury and still retaining its fine 14th century banqueting hall, the chapel and a medieval wood-based picture of Edward the Confessor. Near the churchyard can be seen a couple of relics of harsher times - a set of stocks and a whipping post complete with manacles.

TIRLEY MAP 2 REF C2

4 miles SW of Tewkesbury on the B4213

A curiosity here is the clock of St Michael's Church, made entirely of scrap agricultural implements.

Malcolm (Ossie) and Sandie Hall create an informal, relaxed and friendly ambience at **Haw Bridge Inn**. Both have their roots in Gloucestershire and plenty of experience in the licensed trade. Built on the banks of the Severn in

**Haw Bridge Inn, Town Street, Tirley, Near Tewkesbury,
Gloucestershire GL19 4HJ Tel: 01452 780316**

1630, the inn served as a stopping-over place for river traffic at a point where there was a tollbridge over the river. It has a very traditional look both outside and in the bars, where the floors are flagstoned, the walls oak-panelled and the ceiling beamed. Open fires, horse brasses, sporting prints and a collection of jugs complete the picture. Classic pub dishes are cooked by Sandie, whose menu also includes children's meals and vegetarian main courses. Special baps such as steak & onion are proving real winners. Tables and chairs are set out at the front of the inn, and at the back the beer garden leads to a site licensed for five caravans. The favourite games are pool and skittles, and it's a popular venue for functions, with a private room that can accommodate 80.

DEERHURST Map 2 ref D1
3 miles S of Tewkesbury off the A38

On the eastern bank of the Severn, a village whose current size and status belies a distinguished past. The church, with a distinct Celtic feel, is one of the oldest in England, with parts dating back to the 7th century, and its treasures include a unique double east window, a 9th century carved font, a Saxon carving of the Virgin and Child and some fine brasses dating from the 14th and 15th centuries. One depicts St Anne teaching the Virgin to read, another the Cassey family, local landowners, and their dog.

Another Saxon treasure, 200 yards from the church, is **Odda's Chapel**, dedicated in 1056 and lost for many centuries before being gradually rediscovered after 1885 under an unsuspecting half-timbered house. The connection was then made with a stone inscribed with the date of consecration discovered in 1675 and now on view in the Ashmolean in Oxford.

TEDDINGTON Map 2 ref D1
5 miles E of Tewkesbury off the B4077/A43

Bangrove Farm is a working farm situated at the end of a lane just off the A435, between the villages of Teddington and Alstone on the Gloucestershire-Worcestershire border. The farmhouse, built in the 17th century, is a building of considerable historical interest, and half of it is given over to first-class self-catering guest accommodation. Completely self-contained, it consists downstairs of a large lounge with TV and a wood-burning stove; fully equipped kitchen-dining room with gas cooker, microwave and fridge-freezer, and a cloakroom with lavatory and washbasin. Upstairs there is one family room with a double and single bed and one three-bedded room with a washbasin. A third room with twin beds is available if required. The spacious bathroom incorporates bath, shower, washbasin and lavatory.

All rooms except the kitchen are fully carpeted, the house is very comfortably furnished, all linen and towels are provided and there is a washing machine with tumble drier. Owner Pat Hitchman is pleased for guests to use the garden, barbecue and hard tennis court and welcomes children - a cot and high chair

**Bangrove Farm, Teddington, Near Tewkesbury,
Gloucestershire GL20 8JB Tel: 01242 620223**

can be provided for the very young - but not dogs. Golf and horse-riding can be
arranged locally.

KEMERTON MAP 2 REF D1
3 miles NE of Tewkesbury off the B4079

The Crown at Kemerton is an inn of distinction with a history going back to
the 16th century. It's a lively place with bags of atmosphere and a wealth of
character provided by old flagstones, stripped oak and a Cotswold stone fire-

**The Crown at Kemerton, Main Street, Kemerton,
Gloucestershire GL20 7HP Tel: 01386 725293**

place. The south-facing walled garden is a delightful sun trap. The pub is run by Tim Barber and Marion New, both very experienced in the catering trade and very much driven by the needs of their customers. In the 30-cover restaurant a daily-changing menu tempts with superb dishes such as avocado with hot melted Stilton, breast of goose in gooseberry and cider sauce and oven-baked trout with lemon and almonds. There are theme nights with special menus - seafood; salmon and asparagus; Beaujolais Nouveau - and to accompany the excellent food is a wide selection of wines. Darts and cribbage are the favourite pub games, and there are regular quiz nights. The village of Kemerton, below Bredon Hill and only a mile from the Vale of Evesham, is the scene of an annual tug of war between teams from local villages.

CHELTENHAM

Smart, fashionable Cheltenham: a small, insignificant village until a mineral spring was accidentally discovered in 1715 by a local man, William Mason, who built a pump room and began Cheltenham's transformation into one of Europe's leading Regency spa towns. Mason's son-in-law was the astute Captain Henry Skillicorne, who added a meeting room, a ballroom and a network of walks and carriageways, and called it a spa. A number of other springs were soon discovered, including one in the High Street around which the first Assembly Rooms were built. In 1788 the Royal seal of approval came in the shape of King George lll, who spent five weeks taking the waters with his family and made Cheltenham a highly fashionable resort. An entirely new town was planned based on the best features of neoclassical Regency architecture, and as a result very few buildings of any antiquity still stand. One of these is the Church of St Mary, with parts going back to the 12th century and some very fine stained glass.

Skillicorne's walks and rides are now the tree-lined Promenade, one of the most beautiful boulevards in the country, its crowning glory the wonderful Neptune's Fountain, modelled on the Fontana di Trevi in Rome and erected in 1893. Housed in Pittville Park in the magnificent Pump Room overlooking gardens and lakes north of the town centre is the **Pittville Pump Room Museum**, which uses original period costumes to bring alive the story of Cheltenham from its Regency heyday to the 1960s. Special exhibitions are held throughout the year. **Cheltenham Art Gallery and Museum** has an acclaimed collection of furniture and silver, much of it made by Cotswold craftsmen and inspired by William Morris's Arts and Crafts Movements. Also Oriental porcelain, English ceramics, fine paintings and changing special exhibitions. Gustav Holst was born in 1874 in a terraced Regency house in Clarence Road which is now the **Holst Birthplace Museum and Period House**. The original piano of the composer of *The Planets* is the centrepiece of the story of the man and his works, and there's a working kitchen, a Regency drawing room and a nursery.

Cheltenham Ladies College, where the pioneering Miss Beale was principal, was founded in 1854. Two remarkable modern pieces of public art take the eye in the centre of town. The **Wishing Fish Clock** in the Regent Arcade is a work in metal by the famous artist and craftsman Kit Williams: below the clock, from which a mouse pops out when disturbed by the arrival of an egg laid by a duck on high, is suspended a 12' fish which celebrates the hour by swishing its tail and blowing bubbles, to the delight and fascination of shoppers below. The mechanical parts of the clock are the work of the renowned local clockmaker Michael Harding. Off the High Street are the **Elephant Murals**, which portray an event that occurred in 1934 when three elephants from a travelling circus escaped and raided a provision shop stocked with corn - an incident which older locals with long memories still recall. **Cheltenham Racecourse**, two miles north of town, is the home of National Hunt Racing, staging numerous top-quality races highlighted by the March Festival when the Gold Cop and the Champion Hurdle find the year's best steeplechaser and best hurdler. Several other festivals have their home in Cheltenham, including the International Jazz Festival (April), the International Festival of Music (July) and the International Festival of Literature (October).

When Suffolk Square was created in 1824, one of the first houses to be built was **Willoughby House**, a dignified Regency residence that became the landmark mansion as visitors entered the square from Montpellier. Throughout its history the house has welcomed visitors - Queen Adelaide came to dine in 1837

Willoughby House, 1 Suffolk Square, Cheltenham,
Gloucestershire GL50 2DR Tel: 01242 522798 Fax: 01242 256369

- and since 1963 it has been a hotel of distinction. It was star-listed at that time as a building of special architectural and historical interest, ensuring that all essential features, both internal and external, are maintained in their original condition. Elegance is the keynote throughout, and the nine en suite bedrooms are decorated and furnished to a very high standard, each with its own individual style and appeal. The rooms range from a beautiful suite with a four-poster bed, adjoining second bedroom and lounge area, to family doubles, twins and singles.

In the dining room a multi-choice breakfast starts the day, and from Monday to Saturday a dinner menu offers a good choice of dishes using fresh seasonal produce. In addition to the guest rooms, Willoughby House also has three self-contained apartments, each with its own entrance. Elsewhere in town, in the same ownership, are other self-contained apartments and three houses available for short or long stays, and a health and beauty suite. Willoughby House and the health and beauty suite have a brilliant and very personable young manager in Lee Pemberton.

In a quiet private cul-de-sac of charming period properties, **Wimble Cottage** is at once secluded from the bustle of the town and a convenient self-catering base for visiting its attractions. There's a feeling of rural peace and happiness on entering the cottage, whose bright, cosy sitting room is furnished with antiques. A door leads from here to the fully-equipped kitchen and dining area, also furnished with antiques. Upstairs are a double bedroom, a single bedroom and a bathroom with both bath and built-in shower. The garden at the rear is a peaceful spot to sit and relax after a long day's sightseeing. Off-road parking is available for two cars.

The same owner, Helen Beardsell, also offers self-catering accommodation in a charming, light and airy flat in the grounds of a thatched 400-year-old cottage, **Crane Hill**, at Oxenton, in a lovely rural setting seven miles north of Cheltenham off

**Wimble Cottage, 8 Clare Place, Cheltenham, Gloucestershire GL53 7NH
Tel/Fax: 01242 673631 (Crane Hill)**

the A435. The flat is entered from its own garage and is carpeted and furnished to a high standard, with antique items enhancing the ambiance. B&B in the cottage itself is a recent new offering by prior arrangement only. All establishments are non-smoking, and bookings for all should be directed to Crane Hill.

The village of **Badgeworth**, virtually a suburb of Cheltenham, boasts what is probably the smallest nature reserve in the world, some 350 square yards that are home to the exceptionally rare Adder's-Tongue Spearwort.

AROUND CHELTENHAM

CHARLTON KINGS
MAP 2 REF D2

1 mile SE of Cheltenham on the A435

Charlton Kings, home of poets, has also been more or less subsumed into Cheltenham, on whose eastern edge it lies.

Three spacious, elegantly furnished bedrooms provide a first-class bed and breakfast base for visitors to this most attractive part of the world. **Detmore House**, which stands down a private drive off the London road (A40) on the eastern edge of Cheltenham, started life as a cottage in the 16th century and expanded considerably in the 18th and 19th centuries. The cottage became the kitchen of the enlarged house, and a stream running under the floor gave an instant supply of water. It was the father of the poet Sydney Dobell who added

Detmore House, London Road, Charlton Kings, Near Cheltenham, Gloucestershire GL52 6UT Tel: 01242 582868

the two big sitting rooms, which face southeast and look towards Coxhorne (another Dobell residence) and Red Wood. The setting is at once scenic and serene, with grounds of lawns and trees extending over 7½ acres, and superb panoramic views. Owner Jill Kilminster, a delightful lady and a keen horsewoman, has a warm, personal welcome for her guests, who arrive as names and leave as friends. Days start with a generous English breakfast.

PRESTBURY
Map 2 ref D2
1 mile NE of Cheltenham on the A46

Racing at Cheltenham started at Cleeve Hill but moved to land belonging to **Prestbury Park** in 1819, since when all the great names of steeplechasing have graced the Prestbury turf. The village has an abundance of timber-framed buildings, several ghosts and, alas, no trace at all of the medieval bishop's palace that once stood here. Prestbury's greatest son was not a steeplechasing jockey but the amazing Fred Archer, undisputed champion of flat race jockeys, born in the village in 1857. In the King's Arms a shoe from Archer's first mount hangs proudly in the bar, along with a plaque with this inscription:

> *At this Prestbury Inn lived FRED ARCHER the jockey*
> *Who trained upon toast,Cheltenham water & coffee.*
> *The shoe of his pony hangs in the bar*
> *where they drink to his prowess from near and from far*
> *But the man in the street passes by without knowledge*
> *that twas here Archer swallowed his earliest porridge.*

Home Farm Holiday Cottages are part of a group of 17th century buildings that surround a pleasant courtyard and look out on to open farmland and the slopes of Cleeve Hill. The cottages, attached to owner Charles Banwell's farmhouse, have been tastefully converted from mellow Cotswold-stone outbuildings

Home Farm Holiday Cottages, Home Farm, Prestbury, Near Cheltenham, Gloucestershire GL52 3BG Tel: 01242 583161 Fax: 01242 224161

into high-quality self-catering apartments. They retain many original features, including oak beams, stone walls and the well-worn stone steps that led up to the granary.

The Stables and the Granary offer spacious accommodation comprising a lounge with dining area, a kitchen, bathroom and two bedrooms. The Yew Tree is a half-timbered cottage attached to the grand old tithe barn, which boasts a 14th century weather vane and once contained the stone cider press that now stands in the courtyard. The cottage covers three floors, with a double bedroom and bathroom at ground level, an open-plan lounge, kitchen and dining area above and a delightful attic bedroom reached by a steep staircase. All the cottages are supplied with bed linen, and a cot and high chair are available. There's a communal laundry, a quiet garden and ample off-road parking. All in all, a most charming and civilised place to stay, and the perfect base for Cheltenham racegoers.

CLEEVE HILL MAP 2 REF D2
3 miles NE of Cheltenham on the B4632

The Cotswolds rise to their highest point, 1083' above sea level, at **Cleeve Cloud** above Prestbury and a mile from the village of Cleeve Hill. The view from this high point on the ridge is well worth the exercise, with Tewkesbury Abbey, the Herefordshire Beacon and the distant Brecon Beacons visible on a clear day. Also worth the climb is a massive neolithic long barrow known as **Belas Knap**, where excavations in Victorian times and in the 1920s revealed the bones of more than 30 people. It is very unusual in having a false entrance at the north end apparently leading to no chambers; most of the bodies were found in small chambers at the side and south end, but behind the false entrance were found the bones of a man and five children, perhaps killed in some ancient sacrificial rite.

Rickie and Jennie Gauld own and run **The Old Dairy**, whose position high on the Cotswold escarpment gives it one of the best views in England. Set in four acres of unspoilt meadowland, the house is a carefully restored stone dairy dating from the early 19th century and remodelled internally by its owners to the highest specifications. The Old Dairy is ideal for those seeking true tranquillity, hikers, nature-lovers and explorers of the Cotswolds.

Self-catering accommodation comprises a double en suite bedroom downstairs and two twin bedrooms upstairs, sharing a bathroom. The kitchen is fully equipped, and oil-fired central heating and solar panels provide year-round warmth and instant hot water. The heart of the building is a 30' vaulted, oak-floored sitting room with a gallery and a wood-burning stove. A futon in the gallery and a sofa bed in the sitting room provide extra sleeping space for guests. A TV with video is provided, along with a selection of videos, a growing library, board and card games, tourist information and local maps. The main rooms at

**The Old Dairy, Slades Farm, Bushcombe Lane, Cleeve Hill,
Near Cheltenham, Gloucestershire GL52 3PN Tel: 01242 676003
e-mail: rickieg@btinternet.com
web: www.btinternet.com/~cotswoldcottages**

The Old Dairy ("The Cottage with the Hundred Mile View") afford wonderful vistas westward across the Severn Vale to the Black Mountains of Wales and southward as far as the Severn Bridge. No dogs.

WINCHCOMBE
6 miles NE of Cheltenham on the B4632

MAP 2 REF E2

The Saxon capital of Mercia, where in medieval times the shrine of St Kenelm, martyred here by his jealous sister in the 8th century, was second only to that of Thomas à Becket as a destination for pilgrims. Winchcombe grew in importance into a walled town with an abbot who presided over a Saxon parliament. The abbey was destroyed in 1539 after the Dissolution of the Monasteries and all that remains today is a section of a gallery that is part of the George Inn. As well as pilgrims, the abbey gave rise to a flourishing trade in wool and sheep.

One of the most famous townsmen of the time was Jack Smallwood, the Jack o' Newbury who sponsored 300 men to fight at Flodden Field in 1513 and was a leading producer of woollen goods. Silk and paper were also produced, and for a few decades tobacco was grown locally - a fact remembered in place names such as Tobacco Close and Tobacco Field. This activity ceased in 1670 when a law was passed banning home-produced tobacco in favour of imports from the struggling colony of Virginia.

The decline that followed had the effect of stopping the town's development, with for us the happy result that many of the old buildings have survived largely unaltered. These include St Peter's Church, built in the 1460s and known particularly for its 40 grotesques and gargoyles, the so-called Winchcombe Worthies. **Winchcombe Folk and Police Museum**, in the Tudor-style Town Hall by

the Tourist Information Centre, tells the history of the town from neolithic times to the present day and also keeps a collection of British and international police uniforms and equipment.

A narrow passageway by an ordinary-looking house leads to **Winchcombe Railway Museum and Garden**, a wonderland full of things to do: the railway museum contains one of the largest collections of railway equipment in the country, and visitors can work signals and clip tickets and generally get misty-eyed about the age of steam. The Cotswold garden is full of old and rare plants.

Ireley Grounds is a stunning Cotswold farmhouse built of natural stone and set in 2½ acres of attractive gardens by the B4632 Winchcombe-Broadway road. The ex-GWR Gloucestershire-Warwickshire railway line, where steam trains run once more, forms one of the boundaries. Inside Mike and Pauline Wright's lovely house the lounge, with its sofas, log fire and solid oak bar, has abundant atmosphere and style, and the four main-house bedrooms offer exceptional luxury and comfort. Three of the rooms have four-poster beds and one has extra beds for family occupation. The splendid bridal suite has a balcony with views of the garden and the Cotswolds. All rooms have en suite bath or shower. Three

Ireley Grounds, Broadway Road, Winchcombe, Near Cheltenham, Gloucestershire GL54 5NY Tel: 01242 603736

self-catering cottages (Arkle, Mill House and Red Rum) are also available. The grounds are a riot of colour throughout the year, and the lovely koi carp pond adds further appeal to the surroundings. Ireley Grounds is a superb venue for conferences and seminars, with a function suite that can accommodate 100+ theatre-style, and an equally popular choice for weddings, banquets and private parties. Clay-pigeon shooting can be arranged.

A mile outside Winchcombe on the Broadway Road on the edge of an area of outstanding natural beauty you will find **Winchcombe Pottery**. Probably the longest-running craft domestic pottery in the country, this world-famous pot-

tery is completely unspoilt and still makes everything by hand on the wheel and fires the ware in a wood-fired kiln. The pottery is now run by Mike Finch under the watchful eye of his father Ray Finch (who started working at the pottery in 1936) and with a small team of potters they produce a complete range of pots for use in the home at surprisingly low prices. The pottery is fired to stoneware temperature and is hard, durable and entirely free from lead and any injurious chemicals. Visitors are welcome to look round the showrooms and, at most times, the workshop (free entry). As well as the standard range of domestic ware, a number of individual pots are for sale in the showroom and, with a furniture-maker, a

Winchcombe Pottery, Broadway Road, Winchcombe, Near Cheltenham, Gloucestershire GL54 5NU Tel: 01242 602462 e-mail:winchcombe_pottery@compuserve.com

sculptor and a shoe repairer also on site, this place is a real magnet for admirers of traditional crafts.

A couple of miles north of Winchcombe lies the village of **Gretton**, near the western terminus of the Gloucestershire-Warwickshire Railway (see under Toddington) and the renowned **Prescott Hillclimb**, scene of hillclimb championships and classic car meetings.

In the middle of the village, the pub sign - a classic blue racing Bugatti - tells visitors that they've arrived at **The Bugatti Bar & Brasserie** and that it's definitely time for a pit stop. Run by a go-ahead young couple Alison Holden and Keith Billington, this thoroughbred pub-restaurant is housed in a Victorian building, but inside there's something of a Continental look, with window blinds and shelves of wine bottles. Some of the illuminated prints on the walls have Bugattis as their subject. This is a very serious eating place (but also a pub where you can get a drink and a snack), and booking is recommended to be sure of sitting down to one of Keith's splendid meals. His menu features such superb dishes as twice-baked goat's cheese and chive soufflé on a watercress sauce, salmon

The Bugatti Bar & Brasserie, Gretton, Winchcombe, Near Cheltenham, Gloucestershire GL54 5EU Tel: 01242 602471

and dill fishcakes with hollandaise and braised shoulder of lamb with oregano, thyme, garlic and lemon. There's ample space to park your Bugatti, and at the rear is a beer garden with conifers, shrubs and attractive borders, a children's play area and a barbecue. The famous Prescott Hillclimb starts a mile or so from the pub, and close to it are the Bugatti Trust and Owners Club. The full menu is available every lunchtime and every evening except Sunday.

A mile or so north of Winchcombe stand the ruins of **Hailes Abbey**, founded in 1246 by Richard, Earl of Cornwall, who built it on such an ambitious scale that the Cistercian monks were hard pressed to maintain it. But after a wealthy patron donated a phial said to contain the blood of Christ the abbey soon be-

Hailes Abbey, Nr Winchcombe

came an important place of pilgrimage; it was even mentioned in Chaucer's *Canterbury Tales*. The authenticity of the phial was questioned at the time of the Dissolution and it was destroyed, and with it the abbey's main source of income. The abbey fell into disrepair and the only significant parts to survive are the cloister arches. Some of the many artefacts found at the site, including medieval sculptures and decorated floor tiles, are on display in the abbey's museum. National Trust.

SUDELEY
1½ miles S of Winchcombe off the B4632

Map 2 ref E2

Southeast of Winchcombe lies the village of Sudeley and **Sudeley Castle**, a restored medieval stately home that was the last home, and burial place, of Catherine Parr, Henry VlII's sixth and last wife. She outlived Henry and married her former lover Sir Thomas Seymour, Baron of Sudeley, but died in childbirth; her tomb (not the original but a 19th century replacement designed by Sir Gilbert Scott) can be seen in St Mary's Chapel. The castle was the garrison headquarters of Charles l's nephew Prince Rupert during the Civil War and was besieged in 1643 and 1644. The conflict left the castle severely damaged (Catherine Parr's tomb was destroyed) and a large gap in the wall of the Octagon Tower is evidence of the bombardment. The interior of the castle, restored by the Dent family in sumptuous Victorian style, is a treasure house of old masters, tapestries, period furniture, costumes and toys, and the beautiful grounds include a lake, formal gardens and a 15' double yew hedge. Open daily April to October.

Three miles from Winchcombe, off the road to Guiting Power, **Parks Farm** nestles in a hillside sheltered by beech trees. The stone farmhouse was built in

Parks Farm, Sudeley, Near Winchcombe, Gloucestershire GL54 5JB
Tel: 01242 603874

the early 18th century and the flagstoned entrance and superb old timbers give great period character. The atmosphere is very relaxed and informal, with Rosemary and Roger Wilson and their three sons generating the feel of a real family home. B&B accommodation is provided in two spacious, well-appointed bedrooms with private bathrooms, exposed beams, inviting armchairs, TVs and beverage trays. The setting of this truly Hidden Place is one of its greatest assets, with views that extend beyond Sudeley Castle and the historic town of Winchcombe as far as 40 miles on a clear day. It's an ideal base for walkers, being right on The Warden's Way, and with easy access to The Cotswold and The Windrush Ways. Guests start the day with a real country farmhouse breakfast with all the options. Should they need further sustenance during the day, there are plenty of restaurants and pubs in Winchcombe and the surrounding villages.

TODDINGTON
Map 2 ref E1

8 miles NE of Cheltenham on the B4632/B4077

Toddington Manor, a magnificent Gothic pile built in the 1820s by Sir Charles Hanbury-Tracy, has stood deserted for many years, but the **Gloucestershire-Warwickshire Railway** has been very much better cared for. The northern terminus is the restored Toddington Station, from where trains run on a six-mile return trip through some truly delightful countryside. The station, in pristine GWR condition, is open all year round and includes a signal box and a goods shed. Call 01242 621405 for details of train times.

STANWAY
Map 2 ref E1

9 miles NE of Cheltenham on the B4077

A charming village clustered round one of the finest Jacobean manor houses in the region. Built of mellow golden stone, **Stanway House** has much to interest the visitor, including fine paintings, two superb Broadwood pianos, a shuffleboard table and a Chippendale exercising chair on which keep-fit enthusiasts of the time would bounce for half an hour a day. In the grounds are a 14th century tithe barn, water mill, ice house, brewery, dog's cemetery and a pyramid erected on a hill behind the house in honour of John Tracy, one of the owning family. Another resident was Thomas Dover, the sea captain who rescued Alexander Selkirk from a desert island, an event which gave Daniel Defoe the inspiration for *Robinson Crusoe*. Also on note in Stanway is a thatched cricket pavilion resting on mushroom-shaped stones. The pavilion was a gift from JM Barrie, the author of *Peter Pan*, who was a frequent visitor to the village.

STANTON
Map 2 ref E1

10 miles NE of Cheltenham on the B4632

One of the prettiest spots in the Cotswolds, an attractive village of steeply-

gabled limestone cottages dating mainly from the 16th and 17th centuries. The whole village was restored by the architect Sir Philip Scott in the years before World War l; his home between 1906 and 1937 was **Stanton Court**, an elegant Jacobean residence built by Queen Elizabeth l's Chamberlain. The village church, dedicated to St Michael and All Angels, has many interesting features, including some stained glass from Hailes Abbey and a number of medieval pews with scarred ends caused perhaps by the leashes of dogs belonging to local shepherds. The architect Sir Ninian Comper added several features as World War l memorials. John Wesley is said to have preached in the church. Beyond Stanton, on the road to Broadway, the National Trust-owned **Snowshill Manor** is an elegant manor house dating from Tudor times; once the home of Catherine Parr, it contains a fascinating collection of crafts and artefacts assembled by the last private owner, Charles Paget Wade.

Licensees Colin and Linda Johns are the friendly hosts at **The Mount Inn.** Here in the picturesque North Cotswold village of Stanton, this welcoming public house and restaurant serves a variety of excellent meals and snacks, to be washed down with any of a range of fines beers, ales, spirits or wines. The pub is owned by the small Donnington brewery. Food is served daily from noon - 2 p.m. and from 7-9 every evening except Sunday. The menu includes home-prepared delicacies such as lasagne, cottage pie and chicken balti, together with a variety of sandwiches, toasted sandwiches and other snacks. The large and pretty garden is home to an aviary with cockatiels, budgies, love birds and quail - just one of the Johns' passions, along with cricket. The pub, built in Cotswold stone, dates

**The Mount Inn, Stanton, Nr Broadway Worcestershire WR12 7NE
Tel: 01386 584316**

back to the 1640s. The interior features exposed beams and an inglenook fire-place, and is adorned with cricket bats signed by the Worcester team, brasses and a collection of foreign currency. The pub boasts views over the Cotswolds and the Malverns towards Wales. The pub's resident (and friendly) ghost goes by the name of Billy!

GUITING POWER
8 miles E of Cheltenham off the A436

MAP 2 REF E2

A neat collection of Cotswold stone cottages clustered round a triangular village green. Noteworthy features include the part-Norman St Michael's Church and the World War 1 memorial cross.

Racing folk are in their element at **Fox Hill**, which stands at Tally Ho Lane at the junction of the B4068 and a minor road between Guiting Power and Naunton. The owner of this splendid little place is Sue Marston, whose son Warren is a leading National Hunt rider and whose partner is David Wintle, who trains a

**Fox Hill, Old Stow Road, Guiting Power, Near Cheltenham,
Gloucestershire GL54 5RL Tel: 01451 850496 Fax: 01451 850602**

successful string of horses at Naunton. Sue bought the 17th century building, which had formerly been a pub, three years ago and turned into a very peaceful B&B base for racegoers (Cheltenham is very close) and other visitors to this

lovely part of the world. The three letting bedrooms, all with en suite facilities, are quietly situated at the back of the main house, with doors that open on to a charming garden. Guests stoke up for a hard day's racing or touring with a super country breakfast. Sue has plans to offer self-catering accommodation in a cottage attached to the main house.

Guests are welcome to visit the training establishment at Naunton, where The Gopher is one of the stable stars. There is also a lavender farm on the site. The stables of another leading trainer, Nigel Twiston-Davies, are very close by.

Between Guiting Power and the equally appealing neighbouring village of Temple Guiting is a great family attraction. **Cotswold Farm Park** is a typical Cotswold hill farm which is home to one of the largest collections of rare British farm animals in the country, from Gloucester cattle to Guernsey goats, Cotswold sheep to Crested ducks. Many foals, lambs and calves are born here every year, and there is a Touch Barn, adventure playground, pets and tots corner, woodland walk and Cotswold kitchen.

The lanes to the west of the Guitings cross the **Salt Way**, an ancient trail whose most accessible Cotswold section runs south from Hailes Abbey to a point on the A436 east of Andoversford.

NAUNTON
Map 2 ref E2
9 miles E of Cheltenham off the B4068

Founded in Saxon times, Naunton presents a really pretty picture when viewed from the surrounding hills. Close up, down in the valley, it's still very attractive with its 14th century church (one of two), its dovecote and its long string of typical stone cottages on either side of the Windrush. Local legend has it that Naunton's first inhabitant was an imp who fell to earth and broke a wing while flying with his satanic master. Unable to fly, he built himself a stone cottage and settled in. What a clever imp to choose such a lovely place!

There's plenty to see in this unspoilt village, including two churches and a magnificent 15th century dovecote. For the more energetic, the Black Horse Walk, a full day's walk across hillsides and through woods and water meadows, visits Upper and Lower Slaughter and takes in lunch at the Black Horse.

Originally a row of tiny cottages that were farmworkers' dwellings, **The Black Horse Inn** became a pub in the 1870s. Flagstone floors and open log fires paint a traditional picture in the bars, where Martin and Helen Macklin offer a cheerful welcome, well-kept ales and a regularly-changing menu of splendid home-cooked food. Salmon in wine with dill, Cotswold pork sausages and a haddock, cheese and potato bake are typical main courses, and there are also hot and cold starters and light snacks and "wickedly delicious puddings". Food is served from 12 to 2 and from 7 to 9, and booking is advisable at weekends. Two en suite bedrooms provide a comfortable night's rest at the Black Horse,

**The Black Horse Inn, Naunton, Near Cheltenham,
Gloucestershire GL54 3AD Tel: 01451 850565**

and the same owners offer further en suite accommodation in Naunton View
Guest House (Tel: 01451 850482) about 150 yards from the inn.

STOW-ON-THE-WOLD

At 800' above sea level, this is the highest town in the Cotswolds, and the winds
sometimes prove it. At one time twice-yearly sheep fairs were held on the Mar-
ket Square, and at one such fair Daniel Defoe records that over 20,000 sheep
were sold. Those days are remembered today in **Sheep Street** and **Shepherds
Way**. The square holds another reminder of the past in the town stocks, used to
punish minor offenders. The sheep fairs continued until they were replaced by
an annual horse fair, which was held until 1985. The Battle of Stow, in 1646,
was the final conflict of the Civil War, and after it some of the defeated Royalist
forces made their way to St Edward's Church, while others were cut down in the
market square. The church, which suffered considerable damage at this time,
has been restored many times down the centuries, not always to its advantage,
but one undoubted treasure is a painting of the Crucifixion in the south aisle,
thought to be the work of the 17th century Flemish artist Gaspard de Craeyer.
The church is dedicated to King Edward the Martyr, who was murdered at Corfe
Castle by his stepmother Elfrida. Other buildings of note in the town are the

15th century Crooked House and the 16th century Masonic Hall. In Park Street is the **Toy and Collectors Museum**, housing a charming display of toys, trains, teddy bears and dolls, along with textiles and lace, porcelain and pottery.

AROUND STOW - WEST AND NORTH

UPPER AND LOWER SWELL MAP 2 REF E2
1 mile W of Stow on the B4077 & B4068

A couple of Swells. Lower Swell and Upper Swell are unspoilt neighbouring villages on the banks of the River Dikler a mile west of Stow. Lower Swell's focal point is its triangular village green, and it also has a war memorial designed by Sir Edwin Lutyens. The large mill pond is one of Upper Swell's many delights. Nearby, in Condicote Lane, is **Donnington Trout Farm**, housed in an 18th century stone barn. Lots of trout activity here for visitors: seeing the hatchery where brown and rainbow trout are reared, feeding the larger fish, a secluded lake for fly fishing, a farm shop where customers can select from thousands of live trout, and a smokery.

Woodlands Guest House stands in a quaint village on the A424 just a mile from Stow-on-the-Wold. The Cotswold stone house, of post-war dormer construction, stands in half an acre of superb formal gardens with stunning views over the lake to the rear and the Cotswold hills. The gardens are the hobby of owner Brian Sykes, whose wife Kathryn is a wonderfully talented potter, needleworker and interior designer. Her unerring sense of style and taste is very evident in the beautiful decor and furnishings that grace the house. The six

**Woodlands Guest House, Upper Swell, Near Stow-on-the-Wold,
Gloucestershire GL54 1EW Tel: 01451 832346**

letting bedrooms are all de luxe doubles with en suite bedrooms, TVs and tea/coffee-makers. Central heating and double glazing keep the whole place comfortable and cosy. There's a lounge for guests where a full English breakfast is served and where light snacks can be made available by arrangement in the evening.

DONNINGTON
2 miles N of Stow on the A424

MAP 2 REF F2

The scene of the Battle of Stow, now a peaceful hamlet enjoying spectacular views over the Evenlode Valley. Its most notable building is Thomas Arkells's brewery, dating from 1865 but incorporating some earlier buildings.

Walkers, cyclists, motorists and caravaners all get a warm welcome at **Holmleigh**, where Irene Garbett provides B&B accommodation in the premises of a well-established dairy run by one of her three daughters. There are two letting bedrooms in the bright modern house, one en suite, the other with a private bathroom. The en suite is actually the whole top (first) floor, a neat loft conversion that effectively creates a self-contained apartment. In the grounds there are eight caravan pitches. Superb English breakfasts and traditional cream teas are served inside or in the garden when it's warm enough. Holmleigh en-

**Holmleigh, Donnington, Near Moreton-in-Marsh,
Gloucestershire GL56 0XX Tel: 01451 830792**

joys a very quiet country setting, making it perfect for relaxing and recharging the batteries; it is also an ideal base for touring the Cotswolds, with easy access to the many pretty villages and towns in the region. Children over 5 are welcome with well-behaved parents.

MORETON-IN-MARSH

Map 2 ref F1

4 miles N of Stow on the A429

A bustling market town at the junction of the A44 and the A429 Fosse Way, once an important stop on the coaching route between London and the West Midlands. One of the main coaching inns was the White Hart, where Charles I took refuge during the Civil War. Its broad main street is lined with handsome 17th and 18th century buildings, while from earlier days the old town gaol and the Curfew Tower are well worth a visit; the latter still has its original clock and bell dated 1633. In Bourton Road, the **Wellington Aviation Museum** has a collection of WW2 aircraft paintings, prints and models and a detailed history of the Wellington bomber. A mile east of town on the A44 stands the **Four Shires Stone** marking the original spot where the counties of Gloucestershire, Oxfordshire, Warwickshire and Worcestershire met. Moreton-in-the-Marsh is the scene, every Tuesday, of the biggest open-air street market in the Cotswolds.

BATSFORD

Map 2 ref F1

6 miles N of Stow off the A44

Just north of Moreton, a place of unique attractions for the visitor.

In the 18 years he has been at **Batsford Garden Centre & Nursery**, owner Nick Dicker has turned it from a very small, struggling business into one of the largest suppliers in Europe. The centre stands in the Arboretum of Batsford Park, ancestral home of Lord Dulverton of the Wills tobacco family, which since the 16th century has had only two owning families, the Mitfords and the Willses. All kinds of flowering shrubs, trees and alpines are available, and hardy ferns are a

Batsford Garden Centre & Nursery, Moreton-in-Marsh, Gloucestershire GL56 9QB Tel: 01386 700409 Fax: 01386 701148

speciality. Nursery manager Stuart Priest has prepared an instructive guide to these plants, which have wonderful names such as *Asplenium Scolopendrium*, *Onoclea Sensibilis* and *Polystichum Tsus-Simense*. The centre has started to import ginseng plants, the only nursery in Europe to do so. Garden sundries and machinery are also part of the stock at this fascinating place, which should not be missed by anyone interested in plants and gardens. The centre, which is open every day from 10 till 5, is entered from the A44 only (no access through Batsford village). The Arboretum itself, open from March to mid-November, was designed and planted by Lord Redesdale in 1880 after he had spent time in Tokyo, and had a distinct Japanese look. Lord Dulverton greatly increased the number and variety of the trees, notably the maples and magnolias. The Arboretum is a great place for a leisurely ramble; it has a picnic site, a tea shop and a large falconry centre.

Another major attraction at **Batsford Arboretum** is the **Cotswold Falconry Centre**, home not only to falcons but also to hawks, eagles, vultures, kites and owls. Up to 20 birds of prey are flown each day, providing an exciting and educational spectacle as they exhibit their particular aerial skills, from the slow, majestic eagle to the quick, aerodynamic falcon, the darting hawk and the silent, swooping owl. In the aviaries, some of the species at risk are part of a

**Cotswold Falconry Centre, Batsford Park, Batsford,
Near Moreton-in-Marsh, Gloucestershire GL56 9QB Tel: 01386 701043**

long-term breeding programme. It is sometimes possible, via closed-circuit television, to watch parent birds brooding their young. Also on the site, the Cotswold School of Falconry holds introductory courses, hunting days and a three-day hands-on falconry experience. Adoption schemes, whereby visitors 'adopt' a bird for a year, are very popular. The centre, reached from the A44 only

(no access through Batsford village), is open daily from March to the end of November. It is owned and run by Geoff Dalton, President of the Central Falcon Club, who has worked with birds of prey for 25 years. The centre promises a wonderful day out for all the family - make sure you bring a camera, but leave the dog at home.

BLOCKLEY
Map 2 ref E1

7 miles N of Stow off the A429/A44

Silk-spinning was the main industry here, and six mills created the main source of employment until the 1880s. As far back as the Domesday book water mills were recorded here, and the village also once boasted an iron foundry and factories making soap, collars and pianos. The mills have now been turned into private residences and Blockley is a quieter place. One of the chief attractions for visitors is **Mill Dene Garden**, set around a mill in a steep-sided valley. The garden has hidden paths winding up from the mill pool, and at the top there are lovely views over the Cotswolds. Also featured are a grotto, a potager, a trompe l'oeil and dye plants.

STRETTON-ON-FOSSE
Map 2 ref F1

9 miles N of Stow off the A429

An unspoilt village in a pleasant hilltop setting. Ann Campbell-Smith makes her guests very welcome at **Jasmine Cottage**, a picturesque building in brick

Jasmine Cottage, Stretton-on-Fosse, Near Moreton-in-Marsh, Gloucestershire GL56 9SA Tel: 01608 661972 Mobile: 0401 002990

and stone in a quiet village setting off the A429 about five miles north of Moreton-in-Marsh. A magnificent jasmine tree guards the front of the 200-year-old property, while inside, all is just as it should be in an English country cottage, with neat rooms, well-co-ordinated furnishings and lots of family photographs and mementoes. Two bedrooms - a double and a twin - provide cosy bed and breakfast accommodation; families and pets are welcome. The owner is a charming lady with the ability of putting guests immediately at ease in this delightful setting. A full English breakfast starts the day, and guests have the use of a lounge with TV.

CHIPPING CAMPDEN
MAP 2 REF E1
10 miles N of Stow on the B4081

The 'Jewel of the Cotswolds', full of beautifully restored buildings in golden Cotswold stone. It was a regional capital of the wool trade between the 13th and 16th centuries and many of the fine buildings date from that period of prosperity. In the centre of town is the Jacobean Market Hall, built in 1627 and

Woolstaplers Hall, Chipping Campden

one of many buildings financed by the noted wool merchant and financier Sir Baptist Hicks. He also endowed a group of almshouses and built Old Campden House, at the time the largest residence in the village; it was burnt down by Royalists to prevent it falling into the hands of the enemy, and all that survives

are two gatehouses and the old stable block. The 15th century Church of St James was built on a grand scale and contains several impressive monumental brasses, the most impressive being one of William Grevel measuring a mighty 8' by 4'.

Dover's Hill, a natural amphitheatre above the town, is the scene of the **Cotswold Olympics**, founded in the 17th century by Captain Robert Dover, whom we met at Stanway House. The Games followed the traditions of ancient Greece and added some more down-to-earth activities such as shin-kicking and bare-knuckle boxing. The lawlessness and hooliganism that accompanied the games led to their being closed down in 1852 but they were revived in a modern form in 1951 and are still a popular annual attraction on the Friday following the spring bank holiday.

BROAD CAMPDEN Map 2 ref E1
1 mile SW of Chipping Campden on minor roads

Broad Campden, a quiet conservation village, lies on the southern edge of Chipping Campden on the Blockley road.

Sally and Ray Mayo, both born and brought up locally, have a friendly greeting for visitors to **The Bakers Arms**. This 17th century traditional Cotswold country pub, its facade adorned by luxuriant greenery, has kept all its original appeal with exposed stone walls, beams and inglenook fireplaces. Real ales and good food are served in a relaxed, convivial atmosphere. There are some interesting items including old deeds and a wall-hanging carpet which took an old

The Bakers Arms, Broad Campden, Near Chipping Campden, Gloucestershire GL55 6UR Tel: 01386 840515

regular 1,000 hours to complete and which he presented to the then landlord. Meals are served every lunchtime and every evening from a menu and specials board which include a Sunday roast, cottage pie, chicken curry, lasagne verdi and liver & bacon. Also at lunchtime sandwiches, ploughmans and filled Yorkshire puddings provide lighter snacks. The pub has a large car park and a pleasant garden with a children's play area.

June and John Wadey built **Wyldlands** 30 years ago in the quiet conservation village of Broad Campden, midway between Chipping Campden and Blockley. It enjoys lovely views of the Cotswold countryside and is ideally located for exploring the region. This is a popular area for walking holidays, with several well-known waymarked walks close by. Bed and Breakfast accommoda-

**Wyldlands, Broad Campden, Near Chipping Campden,
Gloucestershire GL55 6UR Tel: 01386 840478 Fax: 01386 849031**

tion (non-smoking) comprises three warm, comfortable bedrooms with en suite or private bathroom, remote-control TV, clock radio and tea/coffee-making facilities. Guests can browse through the many guide books and maps of the area which the owners keep, or relax in the beautiful country garden, which is open to the public for charity twice a year. One of the many delights in the garden is a walnut tree, now some 30 feet high, which John planted when the house was built. June is an authority on buttonhooks and her collection, neatly arranged in display cases, is very special.

MICKLETON MAP 2 REF E1
5 miles N of Chipping Campden on the B4632

One of the main attractions near the village is the National Trust's **Hidcote Manor Garden**, a series of small gardens, both formal and informal, created by Major Lawrence Johnston from 1907.

Kate and Phil Rush are the genial, welcoming owners of **Myrtle House**, an elegant Georgian property on the B4632 in a village three miles north of Chipping Campden. The house is Grade ll listed, and the superbly decorated rooms are bright, airy and spacious. There are four guest rooms, all with en suite facilities, TV, hairdryer, radio-alarm and tea/coffee tray. Children are welcome, and

Myrtle House, High Street, Mickleton, Gloucestershire GL55 6SA
Tel: 01386 430032 Fax: 01386 438965 e-mail: myrtlehouse@lineone.net

the owners can provide a cot, high chair and extra bed. Well-behaved pets can also be accommodated. The bedrooms, each with its own individual style and charm, are non-smoking, but smoking is allowed in the comfortable residents' lounge, where there is an open fire in winter and a stock of books and local guides to browse through. A full English breakfast with freshly baked croissants is served in the dining room, and picnics can be arranged, as well as pre/after-

theatre snacks (Stratford is only 8 miles away). The house has a secluded wall garden, and off-street parking is available in the courtyard.

In the middle of the village, just off the B4632, stands the picturesque 17th century **Butchers Arms**, the pride and joy of Jane and Keith Morris. Keith is a very keen gardener, and the masses of flowers in pots and tubs and the secure garden behind the pub reflect the hard work he puts into his hobby. There's a terrific atmosphere in the lounge and saloon bars, the latter adorned with black-and-white photographs of regular customers down the years. Jane does all the

The Butchers Arms, Chapel Lane, Mickleton, Near Chipping Campden, Gloucestershire GL55 LSD Tel: 01386 438285

cooking, and her printed menu is supplemented by daily specials such as smoked fish platter, beef & Guinness pie and cheese, leek and cauliflower bake served with hot crusty bread. Sandwiches, hot baguettes and jacket potatoes provide lighter snacks. There are traditional roasts for Sunday lunch, but no food on Sunday evening. The skittle evenings are very popular, and the skittle alley, with its own bar, doubles as a function room.

WESTON-SUB-EDGE
MAP 2 REF E1
3 miles NW of Chipping Campden on the B4035

A quiet village at the south end of the Vale of Evesham. The **Seagrave Arms** is a sturdy Cotswold-stone former coaching inn on the main road through a village that lies three miles northwest of Chipping Campden. Hosts Wendy and Joe McDonagh welcome visitors of all ages, both locals and passers-by. Inside are

Seagrave Arms, Friday Street, Weston-sub-Edge, Near Chipping Campden, Gloucestershire GL55 6QH Tel: 01386 840192

two convivial bars mainly for drinking, with prints, photographs and horse tackle on the walls and log fires in winter, and a snug dining room with 18 covers. A full menu of classic pub fare is served all day, supplemented by daily specials; bookings are taken for Sunday lunch, which features a choice of two roast joints. Not many pubs serve toasted teacakes and cream teas, but this one does! Darts and dominoes are the main pub games here, with teams playing in the local leagues. Garden. Children welcome. Dogs welcome.

WILLERSLEY
MAP 2 REF E1

3 miles W of Chipping Campden on the B4632

Owner Jane Hill and her family have been running the delightful **Lower Field Farm** guest house since 1994. This charming B&B is located on the outskirts of the tranquil village of Willersley in the north of the beautiful Cotswolds. The diverse clientele includes walkers, local farmers and horse riders - and apart from the regular guests, staying in the area to follow the many country pursuits the region boasts and to enjoy the peaceful rural atmosphere, about 30 per cent of Jane's guests hail from foreign climes. The three en suite guest rooms are cosy and very comfortable; each has tea and coffee making facilities. Built in the late 17th century, this handsome stone-built traditional farmhouse is adorned with hanging baskets in the warmer months and has a large flower garden for guests to enjoy. The decor is very tasteful and welcoming throughout, with a

**Lower Field Farm, Willersey, nr Broadway, Worcestershire WRI 1 5HF
Tel: 01386 858273**

number of original 18th century features including the exposed beamed ceilings. The breakfasts are home-prepared and home-cooked; evening meals by arrangement.

AROUND STOW - SOUTH

MAUGERSBURY MAP 2 REF F2
½ mile SE of Stow off the A429

The hamlet of Maugersbury is well placed for the Fosse Way, with easy access to the southern Cotswolds and Warwickshire.

Set in its own extensive grounds ½ a mile from the centre of Stow, **Maugersbury Manor** is owned by a warm, very friendly couple, Charlie and Lil Martin. The manor is a large, L-shaped house of rubble construction with a Cotswold stone roof. It probably dates from the late 16th century (though earlier buildings, possibly including Evesham Abbey's house, occupied the site) and has been greatly enlarged down the years. Bed and breakfast accommodation, available from March to November inclusive, comprises three en suite double bedrooms, all decorated and appointed to a very high standard. An excellent breakfast, with vegetarian options, gets the day off to a fine start, and for other

Maugersbury Manor, Maugersbury, Near Stow-on-the-Wold, Gloucestershire GL54 1HP Tel/Fax: 01451 830581

meals there is a good choice of local pubs and restaurants. Notable features of the manor include a 13th century doorway removed from a house in Stow, and a splendid lounge panelled in oak, with a magnificent staircase - a marvellous example of Jacobean workmanship. The lovely Cotswold setting is a great bonus, ensuring peace and seclusion and affording fine views in all directions.

UPPER AND LOWER SLAUGHTER

MAP 2 REF E2

2 miles SW of Stow off the A429/B4068

The Slaughters (the name means nothing more sinister than 'muddy place') are archetypal Cotswolds villages set a mile apart on the little River Eye. Both are much visited by tourists, much explored and much photographed; also much as they have always been, since virtually no building work has been carried out since 1904. Francis Edward Witts, author of the *Diary of a Cotswold Parson*, was the rector here between 1808 and 1854. At Lower Slaughter, the **Old Mill**, with its tall chimney and giant waterwheel, is a prominent feature by the river. This restored 19th century flour mill is open for visits and has a tearoom and ice cream parlour.

BOURTON-ON-THE-WATER

MAP 2 REF E2

4 miles S of Stow on the A429

Probably the most popular of all the Cotswold villages. The willow-lined Windrush flows through the centre, crossed by several delightful low-arched pedestrian bridges, two of which date from the late 18th century. The golden

Bourton-on-the-Water

stone cottages are pretty as a picture, and among the notable larger buildings are St Lawrence's Church, with its 14th century chancel and rare domed Georgian tower, and a manor house with a 16th century dovecote. In the High Street, **Miniature World - The Museum of Miniatures** is a unique exhibition of miniature scenes and models that took the country's leading master miniature makers 3½ years to complete. Bourton is a great place for miniatures, as there is also the famous **Model Village** at the Old New Inn (se below) and **Bourton Model Railway** with over 40 British and Continental trains running on three main displays in OO, HO and N gauge. The **Cotswold Motor Museum and Toy Collection**, in an 18th century water mill, has a fascinating collection of antique toys, a display of historic advertising signs and 30 or so (full-size!) cars and motorcycles. Bourton has Europe's only **Perfumery Exhibition**, a permanent attraction which explains the extraction and manufacturing processes and includes a perfume garden and a perfume quiz to test visitors' noses.

The Old New Inn, a traditional country inn dating back some 300 years, is an ideal base for exploring the delightful hills and villages of the region, on foot, on bicycles or by car. The village itself is a scenic gem, and the inn, originally two cottages and a barn, is the very essence of an English country inn, full of old-world charm and with the warm, welcoming feel of a village local. Most of the 11 letting bedrooms have en suite facilities and one boasts a four-poster bed. The inn, owned by Julian and Vicki Atherton, has a lounge reserved for guests. It also has a splendid dining room serving a multi-choice table d'hote menu in the evening (7.30 -8.30). Light lunches or bar meals are available at

The Old New Inn, Bourton-on-the-Water, Gloucestershire GL54 2AF
Tel: 01451 820467 Fax: 01451 810236
e-mail: old_new_inn@compuserve.com

midday, and packed lunches can be provided with a little notice. In the grounds behind the inn is a wonderful surprise in the shape of a 1/9th replica in local stone of the village, complete with the River Windrush, the Church of St Lawrence and the music of the actual church choir. The model was built by six local men and opened on Coronation Day 1937.

Two attractions outside the village are the Iron Age **Salmonsbury Camp** and **Folly Farm,** home to Europe's largest domestic waterfowl and wildlife conservation area, with over 160 rare breeds. Also at this major attraction off the A436 Cheltenham road are spectacular lavender fields, a garden centre and a coffee shop.

COLD ASTON Map 2 ref E2
6 miles SW of Stow off the A429/A436

Formerly known as Aston Blank, the village is set high in the Cotswolds; its attractive green is overlooked by the Georgian Sycamore House.

In a typical North Cotswold village of Saxon origin, **Pheasant Walk** is a spacious renovated cottage attached to the main house of Grove Farm. Available throughout the year for self-catering holidays, it is furnished and equipped to a very high standard. On the ground floor is the entrance porch with a stor-

Pheasant Walk, Grove Farm, Cold Aston, Near Bourton-on-the-Water, Gloucestershire GL54 3BJ Tel/Fax: 01451 810942

age area and access to a laundry; a fully-fitted kitchen with walk-in pantry; and an open-plan living area comprising a comfortably furnished sitting room with TV and radio/cassette-player, dining room and small study area; and a cloakroom. Upstairs are three generously-sized double bedrooms, one with en suite shower and WC, and a separate bathroom. To the rear of the property is an attractive garden complete with pond where visitors may sit in peaceful seclusion or enjoy a barbecue. The views over open farmland across the Coln Valley are glorious, and the countryside is ideal for walking or riding. Many famous beauty spots are nearby, and golf is available at Naunton Downs, two miles away. Penny and Christopher Avery own and run the farm, and Penny also manages the self-catering side. Cold Aston lies three miles west of Bourton-on-the-Water off the A436 or A429.

GREAT RISSINGTON

MAP 2 REF F2

7 miles S of Stow off the A424

Great Rissington lies halfway between Bourton and Burford, nestling on a hillside overlooking the valley of the Windrush.

The picturesque and peaceful village of Great Rissington in the North Cotswolds is the setting for **Lower Farmhouse**, a Grade ll listed Georgian house offering B&B accommodation in very relaxed, informal surroundings. Owners Kathryn and Andrew Fleming have three young children and are always pleased to welcome families, with most of the essentials provided: cots, high chairs, toys, childrens' suppers, babysitting - and children to play with too! Swings and slides in the garden are an added attraction. The comfortable, well-appointed

**Lower Farmhouse, Great Rissington, Near Cheltenham,
Gloucestershire GL54 2LH Tel: 01451 810163**

bedrooms, a single and a double with a private bathroom, are in a converted
barn separate from the house. Breakfast is taken in the main house, and guests
have the use of a fridge, and of a microwave for preparing snacks or hot drinks.

NORTHLEACH
10 miles S of Stow on the A429

Map 2 ref E2

A traditional market town with some truly magnificent buildings. It was once a
major wool-trading centre that rivalled Cirencester in importance and as a con-
sequence possesses what now seems a disproportionately large church. The
Church of St Peter and St Paul, known as 'the Cathedral of the Cotswolds', is a
fine example of Cotswold Perpendicular, built in the 15th century with pinnacled
buttresses, high windows and a massive square castellated tower. Treasures in-
side include an ornately carved font and some rare monumental brasses of which
rubbings can be made (permits obtainable from the Post Office). An old country
prison is now home to the **Cotswold Heritage Centre**, with displays telling the
story of social history and rural life in the Cotswolds. **Keith Harding's World of
Mechanical Music**, located in a 17th century merchant's house in the High Street,
is a living museum of antique self-playing musical instruments, music boxes,
automata and clocks, all maintained in perfect working order in the world-
famous workshops on the premises.

At **Yanworth**, a couple of miles west of Northleach off the A429 Fosse Way, is the National Trust's **Chedworth Roman Villa**, a large, well-preserved Romano-British villa discovered by chance in 1864 and subsequently excavated to reveal more than 30 rooms and buildings, including a bath house and hypocaust. Some wonderful mosaics are on display, one depicting the four seasons, another showing nymphs and satyrs. Call 01242 890256 for visiting times.

BIBURY
15 miles S of Stow on the B4425

MAP 2 REF E3

William Morris, founder of the Arts & Crafts Movement, described Bibury as 'the most beautiful village in England' and, apart from the tourists, not a lot has changed since he made the claim. The Church of St Mary, with Saxon, Norman and medieval parts, is well worth a visit, but the most visited and most photographed building in Bibury is **Arlington Row**, a superb terrace of medieval stone cottages built as a woolstore in the 14th century and converted three centuries later into weavers' cottages and workshops. Fabric produced here was supplied to nearby **Arlington Mill** for fulling, a process in which the material was cleaned in water and beaten with mechanically-operated hammers. Today the mill, which stands on the site of a corn mill mentioned in the Domesday Book, is a museum with a collection of industrial artefacts, crafts and furniture, including pieces made in the William Morris workshops.

CIRENCESTER

The 'Capital of the Cotswolds', a lively market town with a long and fascinating history. As Corinium Dobonnorum it was the second largest Roman town in Britain (Londinium was the largest). Few signs remain of the Roman occupation, but the award-winning **Corinium Museum** features one of the finest collections of antiquities from Roman Britain, and reconstructions of a Roman kitchen, dining room and garden give a fascinating and instructive insight into life in Cirencester of almost 2,000 years ago.

The main legacy of the town's medieval wealth is the magnificent **Church of St John the Baptist**, perhaps the grandest of all the Cotswold 'wool churches', its 120' tower dominating the town. Its greatest treasure is the Anne Boleyn Cup, a silver and gilt cup made for Henry Vlll's second wife in 1535, the year before she was executed for adultery. Her personal insignia - a rose tree and a falcon holding a sceptre - is on the lid of the cup, which was given to the church by Richard Master, physician to Queen Elizabeth 1. The church has a unique three-storied porch which was used as the Town Hall until 1897. Cirencester today has a thriving crafts scene, with workshops in the Brewery Arts House, a converted Victorian brewery, and regular markets in the Corn Hall. **Cirencester Open Air Swimming Pool**, next to the park, was built in 1869 and is one of the

oldest in the country. Both the main pool and the paddling pool use water from a private well.

Versatile is the word for the **Golden Farm Inn**, a handsome 300 year-old building in Cotswold stone with a slate roof. Juliet Day and Rob Rennie, both very experienced in the licensed trade, welcome visitors of all ages into their

The Golden Farm Inn, Upper Churnsides, Beeches, Cirencester, Gloucestershire GL7 1DN Tel: 01285 652927

inn, which serves as a convivial local, with music and games machines in the bars. The Golden Farm is also a good choice for an evening meal, and the menus (Sunday for residents only) include pasta, lasagne and basket meals. For guests wishing to stay overnight there are three well-decorated bedrooms - a double, a twin and a single - sharing two bathrooms and a shower. The inn also functions as a base for business people, with conference facilities and the use of a computer.

AROUND CIRENCESTER

SOUTH CERNEY
MAP 2 REF E3
3 miles SE of Cirencester off the A419

Two great family attractions here. **The Butts Farm** is a working farmstead with plenty of activity throughout the day. Children can bottle-feed the lambs, ride a pony and milk a goat. There is a pets corner, play area and picnics are welcome. **Cotswold Water Park** is Britain's largest water park, with 132 lakes providing angling, sailing, jet-skiing, water skiing, bird-watching, nature walks and a Thames Trail. On the same site is **Keynes Country Park** for barbecues, a Jurassic fossil display, a children's beach and supervised summer bathing.

FAIRFORD
MAP 2 REF E3
9 miles E of Cirencester on the A417

A welcoming little town in the valley of the River Coln, with many fine buildings of the 17th and 18th centuries and an abundance of inns as evidence that this was an important stop on the London-Gloucester coaching run. John and

Church of St Mary the Blessed Virgin, Fairford

Edmund Tame, wealthy wool merchants, built the superb late-Perpendicular **Church of St Mary**, whose greatest glory is a set of 28 medieval stained glass windows depicting the Christian faith in picture-book style. John Tame's memorial stone, along with those of his wife and son, are set into the floor of the church.

LECHLADE
MAP 2 REF F3
12 miles E of Cirencester on the A417

Lechlade stands at the junction of the A417 and A361 where the Rivers Leach and Coln join the Thames. A statue of Old Father Thames looks over **St John's Lock**, the highest navigable point on the river, where barges loaded with building stone bound for Oxford and London have given way to pleasure craft. Halfpenny Bridge, which crosses the Thames in the town centre, has a tollhouse at its eastern end. The market place is dominated by the Church of St Lawrence with a tall, slender spire visible for miles around across the low-lying water meadows. The churchyard is said to have inspired Shelley to write his *Stanzas in a Summer Evening Churchyard*. The verse can be seen inscribed on a stone at the churchyard entrance.

Behind the neat white frontage of **The Crown** freehouse, many features have been kept intact from its early 16th century days as a coaching inn. The quaint front bar, with its beams, stone walls and open fire, is a favourite spot for a drink and a chat with the locals or the resident parrot. The restaurant, by a small corridor from the bar or by its own side entrance, also features beams and an open fire with original stone surrounds, as well as brass fittings and an old

The Crown, High Street, Lechlade, Gloucestershire GL7 3AE
Tel: 01367 252198

cartwheel hanging from the ceiling.

The menu offers plenty of variety, from chicken satay and lamb's liver paté to moules marinière, local trout, sausages and mash, barbecued spare ribs and a serious mixed grill including sausages, pork chop, gammon, lamb cutlet and steak. Daily specials from the blackboard widen the choice, which always in- cludes main courses for vegetarians. The restaurant, very popular with families, is a non-smoking room. Lighter snacks are served in the bar. Another attraction, emphasising the essentially country charm of this town pub, is an intimate, floodlit beer garden. The Crown, owned and run by mother and son Val and Alan Watkins, is easy to find at a T-junction on the high street and should not be missed by anyone visiting Lechlade.

At **Kelmscott**, about 4 miles east of Lechlade, **Kelmscott Manor** was the country home of William Morris from 1871 to 1896. Built near the Thames in

the 16th century, it is the most evocative of all his houses and he loved it dearly; it is the scene of the end of his utopian novel *News From Nowhere*. Morris is buried in the village churchyard under a tombstone designed by his associate Philip Webb.

EASTLEACH Map 2 ref F3
12 miles E of Cirencester off the A417

Country roads lead north from Fairford past the village of Southrop (where John Keble lived when he was laying the foundations of the Oxford Movement with William Wilberforce and others) to the twin villages of Eastleach Martin and Eastleach Turville facing each other across the River Leach and usually referred to jointly as Eastleach.

Stephen Reeves and Philippa Jenkinson are making a great success of running the **Victoria Inn**, a Cotswold stone building in traditional style dating from 1876. A splendid sign of Queen Victoria adorns the facade of this friendliest of pubs, a favourite meeting place for the local community and a popular stopping place for the many walkers who choose this attractive part of the world for a holiday.

The open-plan lounge and bars are as characterful as the pub's exterior suggests, with low beamed ceilings, half-panelled walls and sturdy bench seating. It's a great place for a meal, with 45 covers and a very appetising menu that

The Victoria Inn, Eastleach, Near Cirencester, Gloucestershire GL7 3NQ
Tel: 01367 850277

typically includes mussel and prawn bake, locally made faggots, roast chicken and a rich beef stew with dumplings. Sunday roast lunch is a particularly popular occasion. Eastleach, which is renowned for its daffodils, is actually two villages, Eastleach Martin and Eastleach Turville, facing each other across the River Leach. For many centuries the two were owned by rival lords of the manor, so each has its own church. The ancient clapper footbridge across the river is known as Keble's Bridge after John Keble, who was appointed non-residential curate of both churches in 1815.

4 Swindon and North Wiltshire

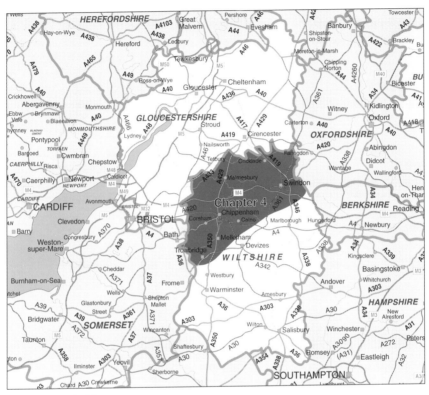

© MAPS IN MINUTES ™ (1998)

A leisurely drive down from Cirencester or Lechlade takes us from Gloucestershire to Wiltshire, a county rich in the monuments of prehistoric man; it also has one of the highest concentrations of historic houses and gardens in the country. It's a great place for walking and cycling, with wide open spaces, woodland and downland and a number of chalk streams that are home to a huge variety of wetland wildlife. The industrial heritage takes many forms, from Brunel's railway to brewing at Devizes, from the Kennet & Avon Canal to Wilton's carpet factory. And, of course, the county has its very own surprises in the shape of the famous white horses, the intriguing crop circles and, above all, the great and ancient stone circles, rich in history and mystery and legend. Pretty villages abound, and the jewel in the crown is the city of Salisbury with its glorious cathedral. The tour round the county begins in a town with a considerably shorter heritage.

SWINDON

Think Swindon, think the Great Western Railway. Think GWR, think Isambard Kingdom Brunel. The largest town in Wiltshire, lying in the northeast corner between the Cotswolds and the Marlborough Downs, was an insignificant agricultural community before the railway line between London and Bristol was completed in 1835. Swindon Station opened in that year, but it was some time later, in 1843, that Brunel, the GWR's principal engineer, decided that Swindon was the place to build his locomotive works. Within a few years it had grown to be one of the largest in the world, with as many as 12,000 on a 320-acre site that incorporated the Railway Village; this was a model development of 300 workmen's houses built of limestone extracted from the construction of Box Tunnel. This unique example of early-Victorian town planning is open to the public as the **Railway Village Museum.**

The **Great Western Railway Museum** moved from the same site in Faringdon Road in the autumn of 1999 to a new home in the former GWR works, with a new name, a great deal more space and a host of new interactive exhibits. **STEAM** will keep the collection of locomotives (6000 *King George V* is the star), nameplates, signalling equipment and an exhibition of the life and achievements of Brunel; it will also focus on the human aspect of a hard industry, telling the

Great Western Railway Museum, Swindon

story of the men and women who built and repaired the locomotives and carriages of God's Wonderful Railway for seven generations. The last locomotive to be built at the works was 92220 *Evening Star*, a powerful 2-10-0 freight engine destined to have all too short a working life. Engineering work continued on the site until 1986, when the works finally closed. The site now also contains the **National Monuments Record Centre** - the public archive of the Royal Commission on the Historical Monuments of England, with 7 million photographs, documents and texts.

There's lots more to Swindon than the legacy of the GWR: it's a bustling and successful commercial town with excellent shopping and leisure facilities and plenty of open spaces. One such is **Coate Water Country Park** on the Marlborough road.

AROUND SWINDON

LATTON
MAP 3 REF E4

7 miles NW of Swindon on the A419

A lovely old village with some delightful 17th century Cotswold-stone cottages and larger Victorian houses. It was once an important junction of the **Wiltshire & Berkshire** and **Thames & Severn Canals**. Work is being carried out to provide a connection between the former at Swindon and the latter, here. Note the impressive old wharf-owner's house.

CRICKLADE
MAP 3 REF E4

6 miles N of Swindon off the A419

The only Wiltshire town on the Thames was an important post on the Roman Ermin Street and had its own mint in Saxon times. There are many buildings of interest, notably the Church of St Sampson, with its cathedral-like four-spired tower, where a festival of music takes place each September; the famous school founded by the London goldsmith Robert Jenner in 1651; and the fancy Victorian clock tower. Nearby **North Meadow** is a National Nature Reserve where the rare snakeshead fritillary grows. Cricklade is the centre of the Cricklade Corridor Trust set up to secure the maximum economic, heritage, leisure and environmental benefits from a number of projects between Swindon and Cricklade and beyond. These include railway and canal restoration, nature conservation and the development of a branch of the National Cycle Network. Tel: 01249 706111.

Three miles west of Cricklade, in the village of Leigh, the chancel of the old church stands in isolation in a low-lying field; the rest was moved to a higher, drier site at the end of the 19th century.

CASTLE EATON

Map 3 ref E4

5 miles N of Swindon off the A419/A361

A pleasant spot on the Thames, midway between Cricklade and Highworth. John and Jackie Vosper took over **The Red Lion** in July 1999, bringing with them a great reputation for providing good food. Their nephew Steve is the head chef at this lovely old Cotswold stone inn, and the owners are planning to extend the eating facilities by opening a new restaurant area. The choice of bar and restaurant meals is always changing, with trout, salmon and steaks among

**The Red Lion, The Street, Castle Eaton, Near Swindon,
Wiltshire SN6 6JZ Tel: 01285 810280**

the firm favourites. The middle bar of this cheerful, convivial inn is used by the regulars for cribbage, cards and dominoes. There's always a good atmosphere here and visitors can be sure of a warm welcome. The Red Lion is no less appealing outside: an extensive beer garden has a 100 yard frontage on the Thames and there's a children's play area and a pétanque pitch.

BLUNSDON

Map 3 ref E4

2 miles NW of Swindon on the A419

More fun for railway buffs in a village that straddles the A419, the old Ermin Way. Blunsdon Station, with a little museum, is the home of the **Swindon & Cricklade Railway**. Eight miles of line have been re-opened, and steam and diesel trains run on special days. Tel 01793 771615 for details.

By the 13th century church at Blunsdon can be seen the ruins of Blunsdon Abbey, whose grounds now house a caravan and camping site.

HIGHWORTH

MAP 3 REF F4

5 miles NE of Swindon on the A361

The name is appropriate, as the village stands at the top of a 400' incline, and the view from **Highworth Hill** takes in the counties of Wiltshire, Gloucestershire and Oxfordshire. There are some very fine 17th and 18th century buildings round the old square, and the parish church is of interest: built in the 15th century, it was fortified during the Civil War and was attacked soon after by Parliamentarian forces under Fairfax. One of the cannonballs which struck it is on display outside. The church contains a memorial to Lieutenant Warneford, who was awarded the VC for destroying the first enemy Zeppelin in 1915.

BISHOPSTONE

MAP 3 REF F4

5 miles E of Swindon off the B4000

A charming Downland village, whose medieval village church is half-hidden in a little wood. Six miles east of Swindon, Bishopstone is the archetypal Downland village, nestling round a large central pond, and **The Royal Oak** is the archetypal English country pub - plain and simple, homely and friendly, old-fashioned in the very best sense. Keith and Jo Walkley-Pratt have built up quite a reputation for their hospitality, well-kept ales and good food, and the place always has

**The Royal Oak, Cues Lane, Bishopstone, Near Swindon,
Wiltshire SN6 8PP Tel: 01793 790481**

a great atmosphere. Chess, cribbage and darts teams meet here, the Monday quiz nights are unfailingly popular, and there's a regular Saturday evening singalong round the piano. The food is particularly good, with a wide choice from snacks to full meals: soups; sandwiches and baguettes; burgers, lasagne, chilli and curries; fish dishes, meat pies and pasta bakes. Daily specials like faggots, bubble & squeak and local sausages are great favourites, and everything is freshly prepared. Organic meat comes from a local supplier Helen Browning of Eastbrook Farm. The Royal Oak has two bars and a dining room, and outside there's a patio and a beer garden with seats for 50.

ASHBURY Map 3 ref F4
7 miles E of Swindon on the B4000

A village on the B4000 near the Ridgeway long-distance path, the oldest road in Europe. Ashbury stands at the junction of the B4057 and B4000 about seven miles east of Swindon and, for the keen walker, the ancient Ridgeway, which covers 78 miles from Avebury to Ivinghoe, runs past the village. A little way to the east lie the ruins of **Uffington Castle**, and the **Uffington White Horse**, a venerable chalk steed which dates back at least 900 years and maybe 2,000.

The **Rose & Crown** is a comfortable and traditional country hotel in this village nestling at the foot of the White Horse Downs. June Blake has been here since 1994 and, with her partner Bill, puts out the welcome mat for a wide spectrum of guests, from locals dropping in for a drink and a chat to business people lunching and tourists visiting the sights of the region. The hotel has ten letting bedrooms, four en suite and all situated in a quiet wing of the building. Each room has a TV and hot beverage facilities, and the decor is in keeping with

**The Rose & Crown Hotel, High Street, Ashbury, Near Swindon,
Wiltshire SN6 8NA Tel: 01793 710222 Fax: 01793 710029**

the character of the 250 year-old building. The public rooms include two con-
vivial bars and a separate games room. A conference room is available for
meetings, weddings and private parties. There are seats for 50 for bar meals and
35 covers in the restaurant, where June produces a tempting menu of excellent
dishes, from deep-fried brie, camembert and mozzarella with a blackcurrant
coulis to poached salmon with creamed leeks and grilled medallions of pork in
a creamy mushroom and wine sauce. Outside is an attractive patio with colour-
ful baskets of tubs and flowers.

LIDDINGTON
MAP 3 REF F5

2 miles SE of Swindon on the B4192

In the scenic expanse of countryside that is Marlborough Downs can be seen
the remains of **Liddington Castle**, an Iron Age fort on a seven-acre site whose
summit is 900' above sea level.

ALDBOURNE
MAP 3 REF F5

6 miles SE of Swindon on the B4192

A regular contender for the Best-Kept Village in Wiltshire Award, renowned in
the 17th and 18th centuries for its bell founding, millinery and cloth-weaving.

CHILTON FOLIAT
MAP 3 REF F5

9 miles SE of Swindon on the B4192

The B4192 crosses the River Kennet near the village of Chilton Foliat with its
13th century flint and stone church and timber-framed cottages. Nearby **Littlecote
House** is a Tudor mansion (now a hotel), where Henry Vlll and Jane Seymour
were early visitors. A Roman villa was discovered nearby in the 18th century, but
was reburied, to be excavated in the years from 1977.

WROUGHTON
MAP 3 REF E5

3 miles S of Swindon on the A4361

Wroughton Airfield, with its historic World War ll hangars, is home to the
National Museum of Science and Industry's collection of large aircraft, and
the road transport and agricultural collection. The museum is open on event
days at the airfield. Tel: 01793 814466.

Nearby **Clouts Wood Nature Reserve** is a lovely place for a ramble, and a
short drive south, by the Ridgeway, is the site of **Barbury Castle**, one of the
most spectacular Iron Age forts in southern England. The open hillside was the
scene of a bloody battle between the Britons and the Saxons in the 6th century;
the Britons lost and the Saxon kingdom of Wessex was established under King
Cealwin. The area around the castle is a country park.

BROAD HINTON
Map 3 ref E5
5 miles S of Swindon off the A4361

In the church at Broad Hinton is a memorial to Sir Thomas Wroughton, who returned home from hunting to find his wife reading the Bible instead of making his tea. He seized the Bible and flung it into the fire; his wife retrieved it but in doing so severely burnt her hands. As punishment for his blasphemy Sir Thomas's hands and those of his four children withered away. The monument shows the whole handless family and a Bible with its corner burnt off.

CLYFFE PYPARD
Map 3 ref E5
6 miles SW of Swindon off the A4361

A couple of miles west of Broad Hinton on a steep slope that affords splendid views traces of a long-deserted medieval village can be seen. Sir Nikolaus Pevsner, the renowned architectural historian, lived nearby and is buried in the churchyard.

LYDIARD TREGOZE
Map 3 ref E4
2 miles W of Swindon off the A3102

On the western outskirts of Swindon, **Lydiard Park** is the ancestral home of the Viscounts Bolingbroke. The park is a delightful place to explore, and the house, one of Wiltshire's smaller stately homes, is a real gem, described by Sir Hugh Casson as "a gentle Georgian house, sunning itself as serenely as an old grey cat". Chief attractions inside include the little blue Dressing Room devoted to the 18th century society artist Lady Diana Spencer, who became the 2nd Viscountess Bolingbroke. St Mary's Church, next to the house, contains many monuments to the St John family, who lived here from Elizabethan times. The most striking is the **Golden Cavalier**, a life-size gilded effigy of Edward St John in full battledress (he was killed at the 2nd Battle of Newbury in 1645).

Golden Cavalier, Lydiard Park

PURTON
Map 3 ref E4
3 miles W of Swindon off the B4553

A long, sprawling community whose part-Norman Church of St Mary is very unusual in having a central spire and a west tower. The windows incorporate

some rare fragments of medieval glass, and there are some striking wall paint-ings, notably a 17th century depiction of the Death of the Virgin. **Purton Museum**, in the public library, has a collection of neolithic flint tools and shards of pottery from Purton's Roman kilns; also agricultural tools, dairy equipment and archive photographs.

WOOTTON BASSETT MAP 3 REF E4
3 miles W of Swindon off the A3102

A small town with a big history. Records go back to the 7th century, and in 1219 King Henry lll granted a market charter (the market is still held every Wednes-day). The first known mayor of Wootton Bassett was John Woolmonger, appointed in 1408. A later mayor was acting as town magistrate when a drunk was brought before him after an overnight drinking spree. When asked by the mayor whether he pleaded guilty to drunkenness, the man said "You knows your worship was just as drunk as I was" (he was on the same spree). "Ah well", said the mayor. "That was different. Now I am the mayor and I am going to fine you five shillings."

The most remarkable building in Wootton is the **Old Town Hall**, which stands on a series of stone pillars, leaving an open-sided ground-floor area that once served as a covered market. The museum above, open on Saturday morn-ings, contains a rare ducking stool, silver maces and a mayoral sword of office.

A section of the **Wilts & Berks Canal** was recently restored at **Templars Fir**, and in May 1998 about 50 boats of all kinds were launched on the canal and a day of festivities was enjoyed by all. The railway station, alas, has not been revived after falling under the Beeching axe in 1966.

MALMESBURY

England's oldest borough and one of its most attractive. The hilltop town is dominated by the impressive remains of the **Benedictine Malmesbury Abbey**, founded in the 7th century by St Aldhelm. In the 10th century, King Athelstan, Alfred's grandson and the first Saxon king to unite England, granted 500 acres of land to the townspeople in gratitude for their help in resisting a Norse inva-sion. Those acres are still known as King's Heath and are owned by 200 residents who are descended from those far-off heroes. Athelstan made Malmesbury his capital and is buried in the abbey, where several centuries later a monument was put up in his honour.

The abbey tower was the scene of an early attempt at human-powered flight when in the early part of the 11th century Brother Elmer strapped a pair of wings to his arms, flew for about 200 yards and crashed to earth, breaking both legs and becoming a cripple for the rest of his long life. The flight of this intrepid cleric, who reputedly forecast the Norman invasion following a sighting of

Halley's Comet, is commemorated in a stained glass window. The octagonal **Market Cross** in the town square is one of many interesting buildings that also include the Old Stone House with its colonnade and gargoyles, and the arched Tolsey Gate, whose two cells once served as the town jail.

In the **Athelstan Museum** are displays of lace-making, costume, rural life, coins, early bicycles and tricycles, a manually-operated fire engine, photographs and maps. Personalities include a local notable, the philosopher Thomas Hobbes.

Market Cross, Malmesbury

A more recent piece of history concerns the **Tamworth Two**, the pigs who made the headlines with their dash for freedom. Their trail is one of many that can be followed in and around the town.

The **Abbey House Gardens** offer five acres of horticulture and history, planted for continuous spring to autumn colour. Adjacent to the Abbey and developed round a late-Tudor house, it has been described as one of the best gardens in the country. Abbey House dates from 1545 and was built on the remains of a 13th century Abbey building. Owners Ian and Barbara Pollard and their family came to live here in 1994. Together their passion for gardening has led to a superb planting scheme with formal areas, yew hedges, orchard, herb garden, herbaceous borders, laburnum tunnel, stew pond and loggia. A massive new planting scheme scheduled to be complete for the new millennium features 2,000 different roses, 2,000 herbs and an expanding collection of trees and shrubs. Lovely walks take the visitor past the river, many rare plants, woodland, fruit and foliage plants and local wildlife. This is a garden that is worth visiting again and again, a truly superb example of the art of Gardening. Open daily Easter - mid-October, 11 am - 6 pm. Light refreshments are available and there are plants for sale.

The Abbey House Gardens, Market Cross, Malmesbury,
Wiltshire SN16 9AS Tel: 01666 822212

AROUND MALMESBURY

CASTLE COMBE MAP 3 REF C5
8 miles SW of Malmesbury on the B4039

The loveliest village in the region, and for some the loveliest in the country, endlessly photographed, flooded with tourists at peak times, and used in the film *Dr Doolittle*, when the gentle By Brook became a busy harbour. It was once a centre of the prosperous wool trade, famed for its red and white cloth, and many of the present-day buildings date from the 15th and 16th centuries, including the Perpendicular Church of St Andrew, the covered market cross and the manor house, which was built with stones from the Norman castle that gave the village its name. One of the Lords of the Manor in the 14th century was Sir John Fastolf, who was reputedly the inspiration for Shakespeare's Falstaff. A small museum dealing with the village's history is open on summer Sunday afternoons. A little way east of the village, by the B4039, is Castle Combe motor-racing circuit, host to a dozen meetings a year, from Formula Ford and saloons to Formula 3 and TVR Tuscans. A racing school offers enthusiasts the chance to drive a racing car round the circuit.

EASTON GREY MAP 3 REF D4
3 miles W of Malmesbury on the B4040

Here the southern branch of the River Avon is spanned by a handsome 16th
century bridge with five stone arches. A manor house has overlooked the village
since the 13th century, and the present house, with a classical facade and an
elegant covered portico, dates from the 18th century. It was used as a summer
retreat by Herbert Asquith, British Prime Minister from 1908 to 1916, and in
1923 the Prince of Wales was in residence during the Duke of Beaufort's hunt-
ing season at Badminton.

SHERSTON MAP 3 REF C4
4 miles W of Malmesbury on the B4040

The Rattlebone Inn, run in fine style by David Baker, stands at the very heart of
the ancient settlement of Sherston Magna. It was built in the 16th century and is
one of the oldest buildings in the village. There's a splendid atmosphere through-
out, and the roomy bars are rich in traditional appeal, with beamed ceilings and
lots of interesting bric-a-brac. The Rattlebone is open all day, every day, with
food served every lunchtime and evening and all day on Sunday. The menus
make mouthwatering reading with such dishes as smoked trout roulade with
crème fraiche and herbs, red pepper and mushroom risotto and collops of fillet
steak with green peppercorns, brandy and double cream. Sunday lunch with

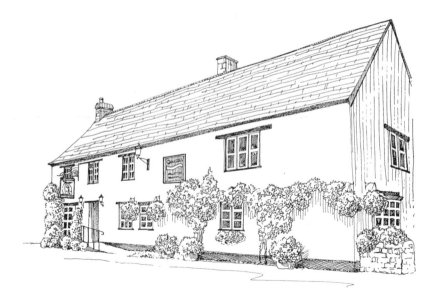

The Rattlebone Inn, Church Street, Sherston, Wiltshire SN16 0LR
Tel/Fax: 01666 840871

roasts is an occasion to savour, and puddings keep up the good work with the likes of pecan nut and treacle pie or raspberry whim-wham (raspberries, whipped cream and meringue pieces). On the drinking side are real ales, a good selection of wines and no fewer than 70 malt whiskies. Pub games include skittles (six teams and their own alley), darts and pool, played on a round table.

The inn's unique name derives from a story about the Battle of Sherston, in which Edmund Ironed defeated Cannot in 1016. John Rattlebone, a local hero, fought bravely in the battle, sustaining a grave wound which he covered with a tile, stemming the flow of blood until the battle was won. Legend has it that he was brought to the site on which the inn now stands and soon expired from his wound.

SUTTON BENGER Map 3 ref D5
6 miles S of Malmesbury off the B4069

The village where JS Fry of chocolate fame was born. Handy for the M4 (J17), it is also on the scenic route from Malmesbury to Chippenham.

Built in 1726 by the parents of JS Fry of chocolate fame (he was born in the house), **The Vintage Inn** was a chocolate factory, a wine store, a village shop and a butchers before becoming a public house in 1921. Bob and Jan Causer bought the premises in 1996, since when local customers, local groups, travellers and tourists have enjoyed their hospitality, their ales and their food. The food, prepared and freshly cooked every day, can be enjoyed in either the Art Gallery restaurant (no smoking) or the vaulted area of the main bar. Favourites on the menu include Scottish beef steaks, savoury pies, rack of lamb and cod

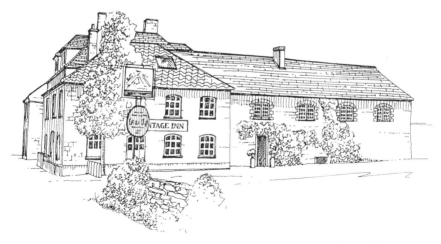

**The Vintage Inn, Seagry Road, Sutton Benger, Near Chippenham,
Wiltshire SN15 4RY Tel: 01249 720247 Fax: 01249 721173**

fillet with mushrooms, wine and cream. The fine fare is accompanied by a good choice of wines, many of them chosen by customers on wine tasting evenings. The inn also offers comfortable overnight accommodation in two double rooms, one en suite, the other with a separate private bathroom. More rooms are planned.

GRITTLETON MAP 3 REF C5
7 miles S of Malmesbury off the A429

Grittleton House (see Garden House below) was designed for Joseph Neeld (see The Neeld Arms below) by James Thomson. He was also responsible for St Margaret's Church at nearby **Leigh Delamere**. Built in 1846, it features a splendid bellcote and some beautiful colours in the west window.

The **Garden House**, built in 1904, stands in the grounds of Grittleton House in the heart of the Wiltshire Cotswold countryside. Audrey and Chris Pitman have lived in this beautiful, tranquil setting since 1974 and make available six bedrooms for B&B guests - a family room, a twin and four doubles, four of them en suite, two with separate bathrooms. All are well equipped, with TV, tea/coffee-makers, hairdryers and bathrobes. There is a television room and lounge

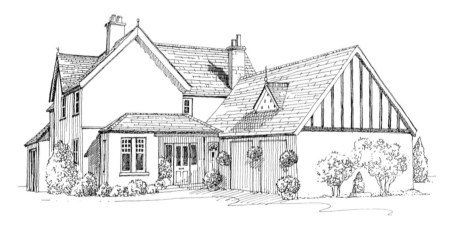

**The Garden House, Grittleton, Near Chippenham, Wiltshire SN14 6AJ
Tel: 01249 782507**

for residents, but when the sun shines the place to be is the magnificent garden with its feature Victorian pond. A full English breakfast makes excellent use of fresh local produce. A lovely peaceful place to stay, and a popular base with tourists and visitors to Castle Combe (motor racing) and Badminton (horse trials).

In March 1999, Bill and Sara Clemence moved from Kent and bought **The Neeld Arms**, a charming 17th century Cotswold stone inn situated in an unspoilt village just north of the M4 (leave at J17). Bill was a wine importer, Sara an expert in the field of Oriental antiques, but their interests now take second place to the business of running this lovely local. Delicious home-made meals are served every evening, and lunchtime Saturday and Sunday. Typical dishes include warm goat's cheese salad, pan-fried salmon with ratatouille and chicken basquaise served with a confit of carrots and couscous. Vegetarian main courses are always available, along with a snack menu for lighter appetites. There's a worldwide wine list and a good choice of real ales. High-quality B&B accommodation comprises six rooms - three twins, a family room and two doubles, one

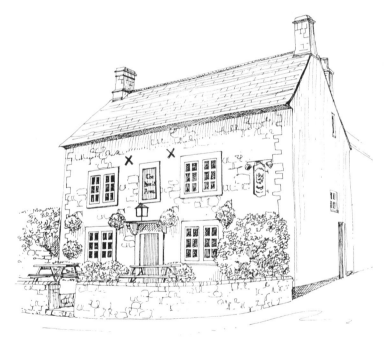

The Neeld Arms, Grittleton, Near Chippenham, Wiltshire SN14 6AP
Tel: 01249 782470 Fax: 01249 782358 e-mail: neeldarms@genie.co.uk

with a four-poster bed. The rooms, all en suite and equipped with TV, radio-alarm and tea/coffee-making facilities, are very comfortable and cosy, in keeping with the character of the inn, whose bar, with its stone walls, beams, inglenook and memorabilia, has a terrific atmosphere, especially in the evening. The Neeld Arms is named after Joseph Neeld, who in the first part of the 19th century built homes in Grittleton, Sevington and Alderton and was MP for Chippenham.

LITTLE SOMERFORD

MAP 3 REF D4

4 miles E of Malmesbury off the B4042

A quiet village on the scenic route between Malmesbury and Chippenham.

Eric Lepine, chef-manager of **Simply Oz**, has a wealth of experience that includes top restaurants in France and a spell at the renowned Hole in the Wall in Bath. Here, in a quiet village off the B4042 Malmesbury-Wootton Bassett road, in a brick and stone building that was previously a pub, he is cooking up a storm with a new approach to contemporary Australian cuisine, producing an

**Simply Oz, The Hill, Little Somerford, Near Chippenham,
Wiltshire SN15 5JP Tel: 01666 826535**

exciting blend of fresh, healthy dishes under the banner of 'Pacific Rim'. Some dishes are baked in a wood-burning oven, while others are grilled on the barbie - diners can sample the delights of not only steaks and chicken, but also of shark and swordfish, ostrich, kangaroo and even crocodile. Almost everything is a little bit out of the ordinary, even the pizzas, like the Australian with a topping of lamb, ostrich, mushrooms, shallots, cherry tomatoes and mozzarella. The Australian theme extends to the decor in the bar, with seats for 40, and the 60-cover restaurant. Simply Oz is fresh, new and fun, with very pleasant staff and a great atmosphere.

CHIPPENHAM

This historic settlement on the banks of the Avon was founded around 600 by the Saxon king Cyppa. It became an important administrative centre in King Alfred's time and later gained further prominence from the wool trade. It was a major stop on the London-Bristol coaching run and is served by the railway between the same two cities. Buildings of note include the Church of St Andrew (mainly 15th century) and the half-timbered Hall, once used by the burgesses and bailiffs of the Chippenham Hundred and latterly a museum (as we went to press the museum was due to move into a Heritage Centre in the market place). At Hardenhuish Hall on the edge of town, John Wood the Younger of Bath fame built the Church of St Nicholas; completed in 1779, it is notable for its domed steeple and elegant Venetian windows.

In the flood plain to the east of Chippenham stands the 4½ mile footpath known as **Maud Heath's Causeway**. This remarkable and ingenious walkway consisting of 64 brick and stone arches was built at the end of the 15th century at the bequest of Maud Heath, who spent most of her life as a poor pedlar trudging her often muddy way between her village of Bremhill and Chippenham. She died a relatively wealthy woman, and the land and property she left in her will provided sufficient funds for the upkeep of the causeway, which is best seen near the hamlet of Kellaways. A statue of Maud, basket in hand, stands overlooking the flood plain at Wick Hill.

AROUND CHIPPENHAM

CALNE Map 3 ref D5
5 miles E of Chippenham on the A4

A former weaving centre in the valley of the River Marden; the prominent wool church reflects the prosperity of earlier times. One of the memorials in the church is to Dr Ingenhousz, who is widely credited with creating a smallpox vaccination before Jenner.

A short distance from Calne, to the west, stands **Bowood House**, built in 1625 and now a treasury of Shelborne family heirlooms, paintings, books and furniture. In the Bowood Laboratory Dr Joseph Priestley, tutor to the 1st Marquess of Lansdowne's son, conducted experiments that resulted in the identification of oxygen. The house is set in lovely Capability Brown grounds with a lake and terraced garden. The mausoleum was commissioned in 1761 by the Dowager Countess of Shelborne as a memorial to her husband and was Robert Adam's first work for them. A separate woodland garden of 60 acres, with azaleas and rhododendrons, is open from late April to early June.

The **Atwell Motor Museum**, on the A4 east of Calne, has a collection of over 70 vintage and classic cars and motorcycles from the years 1924 to 1983.

CHERHILL MAP 3 REF E5
7 miles E of Chippenham on the A4

Cherhill was another stop on the London-Bristol coaching route, and, for a time in the 18th century, one which caused passengers some trepidation. The Cherhill gang regularly held up and robbed the coaches, and the fact they carried out their crimes wearing nothing at all made identification more than a little tricky.

On the chalk ridge south of the village by the ancient earthwork of **Oldbury Castle** (National Trust) is another of Wiltshire's famous **white horses**. This one was built in 1790 under the instruction of Dr Christopher Alsop, known as "the mad doctor". For some years the horse's eye, four feet across, was filled with upturned bottles which sparkled in the sunlight.

SANDY LANE MAP 3 REF D5
4 miles SE of Chippenham on the A342

A mile south of Bowood House, this charming village has some traditional thatched ironstone cottages and an unusual thatched Victorian church.

LACKHAM MAP 3 REF D5
3 miles S of Chippenham on the A350

Lackham Gardens, in the grounds of an agricultural college, are part of an estate old enough to have been mentioned in the Domesday Book. The grounds, modelled in the style of Capability Brown, incorporate a rose garden, glass-houses, a long herbaceous border and a series of walled gardens renowned for their summer vegetables and striking flower displays.

LACOCK MAP 3 REF D5
4 miles S of Chippenham on the A350

The National Trust village of Lacock is one of the country's real treasures. The quadrangle of streets - East, High, West and Church - holds a delightful assortment of mellow stone buildings, and the period look (no intrusive power cables or other modern-day eyesores) keeps it in great demand as a film location. Every building is a well-restored, well-preserved gem, and overlooking everything is **Lacock Abbey**, founded in 1232 by Ela, Countess of Salisbury in memory of her husband William Longsword, stepbrother to Richard the Lionheart. In common with all monastic houses Lacock was dissolved by Henry VIII, but the original cloisters, chapter houses, sacristy and kitchens survive.

Lacock Abbey

Much of the remainder of what we see today dates from the mid 16th century, when the abbey was acquired by Sir William Sharington. He added an impressive country house and the elegant octagonal tower that overlooks the Avon. The estate next passed into the hands of the Talbot family, who held it for 370 years before ceding it to the National Trust in 1944.

The most distinguished member of the Talbot family was the pioneering photographer William Henry Fox Talbot, who carried out his experiments in the 1830s. The **Fox Talbot Museum** commemorates the life and achievements of a man who was not just a photographer but a mathematician, physicist, classicist, philologist and transcriber of Syrian and Chaldean cuneiform. He also remodelled the south elevation of the abbey and added three new oriel windows. One of the world's earliest photographs shows a detail of a latticed oriel window of the abbey; made in 1835 and the size of a postage stamp, it is the earliest known example of a photographic negative.

Lacock Village Street

One of the area's loveliest and most atmospheric places to stay or enjoy a meal can be found in Lacock's main Church Street. The unusually named **At the Sign of the Angel** is a superb 14th century half-timbered inn which has been run as a top-class guesthouse and restaurant by the Levis family for over four decades. With its low doorways, timber beams, oak panelling, antique furniture and open log fires, the interior is filled with genuine character and charm. The establishment is now jointly owned and run by Lorna Levis and George Hardy, friendly and experienced hosts who provide a warm welcome, charming hospitality and the very finest food and drink. At the Sign of the Angel is renowned for its outstanding cuisine, all of which is freshly prepared using fresh local pro-

At the Sign of the Angel, 6 Church St, Lacock, Near Chippenham, Wiltshire SN15 2LB Tel: 01249 730230 Fax: 01249 730527

duce wherever possible. Diners can eat inside, or have lunch or a quiet drink by the stream at the foot of the beautiful flower-filled garden to the rear. The accommodation, too, is of a very high standard. The guest bedrooms are delightfully decorated and full of atmosphere, yet are equipped with the full range of up-to-date facilities, including en suite bathrooms. Six of the ten bedrooms are located in the main inn and four in a lovely cottage set within the garden.

The Stable Tea Rooms, formerly the stables next to the Red Lion pub at the other end of the village, have been tastefully renovated to a high standard, with seating inside and out. All the produce is home-made, including superb baking and preserves, and the friendly atmosphere is in keeping with the excellence and high quality that are the hallmark of At the Sign of the Angel. Tel: 01249 730585.

Every building and every enterprise in Lacock is full of interest, and none more so than **The Lacock Bakery**. Run by Jean Sheard and her daughter Debbie, this celebrated bakery and coffee shop occupies a lovely old building dating from the 14th century and leased from the National Trust. Fresh bread is baked

Lacock Bakery, 8 Church Street, Lacock, Near Chippenham, Wiltshire SN15 2LB Tel: 01249 730457

on the premises each day, along with a wonderful assortment of home-made cakes, scones and pastries. Specialities of the house include a delicious Lardy Cake, which is made to a secret recipe, and a range of English preserves which are prepared using the finest traditional ingredients. Visitors can enjoy an excellent morning coffee in the lovely atmosphere of this friendly family-run establishment, where Carole always greets customers warmly and where the pleasant, helpful staff are clothed in Victorian dress. Continuing the family connection is Jean's eldest daughter Jacqui, who in partnership with David owns Sheard & Hudson, a company based in the Bath Brewery producing some of the design and artwork for the Bakery's signs and labels.

Aura Health and Beauty is situated on the first floor above the Bakery. Run by Jean's daughter Debbie, a fully qualified beauty therapist, it has a relaxing treatment room and offers a range of Decleor products among the goods for sale. Tel: 01249 730174.

After a coffee break many visitors take a short stroll to the courtyard behind the Bakery, where **Nightingales**, a classic clothes shop for ladies, is located, and where Jennifer is one of the charming assistants. The shop has been tastefully

converted from an old (believed to be part 14th century) wash house. Nightingales is renowned for quality and has proved very popular with tourists. It is open Monday to Saturday from 10 till 5. Tel: 01249 730888

Situated a little further along Church Street, **King John's Hunting Lodge** has parts dating from the turn of the 13th century, which almost certainly makes it the oldest house in Lacock. Much of its original cruck beam structure can be seen on the first floor, while the rear of the building was added in Tudor times. King John was Lord of the Manor of nearby Melksham and frequently indulged his passion for hunting in the adjoining forest. There being no manor house at Melksham, it is likely that the King made regular use of his hunting lodge at

King John's Hunting Lodge, 21 Church Street, Lacock, Near Chippenham, Wiltshire SN15 2LB Tel & Fax: 01249 730313

Lacock. Eight centuries later, the tradition of hospitality is maintained by present-day proprietor Margaret Vaughan, who offers comfortable accommodation in the relaxed and friendly atmosphere of this delightful refurbished property. A real sanctuary from the stresses and strains of modern life, the guest rooms are equipped with en suite bathrooms and tea-coffee facilities, and a full English breakfast with home-made breads is served at a time to suit guests. Evening meals, if required, can be enjoyed in one of the many nearby pubs and restaurants. King John's Hunting Lodge is renowned for its traditional English cream teas, which are served in the delightful secluded garden in summer and in the Garden Tearoom, with its roaring log fire, in winter. The menu features local clotted and Jersey creams and home-made jams and preserves, along with scones, cakes, cheese muffins and teacakes baked daily on the premises.

The **Carpenters Arms** is a stone building, part 13th century, part 16th, that was once a stopping place on the London-Bath coach run. The coaches that stop here nowadays are the motorised variety, bringing visitors to the marvellous village of Lacock and to the hospitality of landlords Frank and Nathalie Galley. Ancient beams hark back to the days when it was known as The White Hart, from the badge of King Richard ll, and open fires keep things cosy when the wind blows. Nathalie does all the cooking for the 40-cover non-smoking restaurant, using the best fresh raw materials including home-grown vegeta-

The Carpenters Arms, 22 Church Street, Lacock, Wiltshire SN15 2LB
Tel: 01249 730203

bles. The menu is impressively varied, with a particularly generous selection of vegetarian main courses. There's also a good choice of real ales. On the social side, the pub fields two teams (including the landlords) in the local winter darts league. Lacock deserves more than a day trip, and for guests staying overnight the Carpenters Arms has three comfortable en suite bedrooms.

A redbrick slate-roofed lodge dating from 1890, **Lower Lodge Guest House** stands in a beautiful ¾ acre garden on Bowden Hill, just above the village of Lacock. The setting overlooking Avon Vale is truly magnificent, fully justifying the boast that it offers "the best view in Wiltshire". Katharine Duboulay, ten years at Lower Lodge, has been offering bed and breakfast accommodation for

**Lower Lodge Guest House, Bowden Hill, Lacock, Wiltshire SN15 2PP
Tel: 01249 730711**

the past four in three very attractively decorated bedrooms, one double en suite and two twins sharing a bathroom. A full English breakfast starts the day. The quiet, relaxed atmosphere attracts guests from all parts of the world.

CORSHAM
MAP 3 REF D5

3 miles SW of Chippenham off the A4

"Corsham has no match in Wiltshire for the wealth of good houses", asserted Pevsner. Many of the town's fine buildings are linked to the prosperity that came from the two main industries of cloth-weaving and stone-quarrying. **Corsham Court**, based on an Elizabethan house dating from 1582, was bought by Paul Methuen in 1745 to house a fabulous collection of paintings and statuary. The present house and grounds are principally the work of Capability Brown, John Nash, Thomas Bellamy and Humphrey Repton a top-pedigree setting for the treasures inside, which include paintings by Caravaggio, Fra Filippo Lippi, Reynolds, Rubens and Van Dyke and furniture by Chippendale. Among other important buildings in Corsham are the row of 17th century Flemish weavers' cottages, the old market house and the superb almshouses built in 1668 by Dame Margaret Hungerford. A unique attraction is the **Underground Quarry Centre**, the only shaft stone mine open to the public in the world, opened in 1810 and reached by 159 steps. Helmets, lamps and an experienced guide are provided for this fascinating underground tour.

In 1998 Gill Habgood, Mark and Beau moved from Oxford, fell in love with Corsham and bought **Cheviot House**, a handsome Georgian building in a quiet

part of the main street. Gill had offered B&B accommodation in Oxford and continues to do so here, in two en suite bedrooms - a double/family room and a twin decorated and furnished in keeping with the character of the house but also provided with modern amenities such as remote-control TVs. The original rubble wall of the house, once a schoolhouse, is still visible, but the rest of the old core was made 'grand' with ashlar frontage, moulded cornices and parapets when the local stone industry expanded. Cheviot House was named after a type

Cheviot House, 76 High Street, Corsham, Wiltshire SN13 0HF
Tel: 01249 713664 Fax: 01249 701866

of tweed by a master tailor who owned the property before the First World War. Behind the house, which is Grade ll listed, are lovely gardens, where Pierre the peacock struts his stuff, and an old malthouse, now residential, which was opened by that same tailor, Alf Butt, and later saw service as a place of recreation for war casualties, a glove factory, a cardboard box factory and a laundry.

BOX MAP 3 REF C5
6 miles SW of Chippenham on the A4

Another really delightful and photogenic spot, known for the quality of its Bath stone (still quarried) and for one of the most remarkable feats of civil engineering of its day, **Box Tunnel**. The 1.8 mile-long railway tunnel took five years to excavate and when completed, in 1841, was the longest such tunnel in the

world. According to local legend the sun shines through its entire length on only one occasion each year - sunrise on April 9, the birthday of its genius creator Isambard Kingdom Brunel.

Pat and Gordon Taylor offer high-quality bed and breakfast accommodation at **Lorne House**, which stands by the A4 at the Chippenham end of the village. Built of Bath stone in the middle of the 19th century, it is known locally as the "Home of Thomas the Tank Engine", for it was once the home of the Reverend Awdry, Thomas's creator. There are four letting rooms, all with en suite facilities and three of them big enough for family occupation, with both a single and a double bed. Cots and Z-beds can be made available for younger family mem-

Lorne House, London Road, Box, Wiltshire SN13 8NA
Tel/Fax: 01225 742597

bers. The rooms are equipped with TVs, radio-alarms and tea/coffee-makers. There is also a large guest lounge and breakfast room, and a lovely garden with a tree house, swings and slides, and a covered pond. The Taylors also own the White Horse pub in the village of Biddestone, a short drive northeast of Box. The pub offers a selection of real ales and a very extensive menu.

MAP 3 REF D5

WHITLEY
5 miles SW of Chippenham on the B3353

A quiet location away from major roads, but Chippenham and Bath are easily accessible.

Martin and Debbie Still, along with chef Jonathan Furby, have in a short time turned **The Pear Tree at Whitley** into one of the very best pub-restaurants in the region, and already the recipient of national accolades. Set in four acres of grounds in the middle of the village, The Pear Tree is a fine old stone-tiled building which the owners have lovingly restored to its former splendour. It also retains its original role as the village local, but what marks it out as something really special is its marvellous food. A la carte and fixed-price menus are

The Pear Tree at Whitley, Top Lane, Whitley, Near Melksham, Wiltshire SN12 8QX Tel: 01225 709131

far removed from traditional pub grub, taking their inspiration from around the globe and applying it to the finest local produce. Just a few typical dishes from the ever-changing and always exciting selection: ham and leek terrine on a smoked bacon and new potato salad with a caper dressing; poached monkfish in a tomato and lime relish with crispy fried vegetables; lamb and rosemary sausage with wild mushrooms and a Madeira sauce; Pimms cheesecake with a strawberry and mint compote. Martin and Debbie are planning to have high-quality en suite accommodation ready for the summer of 2000.

MELKSHAM
7 miles S of Chippenham on the A350

MAP 3 REF D6

An important weaving centre which also, at the very beginning of the 19th century, had a brief fling at being a spa town. It didn't make much of a splash, being unable to compete with nearby Bath, so it turned to manufacturing and was given a boost when the **Wiltshire & Berkshire Canal** was opened. That canal, built between 1795 and 1810, linked the Kennet & Avon Canal with Abingdon, on the Thames. The canal was abandoned in 1914, but much of its path still exists in the form of lock and bridge remains, towpaths and embankments. A walk along "the lost waterway of Melksham" has been mapped out by the Wiltshire & Berkshire Canal Amenity Group.

HOLT
9 miles SW of Chippenham on the B3107

MAP 3 REF D6

The village was once a small spa, and the old mineral well can still be seen in a factory in the village. Right at the heart of the village is **The Courts**, a National Trust English country garden of mystery with unusual topiary, water gardens and an arboretum. The house, where local weavers came to settle disputes until the end of the 18th century, is not open to the public.

John & Liz Moody, from one of Holt's best-known families, have been at **Gaston Farm** for many years, and the cottage they lived in when they were first married is now a holiday apartment of charm and character. Part of a farmhouse dating from the 16th century, it consists of a large lounge/dining room with an open fire; two generously proportioned upstairs bedrooms; a shower room and

Gaston Farm, Holt, Near Trowbridge, Wiltshire BA14 6QA
Tel: 01225 782203

separate toilet; and an airy kitchen with light oak-finish units, cooker, micro-wave, fridge and washing machine. A sofa in the lounge converts to a bed for an extra guest, and a cot is available. Gaston Farm, at the western end of the village, is a 170-acre working farm with a Charolais suckler herd. Part of the meadowland is bounded by the River Avon, on which the farm has fishing rights. Off-road parking at the side of the house.

When Alexander Venables and Alison Ward-Baptiste took over **The Tollgate** in July 1999 they brought years of experience with them. Alexander trained at The Savoy, Chester Grosvenor and also worked at the five star, one michelin Cliveden (famous for the Profumo affair). He later became head chef at Lucknam Park Hotel in Wiltshire where he gained a Michelin star for his fine cuisine Alison has had a varied career that was always involved with people, so she is a natural for running front of house. The sturdy stone building dates back to the 17th century, and in the bars, with open fires and original beams, the atmosphere is calm and civilised, making them ideal places to relax over a drink and a

The Tollgate Inn, Ham Green, Holt, Near Trowbridge, Wiltshire BA14 6PX
Tel/Fax: 01225 782326

chat. Paintings by local artists hang in the upstairs restaurant, where the polished wood floor and the handsome drapes are in keeping with the age and character of the place. Alexander's main menu is full of mouthwatering choices, with typical dishes running from risotto of mussels in a white wine and tarragon sauce through sautéed chicken breast with braised pearl barley, lemon and rosemary to banana crème brûlée with home-made coconut biscuits. To accompany the superb food is an adventurous wine list that encircles the globe. The restaurant is a no-smoking zone, but smoking is allowed in the buttery. The Tollgate is the last building in the village on the Bradford/Trowbridge side, a short walk up from the National Trust gardens of The Courts.

GREAT CHALFIELD
MAP 3 REF C6
9 miles SW of Chippenham off the B3107/B3109

Great Chalfield Manor, in the care of the National Trust, is a fascinating moated manor house built in the 1480s, with formal lawns and a tiny parish church. Exceptional internal features include an impressive great hall and an original Tudor screen.

BIDDESTONE
MAP 3 REF D5
3 miles W off Chippenham off the A420

Cotswold stone cottages, old farmhouses and a 17th century manor cluster round a delightful village green and duck pond. In this lovely old village, a short drive west of Chippenham off the A4 or A420, Penny Lloyd provides quiet, comfortable B&B accommodation in **The Granary**, a slate-roofed Cotswold stone house built 200 years ago. Beautifully decorated throughout, it has two letting bedrooms, a double and a twin, one with en suite facilities. There are radios and tea-makers in both rooms, and guests have the use of a sitting room, where

**The Granary, Cuttle Lane, Biddestone, Wiltshire SN14 7DA
Tel: 01249 715077**

books and a TV are at their disposal. Guests are also very welcome to stroll round the lovely secluded garden. The Granary is a great place for a quiet, relaxing break, with a civilised atmosphere and a charming owner who is sure to make your stay enjoyable.

BRADFORD-ON-AVON

An historic market town at a bridging point on the Avon, which it spans with a superb nine-arched bridge with a lock-up at one end. The town's oldest building is the **Church of St Lawrence**, believed to have been founded by St Aldhelm around 700. It 'disappeared' for over 1,000 years, when it was used variously as a school, a charnel house for storing the bones of the dead, and a residential dwelling. It was re-discovered by a keen-eyed clergyman who looked down from a hill and noticed the cruciform shape of a church. The surrounding buildings were gradually removed to reveal the little masterpiece we see today. Bradford's Norman church, restored in the 19th century, has an interesting memorial to Lieutenant-General Henry Shrapnel, the army officer who, in 1785, invented

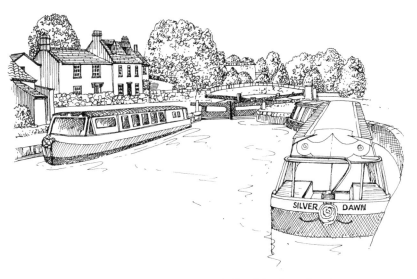

Kennet & Avon Canal, Bradford-on-Avon

the shrapnel shell. Another of the town's outstanding buildings is the mighty **Tithe Barn**, once used to store the grain from local farms for Shaftesbury Abbey, now housing a collection of antique farm implements and agricultural machinery. The centrepiece of the museum in Bridge Street is a pharmacy which has stood in the town for 120 years before being removed lock, stock and medicine bottles to its new site.

Walk through the door of **The Bridge Tea Rooms** and you step back in time to the glorious Victorian era. Housed in a beautiful 17th century Cotswold stone building, it has great character, elegant furnishings and lots of Victorian memorabilia. Francine Whale bought the property - previously an antique shop - in 1989 and has turned it into one of the country's very best tea rooms, winner of

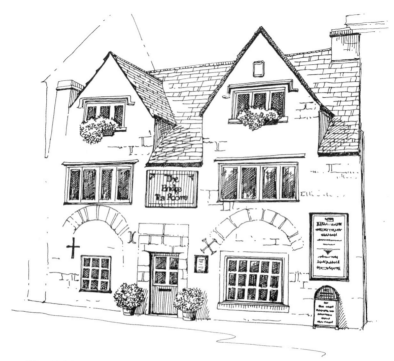

The Bridge Tea Rooms, 24a Bridge Street, Bradford-on-Avon, Wiltshire BA15 1BY Tel: 01225 865537

many awards and voted the Tea Council's UK Top Tea Place of the Year in 1998. Waitresses in Victorian costume serve a wonderful array of cakes, pastries, snacks and light meals. All the baking is done on the premises by pastry chef Kevin, and among the savoury favourites are toasted sandwiches, rarebits (six varieties!), and filled jacket potatoes. For larger appetites, perhaps salmon and mushroom pasta, savoury pancakes or a terrific casserole of pork, apples and cider topped with a herb scone. There's an impressive range of teas and coffees, and visitors are welcome to bring their own wine - no corkage. Tourists from around the world visit Bradford-on-Avon, and this marvellous establishment in the heart of town is deservedly high on many lists. No smoking.

Leigh House is a 16th century farmhouse standing on the B3105 north of town in six acres of grounds, with views across fields and paddocks. Alan Griffiths and Peter Vincent bought the house in 1995 as a run-down farmhouse and have invested a great deal of time and effort in restoring it to its present superb state. It's a quiet, relaxed and civilised place for a break, and the owners offer both B&B and self-catering accommodation. Three bedrooms, all with en suite bath-

Leigh House, Leigh Road West, Bradford-on-Avon, Wiltshire BA15 2RB
Tel: 01225 867835

rooms and views of the garden or the Westbury hills, are in the main house, while two further rooms are in the converted Bakehouse, which retains many original features including the open hearth fireplace and ovens for baking and smoking. Here there are two bedrooms, a ground-floor double and a large first-floor room with double and single beds. A sofa bed in the sitting room allows up to seven guests to stay in the Bakehouse, which has its own kitchen for self-catering. The Bakehouse has views into the main courtyard and its own door into the walled garden. The house is beautifully decorated throughout, and very comfortable - in winter a fire blazes in the magnificent inglenook fireplace in the lounge. With a little advance notice guests in either part of the house can enjoy a home-cooked meal at a long chestnut table in the candle-lit dining room.

Off the A363 on the northern edge of town, **Barton Farm Country Park** offers delightful walks in lovely countryside by the River Avon and the Kennet & Avon Canal. It was once a medieval farm serving Shaftesbury Abbey. Barton Bridge is the original packhorse bridge built to assist the transportation of grain from the farm to the tithe barn.

Half a mile south of town by the River Frome is the Italian-style **Peto Garden** at **Iford Manor**. Famous for its romantic, tranquil beauty, its steps and terraces, statues, colonnades and ponds, the garden was laid out by the archi-

Iford Manor Gardens

tect and landscape gardener Harold Ainsworth Peto between 1899 and 1933. He was inspired by the works of Lutyens and Jekyll to turn a difficult hillside site into "a haunt of ancient peace".

East of Bradford, off the A366, the charming 15th century **Westwood Manor** has many interesting features, including Jacobean and Gothic windows and ornate plasterwork.

TROWBRIDGE

The county of town of Wiltshire, and another major weaving centre in its day. A large number of industrial buildings still stand, and the Town Council and Civic Society have devised an interesting walk that takes in many of them. The parish church of St James, crowned by one of the finest spires in the county, contains the tomb of the poet and former rector George Crabbe, who wrote the work on which Benjamin Britten based his opera *Peter Grimes*. Trowbridge's most famous son was Isaac Pitman, the shorthand man, who was born in Nash Yard in 1813.

AROUND TROWBRIDGE

STEEPLE ASHTON

Map 3 ref D6

3 miles E of Trowbridge off the A350

The long main street of this village is lined with delightful old buildings, many featuring half-timbering and herringbone brickwork. The Church of St Mary

Steeple Ashton

the Virgin, without a steeple since it was struck by lightning in 1670, houses the **Samuel Hey Library** whose highlight is the early 15th century Book of Hours.

5 Marlborough to Devizes

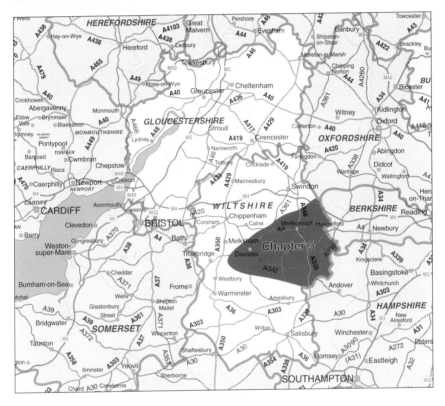

© MAPS IN MINUTES ™ (1998)

This chapter starts in the distinguished town of Marlborough and visits some of the most renowned prehistoric sites in the country as well as monuments to Wiltshire's industrial past.

MARLBOROUGH

Famous for its public school and its wide high street, Marlborough is situated in the rural eastern part of Wiltshire in the upland valley of the Kennet, which flows through the town. It was once an important staging post on the coaching run from London to Bath and Bristol, and the presence of the A4 means that it still has easy links both east and west. Its main street, one of the finest in the

country, is dignified by many Tudor houses and handsome Georgian colonnaded shops, behind which are back alleys waiting to be explored. St Mary's Church, austere behind a 15th century frontage, stands in **Patten Alley**, so named because pedestrians had to wear pattens (an overshoe with a metal sole) to negotiate the mud on rainy days. The porch of the church has a ledge where churchgoers would leave their pattens before entering. Other buildings of interest include those clustered round The Green (originally a Saxon village and the working-class quarter in the 18th and 19th centuries); the turn-of-the-century Town Hall looking down the broad High Street; and the ornate 17th century Merchant's House, now restored as a museum.

Marlborough College was founded in 1843 primarily for sons of the clergy. The Seymour family built a mansion near the site of the Norman castle. This mansion was replaced in the early 18th century by a building which became the Castle Inn and is now C House, the oldest part of the College.

AROUND MARLBOROUGH

SAVERNAKE FOREST
2 miles E of Marlborough off the A346

MAP 3 REF F5

The ancient woodland of **Savernake Forest** is a magnificent expanse of unbroken woodland, open glades and bridle paths. King Henry VIII hunted wild deer here and married Jane Seymour, whose family home was nearby. Designated an SSSI (Site of Special Scientific Interest), the forest is home to abundant wildlife, including a small herd of deer and 25 species of butterfly.

RAMSBURY
4 miles E of Marlborough off the A4

MAP 3 REF F5

Follow the signs from the A4 or take the scenic route by the River Kennet to find a village that was once an important ecclesiastical centre, a residence in the 10th and 11th centuries of the Bishops of Wiltshire. Many of the village's handsome Jacobean and Georgian buildings have gardens running down to the river. The oak tree in the square was planted in 1986 to replace an earlier specimen - a risky move in some opinions, as village legend had it that the old tree was the home of the local witch Maud Toogood (what a name for a witch!).

High up on the Marlborough Downs above the Kennet Valley, **Marridge Hill House** is the perfect place for a relaxing break. The atmosphere is very peaceful and civilised, and guests can be sure of a warm welcome from owners Judy and Chris Davies, who have lived here for over 30 years. They offer top-quality bed and breakfast accommodation in three guest bedrooms, which comprise a superb en suite twin and two more twins with separate toilets and a shared bathroom. Log fires warm the lounge and dining room, which, like the

Marridge Hill House, Marridge Hill, Ramsbury, Near Marlborough,
Wiltshire SN8 2HG Tel: 01672 520237 Fax: 01672 520053
e-mail: dando@impedaci.demon.co.uk

bedrooms, are decorated and furnished to the highest standards. The house, which dates from about 1750, was originally two brick-and-flint cottages, with an extension added in 1902. It stands off the B4192 two miles from Ramsbury – get directions when booking – in an acre of very attractive lawns and flower beds, and the views are superb. No smoking. No children under 5. Dogs by arrangement.

The least well known of Wiltshire's famous white horses is one cut by school-boys in 1804 on a hill above the Kennet. The best way to see it is from a footpath along the river from Marlborough to Manton on the western edge.

WEST OVERTON MAP 3 REF E5
3 miles W of Marlborough off the A4

The area between Marlborough and Avebury sees the biggest concentration of prehistoric remains in the country. The scattered community of West Overton stands at the foot of **Overton Hill**, the site of an early Bronze Age monument called **The Sanctuary**. These giant standing stones are at the southeastern end of West Kennet Avenue, an ancient pathway which once connected them to the main megalithic circles at Avebury (see below). Overton Hill is also the start point of the Ridgeway long-distance path, which runs for 80 miles to the Chilterns. Just off this path is **Fyfield Down**, now a nature reserve, where quarries once provided many of the great stones that are such a feature of the area. **Devil's Den** long barrow lies within the reserve. The local legend that Satan

sometimes appears here at midnight attempting to pull down the stones with a team of white oxen has not in recent times been corroborated.

On the edge of the village on the A4 Bath Road, **The Bell** is a very popular pub with a justified reputation for good beers, great food and a friendly, lively atmosphere. Proprietor Stephen Austin and his super staff attract a strong local trade as well as visitors and passing motorists, who can truthfully say that they

The Bell Inn, Bath Road, West Overton, Near Marlborough, Wiltshire SN8 1QD Tel: 01672 861663

were saved by The Bell. Built in 1765 and later extended, the inn has a pleasant garden with views across farmland to the church and village. The River Kennet runs 120 yards from the garden. The bar sports original beamed ceilings and half-panelled walls hung with jugs, brasses and pictures and photographs of local interest. At one end of the bar is a pool table, at the other the main dining area with seats for 30. An excellent selection of beers and wines accompanies the food, which is first-rate in both quality and quantity. The choice runs from light bites (filled baguettes, ploughman's, jacket potatoes) to fisherman's platter, chicken Kiev, steaks, home-made savoury pies and home-made vegetarian dishes. This place is never less than cheerful, and it really buzzes on Irish folk music nights, which take place once a month on a Friday. Sunday night is quiz night, a very popular occasion with one and all.

Situated on the western edge of the village between the historic site of Avebury and the market town of Marlborough, **Cairncot** offers comfortable accommodation with superb country views. Rachel Leigh's house, built in 1955 in chalet style, and centrally heated throughout, stands in very attractive grounds of trim lawns, shrubs and flower beds. The two guest bedrooms have TVs, radios and tea/coffee-making facilities. The rooms are on the first floor and share a bathroom. Cairncot is a very pleasant base for touring the area, whose major points

Cairncot, West Overton, Near Marlborough, Wiltshire SN8 4ER
Tel: 01672 861617

of interest include Silbury Hill, Avebury Stone Circle and Kennet Long Barrow. Close by at Overton Hill is the start of the Ridgeway Path National Trail, which stretches for some 80 miles.

EAST AND WEST KENNET
4 miles W of Marlborough on the A4

MAP 3 REF E5

West Kennet Long Barrow, one of Britain's largest neolithic burial tombs, is situated a gentle stroll away from the twin villages. The tomb is of impressive proportions - 330' long, 80' wide and 10' high - and is reached by squeezing past some massive stones in the semicircular forecourt.

SILBURY HILL
5 miles W of Marlborough on the A4

MAP 3 REF E5

The largest man-made prehistoric mound in Europe, built around 2800BC, standing 130' high and covering five acres. Excavation in the late 1960s revealed some details of how it was constructed but shed little light on its purpose. Theories include a burial place for King Sil and his horse and a hiding place for a large

Silbury Hill

gold statue built by the Devil on his way to Devizes. Scholarship generally favours the first.

AVEBURY
Map 3 ref E5
6 miles W of Marlborough on the A4361

A 28-acre World Heritage Site is the centre of the **Avebury Stone Circles**, the most remarkable ritual megalithic monuments in Europe. A massive bank and ditch enclose an outer circle and two inner circles of stones. The outer circle of almost 100 sarsen stones (sand and silica) enclose two rings with about 40 stones still standing. Archaeologists working on the site have recently found the remains of a long-vanished avenue of stones leading south towards Beckahmpton. This discovery seems to vindicate the theory of the 18th century antiquary William Stukeley, who made drawings of the stone circles with this avenue marked. The stones in the avenue had disappeared so completely (perhaps destroyed out of some superstition in the Middle Ages) that few believed Stukeley. The research team from Southampton, Leicester and Newport Universities uncovered a series

Avebury Stones

of subterranean features which appear to be buried stones and the sockets in which they were set. Two large stones, known as Adam and Eve, had always been known about on this route, but there were no further traces unitl the team's discoveries in 1999. The **Avebury Stones** bear testimony to the enormous human effort that went into their construction: some of the individual stones weigh 40 tons and all had to dragged from Marlborough Downs. The Avebury stones are in two basic shapes, which have been equated with male and female and have led to the theory that the site was used for the observance of fertility rites. Many of the archaeological finds from the site are displayed in Avebury's **Alexander Keiller Museum**, which also describes the reconstruction of the site by Keiller in the 1930s.

Avebury Manor

Avebury has a gem from Elizabethan times in **Avebury Manor**, which stands on the site of a 12th century priory. The house and its four-acre walled garden, which features a wishing well, topiary, a rose graden and an Italian walk, are owned by the National Trust. Open daily except Monday and Thursday.

GREAT BEDWYN
6 miles SE of Marlborough off the A4

MAP 3 REF F6

A major village on the **Kennet & Avon Canal**. The tomb of Sir John Seymour, the father of Henry Vlll's third wife Jane, is in the chancel of the 11th century Church of St Mary the Virgin. Not far away is **Lloyds Stone Museum**, a monument to the skills of the English stonemason. The museum is run by the seventh generation of a family of stonemasons and includes an assortment of tombstones and a stone aeroplane with an 11' wingspan. Tel: 01672 870234

CROFTON
6 miles SE of Marlborough off the A338

MAP 3 REF F6

The eastern end of the Vale of Pewsey carries the London-Penzance railway line and the **Kennet & Avon Canal**, which reaches its highest point near Crofton. The site is marked by a handsome Georgian pumping station which houses the **Crofton Beam Engines**. These engines - the 1812 Boulton & Watt and the 1845 Harvey of Hayle - have been superbly restored under the guidance of the Kennet & Avon Canal Trust and the 1812 engine is the oldest working beam engine in

the world, still in its original building and still doing its original job of pumping water to the summit level of the canal. Both engines are steamed from a hand-stoked, coal-fired Lancashire boiler. The separate bick chimney has also been restored, to its original height of 82 feet. Tel 01672 870300 for details of steaming weekends.

WILTON MAP 3 REF F6
8 miles SE of Marlborough off the A338

A footpath of about a mile links the Crofton Beam Engines with Wilton. This is the smaller of the two Wilt-
shire Wiltons, best known as the site of the **Wilton Windmill**. This traditional working windmill, the only one operating in the county, was built in 1821 after the **Kennet & Avon Canal** Company had taken the water out of the River Bedwyn for their canal, thereby depriving the water millers of the power to drive their mills. The mill worked until 1920, when the avail-ability of steam power and electricity literally took the wind out of its sails. After standing derelict for 50 years it was restored at a cost of £25,000 and is now looked after by the Wilton Windmill Society. This su-perb mill is floodlit from dusk until 10pm, making a wonderful sight on a chalk

Wilton Windmill

ridge 550 feet above sea level. Open Sundays and Bank Holiday Mondays in summer for guided tours. Tel: 01672 870427

MARTEN MAP 3 REF F6
9 miles SE of Marlborough off the A338

A short drive south of Wilton Windmill, on the other side of the A338.

The Tipsy Miller, built in 1902 on the site of a much earlier inn, stands on

**The Tipsy Miller, Marten, Near Marlborough, Wiltshire SN8 3SH
Tel: 01264 731372**

the A338 in an acre of grounds that include a spacious beer garden with a play area for children. It's very much a family business, with Maggie and Michael Dennis at the helm and son Stuart helping in the bar. A full-time chef, Tony, is also a partner in the enterprise. The locals bar has seats for 20+, an open fire in winter and an assortment of prints, paintings and memorabilia on the walls. It's a quiet, civilised room where regulars meet for a drink and a chat or a game of darts or dominoes. A door leads from here to the non-smoking restaurant, where a bar counter hewn from a Savernake Forest oak is an eyecatching feature. Tony proposes both snack and à la carte menus, the former offering treats like crab cakes and toad-in-the-hole, the latter including roast duck, rack of lamb and steaks - how about fillet steak with a prawn and Stilton glaze? Guests staying overnight have the use of a charming little chalet with an en suite bedroom that is just right for a family. It is appropriate that one of the chief attractions in the neighbourhood is the renowned working windmill at Wilton!

BURBAGE
7 miles SE of Marlborough on the A346

<div align="right">MAP 3 REF F6</div>

A sizeable village on a cycle trail a little way south of the Kennet & Avon Canal. Burbage is a convenient access point for the Wilton Windmill (see above).

Overlooking Stibb Green north of Burbage's main street, the **Three Horse-shoes Inn** invites locals, walkers, cyclists and tourists from all over the world - even horses are sometimes tied up outside while their riders take refreshment. Philip Prew and Grace Amor extend a warm welcome to one and all, and Grace, with the help of Auntie Sue, produces a fine choice of dishes both lunchtime and evening (no food Sunday evening). The home-cooked specialities include

**The Three Horseshoes Inn, No 1 Stibb Green, Burbage,
Wiltshire SN8 3AE Tel: 01672 810324**

Italian Chicken, Thatched Horseshoe Pie and Fisherman's Hot Pot. The thatch-roofed pub, built 200 years ago, has a central bar counter with a non-smoking lounge at one end and a public bar - food is served in both. All the ceilings are beamed, and the walls are adorned with railway memorabilia. An old railway clock stands in the public bar. The lounge overlooks a pretty courtyard, beyond which is a beautiful garden with shrubbery, flower beds and seats for 40. In-house activities at this quiet, secluded and very civilised inn include dominoes, cribbage, bar skittles and shove ha'penny.

COLLINGBOURNE KINGSTON
10 miles SE of Marlborough on the A338

MAP 3 REF F6

The Old School House, one of the most important buildings in the village, is now teaching the whole neighbourhood a lesson in producing good food. Built

in 1845 and still visited by former pupils, is now top of the class in the local dining out stakes. Livio and Lynda Guglielmino came here in 1987 and turned the former assembly hall of the school – it was at that time a tea shop – into a restaurant of real quality which has acquired an ever-growing band of enthusiastic regulars. The decor throughout is superb, in complete sympathy with the original high-pitched ceiling and beams, and the walls are adorned with details

The Old School House, Collingbourne Kingston, Near Marlborough, Wiltshire SN8 3SD Tel: 01264 850799

of the school's history and photographs of pupils down the years. Livio's menu makes appetising reading, and results on the plate fully live up to the anticipation. Classics include Pepper Steak, Steak Diane, Veal Marsala and Pollo Verbena (chicken breast topped with cheese, tomato, asparagus and white sauce). School dinners were never like this! The Old School House also offers high-quality overnight accommodation in four bedrooms with en suite facilities and TVs.

CLENCH COMMON MAP 3 REF E6
2 miles S of Marlborough on the A345

A lovely part of the world for walking or cycling. The Forestry Commission's **West Woods**, particularly notable for its bluebells in May has a picnic site. The Wansdyke Path, a long earthwork of a single bank and ditch, forms part of the wood's boundary. Also nearby is **Martinsell Hill**, topped by an ancient fort. Downland to the east of the fort is particularly beautiful in early spring and summer.

Surrounded by the 400 acres of its own farmland, with the Wansdyke path-

way running through the land, **Wernham Farm** is the family home of Maggie and Gerald Vigar-Smith. Located half a mile along a well-surfaced drive off the A345, the house was built in the 16th century and rebuilt in the Georgian period. Total peace and quiet are guaranteed in this lovely setting, and guests will find abundant comfort in the two bedrooms, both with en suite facilities, TVs and

**Wernham Farm, Clench Common, Near Marlborough, Wiltshire SN8 4DR
Tel: 01672 512236**

tea/coffee-makers. There's a good family atmosphere, with a sitting room for guests and plenty of books to read. Clotted cream teas, with everything home-made, are much too delicious to resist! Gerald and Maggie and their son James run the farm, which guests are encouraged to look round, and daughter Liz is at home, too, after finishing college, where she studied psychology and english. Maggie also looks after the B&B side and the secluded caravan site, which is registered with the Caravan & Camping Club and has space for five vans. Maggie is also a Spiritual Healer and many guests take advantage of this added service. No smoking.

WOOTTON RIVERS
4 miles S of Marlborough off the A345

MAP 3 REF F6

An attractive village with a real curiosity in its highly unusual church clock. The **Jack Sprat Clock** was built by a local man from an assortment of scrap metal,

including old bicycles, prams and farm tools, to mark the coronation of King George V in 1911. It has 24 different chimes and its face has letters instead of numbers.

MILTON LILBOURNE
MAP 3 REF F6
6 miles S of Marlborough off the B3087

A place of outstanding natural and archaeological beauty. The village is well worth exploring, and nearby are **Milton Hill** and the neolithic long barrow known as the **Giant's Grave**.

ALTON BARNES AND ALTON PRIORS
MAP 3 REF E6
6 miles SW of Marlborough off the A345

The largest **White Horse** in Wiltshire can be seen on the hillside above Alton Barnes. According to the local story the original contractor ran off with the £20 advance payment and the work was carried out by Robert Pile, who owned the land. The absconder was later arrested and hanged for a string of crimes. The figure of the horse can be seen from as far away as Old Sarum, 20 miles distant. To the north of Alton Barnes, high up on a chalk ridge, are the remains of three prehistoric hill forts, Knap Hill, Adam's Grave and Rybury.

PEWSEY
MAP 3 REF E6
7 miles S of Marlborough on the A345

In the heart of the beautiful valley that bears its name, this is a charming village of half-timbered houses and thatched cottages. It was once the personal property of Alfred the Great, and a statue of the king stands at the crossroads in the centre. The parish church, built on a foundation of sarsen stones, has an unusual altar rail made from timbers taken from the *San Josef*, a ship captured by Nelson in 1797.

Attractions for the visitor include the old wharf area and the **Heritage Centre**. In an 1870 foundry building it contains an interesting collection of old and unusual machine tools and farm machinery. The original **Pewsey White Horse**, south of the village on Pewsey Down, was cut in 1785, apparently including a rider, but was redesigned by a Mr George Marples and cut by the Pewsey Fire Brigade to celebrate the coronation of King George VI. **Pewsey Carnival** takes place each September, and the annual Devizes to Westminster canoe race passes through **Pewsey Wharf**.

A minor road runs past the White Horse across Pewsey Down to the isolated village of **Everleigh**, where the Church of St Peter is of unusual iron-framed construction. Rebuilt on a new site in 1813, it has a short chancel and narrow nave, an elegant west gallery and a neo-medieval hammerbeam roof.

MANNINGFORD BRUCE & MANNINGFORD ABBOTS
Map 3 ref E6
9 miles S of Marlborough on the A345

A couple of miles south of Pewsey is a trio of linked villages on or near the Avon: Mannington Abbots, Manningford Bruce and Mannington Bohune. Mannington Bruce has a part-Saxon, part-Norman church with a memorial to Mary Nicholas, who with her sister Jane Lane helped King Charles ll to safety after the Battle of Worcester in 1651. Jane rode pillion dressed as a groom to guide the king along roads thick with Parliamentarian troops.

The head office and workshops of **Indigo** are located in a long redbrick barn in the village of Manningford Bruce, on the A345 just below Pewsey. Indigo are importers and restorers of antique furniture, decorative art and handicrafts from China, India and Indonesia. Every piece is selected by the partners Richard and Marion Lightbown on their regular buying trips. This means that not only are the pieces selected for their exceptional quality, patina and individuality but

Indigo, Dairy Barn, Manningford Bruce, Near Pewsey, Wiltshire SN9 6JW Tel: 01672 564722 Fax: 01672 564733 e-mail: indigo_uk@compuserve.com

also to meet specific customer demands and to re-stock their two shops, in London and Bath, with beautiful and genuine finished pieces. Once in the UK the antiques are restored in the workshops, with great care being taken to preserve the original quality of the pieces. The large stock includes spice boxes, wooden bowls, chests, cupboards, beds and textiles. The pieces date from the 19th century through to the present day. Indigo are also able to create and have made their own designs, crafted using traditional tools and techniques, in In-

dia. The warehouse caters for the discerning buyer, who can see the stock in unrestored condition, just as it was discovered in India, China or the Far East.

Margot and Dick Andrews have two strings to their bows - **Huntleys Farmhouse**, in the quiet village of Manningford Abbots, and the nearby **Woodborough Garden Centre**. In the 17th century thatched farmhouse, on a 350-acre farm, they offer peaceful, comfortable bed and breakfast accommodation in two very attractive bedrooms, an en suite twin which an extra bed can

Huntleys Farmhouse, Manningford Abbots, Near Pewsey,
Wiltshire SN9 6HZ Tel: 01672 563663 Fax: 01672 851249

turn into a family room, and a double with a private bathroom. Both have TVs and tea/coffee-making facilities. Days at the farmhouse get off to the best of starts with an English breakfast that includes home-baked bread and eggs from the farm. Woodborough Garden Centre, just two miles away in the village of Woodborough, stocks a wide range of interesting and unusual plants, plus hanging baskets, garden furniture, statuary and gifts. There are also 20 acres of Pick Your Own crops, starting with daffodils in February and moving by way of other flowers to all sorts of berries and currants, beans, peas, courgettes, sweetcorn and rhubarb. The Four Seasons Coffee Shop at the Centre makes excellent use of farm-grown fruit and vegetables in its menu of light, wholesome dishes.

UPAVON
MAP 3 REF E6
10 miles SW of Marlborough on the A345

A bustling village, originally a Saxon settlement, whose most famous son was Henry "Orator" Hunt, who became MP for Preston in 1830.

ENFORD

MAP 3 REF E6

12 miles S of Marlborough off the A345

A peaceful village on the River Avon south of Upavon.

Visitors from all walks of life endorse the qualities of **The Swan at Enford**, where Bob and Phil Bone are the hands-on proprietors. The brick and flint building dates from the 17th century, with a thatched roof, beautiful gardens front and back, and oak beams in the lounge bar and restaurant. The latter is a non-

The Swan at Enford, Long Street, Enford, Near Pewsey, Wiltshire SN9 6DD Tel: 01980 670338 Fax: 01980 671318 e-mail: theswanatenford@easynet.co.uk

smoking area with seats for 18 and a menu to set the taste buds tingling. In addition to classic pub fare - ploughman's, basket meals, chicken Kiev, steak & kidney pie, steaks - there are always some interesting specials including trout (the River Avon runs 60 yards from the front of the pub) and seasonal game, the basis of delicious dishes such as warm salad of pigeon breast or stuffed venison fillet served on a bed of pickled cabbage with a port wine sauce. There's a particularly good choice for vegetarians, including perhaps a lentil-based moussaka or apricot and quorn pie. Real ales and a worldwide selection of wines accompany the fine food. Tuesday night is quiz night - always a very popular occasion - and four times a year a jazz group or blues band performs.

MARDEN

Map 3 ref E6

12 miles S of Marlborough on the A342

On the southern edge of the Vale of Pewsey, Marden has a 12th century pinnacled church with several interesting features. The door is thought to be one of the oldest in the country, perhaps as old as the church itself, and the lock is at least 300 years old. Also of note in the village are a mill that was mentioned in the Domesday Book and a fine 18th century manor. On a 35-acre site to the northeast of Marden is one of the largest neolithic henge monuments in the land. Dating from about 2000BC, it once contained an enormous earthwork mound called **Hatfield Barrow**.

DEVIZES

At the western edge of the Vale of Pewsey, Devizes is the central market town of Wiltshire. The town was founded in 1080 by Bishop Osmund, nephew of William the Conqueror. The bishop was responsible for building a timber castle between the lands of two powerful manors, and this act brought about the town's name, which is derived from the Latin *ad divisas*, or 'at the boundaries'. After the wooden structure burnt down, Roger, Bishop of Sarum, built a stone castle in 1138 that survived until the end of the Civil War, when it was demolished. Bishop Roger also built two fine churches in Devizes. Long Street is lined with elegant Georgian houses and also contains the Wiltshire Archaeological and Natural History Society's **Devizes Museum**, which has a splendid collection of artefacts from the area, and a gallery with a John Piper window and regularly changing exhibitions.

The newly opened **Devizes Visitor Centre** offers a unique insight into the town. The Centre is based on a 12th century castle and takes visitors back to medi-

Devizes Visitor Centre, Cromwell House, Market Place, Devizes, Wiltshire SN10 1JG Tel: 01380 729408 Fax: 01380 730319

eval times, when Devizes was home to the finest castle in Europe and the scene of anarchy and unrest during the struggles between Empress Matilda and King Stephen. An interactive exhibition shows how the town came to be at the centre of the 12th century Civil War and thrived as a medieval town, many traces of which remain today. But the Devizes story doesn't stop there. The town found itself in the midst of the 17th century Civil War, when Oliver Cromwell's soldiers destroyed the castle. It has a wealth of Georgian architecture, and eventually became an inland port on the **Kennet & Avon Canal**. This rich history has provided the town with many notable buildings and fascinating stories which the Visitor Centre helps to reveal. The Centre is home to Devizes Tourist Information Centre, where staff are able to direct visitors to innumerable places of interest and activities in the town and the surrounding area. Also on the premises is the Keepsake Gift Shop. Based on a medieval merchant's house, it has an imaginative display of unusual and historical gifts and crafts.

Market Cross, Devizes

Many more of the town's finest buildings are situated in and around the old market place, including the Town Hall and the Corn Exchange. Also here is an unusual **market cross** inscribed with the story of Ruth Pierce, a market stall-holder who stood accused, in 1753, of swindling her customers. When an ugly crowd gathered round her, she stood and pleaded her innocence, adding "May I be struck dead if I am lying". A rash move, as she fell to the ground and died forthwith.

The Bell by the Green is a handsome Bath stone building in Georgian style, facing a large green and pond and just a short walk from the Kennet & Avon Canal. Tenants Bryan and Carol Smith-Dowse are both keen gardeners, and the front of their pub is adorned with prize-winning window boxes. The strong local following testifies to the popularity of Bryan and Carol, whose regulars include a large number of exponents of traditional pub games. The pub fields no fewer than nine skittles teams (it has its own alley), plus four darts teams,

**The Bell by the Green, Estcourt Street, Devizes, Wiltshire SN10 1LQ
Tel: 01380 723746 Fax: 01380 727381**

and a cabinet in the comfortable central bar is filled with trophies won by the teams. One part of the bar and a separate (non-smoking) restaurant provide plenty of room to enjoy a bar lunch or evening meal. Lunchtime fare includes sandwiches, jacket potatoes, pies, curries and lasagne, while the evening à la carte menu proposes grills, sauced fish and meat dishes and a good choice for vegetarians. Tourists and business people both make good use of the overnight accommodation, which comprises a single, a twin and two family rooms with a shared bathroom.

Devizes stands at a key point on the Kennet & Avon Canal, and the **Kennet & Avon Canal Museum** tells the complete story of the canal in fascinating detail. Many visitors combine a trip to the museum with a walk along the towpath, which is a public footpath. Each July the Canalfest, a weekend of family fun designed to raise funds for the upkeep of the canal, is held at the Wharf, which is also the start point, on Good Friday, of the annual Devizes-Westminster canoe race.

The Kennet & Avon Canal at Devizes tumbles down the hillside through 29 locks over just two miles and the **Lock Cottage Tea Rooms** are within what was once a lock-keeper's cottage. There is ample seating either in the tea rooms or in the shady garden right by the lock. Parking is nearby, while for the more active a cycle ride or walk along the towpath will not disappoint. Opened in 1810, the Kennet & Avon Canal was used to transport many goods along its route be-

The Lock Cottage Tea Rooms, Caen Hill Locks, Devizes, Wiltshire
Tel: 01380 724880

tween Reading and Bristol. However, as time passed, the railways and then the roads took away much of the trade and the waterway became derelict and unnavigable. It was opened again through the efforts of British Waterways, The Kennet & Avon Canal Trust and the Local Authorities, and the pretty towns and villages that nudge the route are now visited by many holiday boats and tourists. The brightly coloured boats, the canalside cottages, the black-and-white-painted locks, the tranquil walks, the tall aqueducts and the wonderful countryside are all part of our living waterway heritage available for all to enjoy. For more information contact British Waterways, Bath Road, Devizes, Wiltshire SN10 1HB (Tel: 01380 722859 Net: www.britishwaterways.co.uk) or The Kennet & Avon Canal Trust, The Canal Centre, Couch Lane, Devizes, Wiltshire SN10 1EB (Tel: 01380 721279 Net: www.katrust.demon.co.uk).

In a rural setting on the edge of Devizes, **The Fox & Hounds** is a redbrick, thatch-roofed building (a farmhouse in the 17th century) whose facade is adorned with hanging baskets, climbing roses and honeysuckle. But the crowning glory is the marvellous garden, the result of the hard work put in by tenants Terry and Sheila Jarvis. Both very keen gardeners, they have transformed the site, and it's a real delight to sit outside with a drink and a snack. Inside, the long bar, with original beamed ceiling and a wealth of memorabilia, brasses and plates, extends into a dining area with candlelight in the evenings and lovely flower displays. Book a table, and you have it for the evening, so a meal here is a really relaxing occasion. Specialities on the menu include Foxy's Fungi (mushrooms in a brandy and cream sauce with bacon and onions) and fish combos in both

The Fox & Hounds, Nursteed Road, Devizes, Wiltshire SN10 3HJ
Tel: 01380 723789

hot and cold versions; meat-lovers can tuck into their choice of steaks, duck or chicken, and there are half a dozen main courses for vegetarians. A wine list of worldwide provenance accompanies the excellent food. There's also a fine choice of bar snacks to enjoy in the bar or out in the garden. Other attractions of this splendid pub include a skittle alley with its own bar. The pub fields three skittles teams, plus darts and cribbage teams.

Steve and Nicky Wragg are the tenants of **The Cavalier**, a 1960-built Wadworth pub off the Andover road on the edge of Devizes. They are a very

The Cavalier, Eastleigh Road, Devizes, Wiltshire SN10 3EG
Tel: 01380 723285

friendly couple who put a great deal into the local community, and many local clubs and groups hold regular meetings in the pub. The whole place is comfortable, well decorated and well ventilated, and the walls are hung with fishing and military memorabilia. A central bar serves the lounge and the dining area, where food is available at most times. The menu offers a particularly good choice, and among the specialities are cheesy stuffed mushrooms, Thai-style fishcakes with sweet chilli sauce, rib-eye steak, curries and home-made bread & butter pudding with butter toffee ice cream. Booking is advisable on Sundays. The Cavalier has a pool table and a skittle alley that doubles as a function room, with seats for 80 and full bar facilities. The pub fields teams for skittles, darts and pétanque. The beer garden has plenty of seats and there's a large car park.

On the edge of town, the 18th century brick-built **Queen's Head** presents a very attractive sight with its lovely hanging baskets, window boxes and flower tubs. The licensees are Nicky and Craig Russell, who attract a busy local trade as well as visitors enjoying the many places of interest in and around Devizes. It's a quiet, civilised pub, with no music and a very cosy ambience. A handsome stone porch leads into the bar, which sports an original beamed ceiling and an inglenook fireplace. There are seats for 30 in the bar, with a further 15 places in the non-smoking dining room. Food is available every lunchtime and every evening from a menu that spans starters and light meals, a daily roast, pasta dishes and a wide range of main courses. Skittles is a popular pastime here – the pub fields five teams and has its own alley, which doubles as a function room with seats for 40.

The Queen's Head, Dunkirk Hill, Devizes, Wiltshire SN10 2BG
Tel: 01380 723726

AROUND DEVIZES

ROWDE
MAP 3 REF D6
2 miles W of Devizes on the A342

Tim and Helen Withers have earned high praise both locally and further afield for the quality of the food at **The George & Dragon**. In a quiet village location just outside Devizes, the crook-built 17th century pub has won many awards, particularly for its fresh fish, which is delivered regularly from Cornwall. Tim, who started in the trade in 1982 at The Hole in the Wall in Bath, is the chef and the owner, and his prowess brings customers from a wide area both lunchtime and evening from Tuesday to Saturday (no food Sunday or Monday). Anything from pan-fried scallops in a bacon and shallot sauce to steamed skate with salsa

The George & Dragon, High Street, Rowde, Wiltshire SN10 2PN
Tel: 01380 723053 Fax: 01380 724738 e-mail: gd-rowde@lineone.net

verde and cider-baked gurnard could appear on the fish list, which is just one part of a menu that is outstanding in variety and interest. Even without the food the pub has great appeal, with original wood panelling for walls and floors, and fine beamed ceilings. There is a real fire in the bar, and a legacy from early days is a tunnel that runs from the pub towards the nearby vicarage. There are seats for 36 in a lovely beer garden.

BISHOPS CANNINGS
MAP 3 REF E6
4 miles NE of Devizes on the A361

This old ecclesiastical community owes its name to the fact that the Bishops of Salisbury once owned a manor here; that probably explains why the very grand

parish church bears more than a passing resemblance to Salisbury Cathedral, even down, or rather up, to the tall, tapering spire. The church's organ was a gift in 1809 from Captain Cook's navigator, William Bayley, who lived nearby. Devizes is at the heart of Moonraker country. According to legend, a gang of 17th century smugglers from Bishops Cannings fooled excisemen when caught recovering dumped brandy kegs from a pond known as the Crammer. The smugglers pretended to be mad and claimed the moon's reflection on the pond was actually a cheese, which they were trying to rake in. The ruse worked, so who were the real fools?

A hollow in the downs west of the village was the scene of a bloody Civil War battle in 1643, when the Royalist forces under Prince Rupert's brother, Maurice, defeated the Parliamentarian forces at Roundway Down. According to a local legend, the cries of the dead can be heard coming from a burial ditch on the anniversary of the battle (July 13).

POULSHOT
Map 3 ref D6
3 miles W of Devizes off the A361

A peaceful village a short distance south of **Caen Locks,** with a pleasant green and cricket pitch.

Just off the A361 two miles south of Devizes, **Higher Green Farm** is a peaceful 17th century timbered farmhouse facing the Raven Inn and the village green and cricket pitch. Marlene and Malcolm Nixon have lived at the farm for more

**Higher Green Farm, Poulshot, Near Devizes, Wiltshire SN10 4RW
Tel: 01380 828355**

than 20 years, and Malcolm works the 130-acre dairy farm with their son Tim. Guests are greeted with a cup of tea on arrival, a nice touch which typifies the relaxed, civilised atmosphere generated by the owners. Bed and breakfast accommodation comprises four bedrooms - two singles, a twin and a double with shared bath/shower facilities, Tvs and tea-coffee-makers. The house, whose exterior is adorned with Virginia creeper, flowers and plants, is very well furnished throughout, and guests can while away a happy hour or two in the lounge. Open March-November. No smoking.

STERT MAP 3 REF E6
2 miles SE of Devizes off the A342

A sleepy little village with great views south to Salisbury Plain and east to the Vale of Pewsey. The Wessex Ridgeway runs past the village.

Four acres of beautiful landscaped gardens provide the idyllic setting for **Orchard Cottage**, a fine old thatched building in a sleepy hamlet 2½ miles out of Devizes. Mr and Mrs Martin, who have lived here for over 30 years, offer high-quality bed and breakfast accommodation in three beamed bedrooms,

**Orchard Cottage, Stert, Near Devizes, Wiltshire SN10 3JD
Tel: 01380 723103**

which all have tea/coffee-makers and hot and cold washing facilities; they share a bathroom and shower room. Guests can relax in a lovely lounge or enjoy the delights of the garden, where the grass in the orchard is kept short by the pres-

ence of two donkeys. The views are superb, with Salisbury Plain to the south and Pewsey Vale to the east. Many guests return to this lovely tranquil spot in a village that was, for over 500 years, the property of New College, Oxford.

POTTERNE MAP 3 REF D6
1 mile S of Devizes on the A360

Some fine old buildings here, including a 13th century church with a Saxon font, and the 500-year-old Porch House, a half-timbered building that has been a priest's home, an alehouse, a bakery and an army billet. It's now a private residence. **Wiltshire Fire Defence and Brigades Museum**, in the old coach house at Potterne Manor House, charts the history of firefighting in Wiltshire. Tel 01380 731108 for visiting times.

Country cooking, fine local ales and a comfortable bed for the night - **The George & Dragon** offers all this, with a generous measure of hospitality added by friendly landlords Joyce Joyce and husband Derek. The inn has a long and colourful history that starts in the 15th century when it was built on the instructions of the Bishop of Salisbury. Behind the redbrick thatched exterior the bar is full of character, with a large inglenook fireplace, interesting prints and photographs, old banknotes pinned to ceiling beams and a collection of mugs used by valued customers past and present. The George & Dragon attracts a strong local trade from all walks of life as well as visitors from as far afield as America and Australia. It is host to many local clubs and societies, including the Rifle Club -

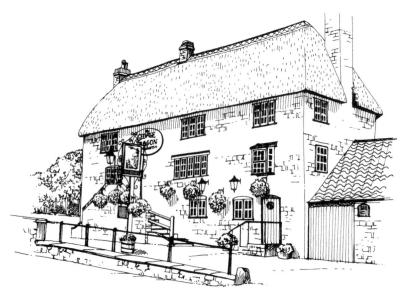

The George & Dragon, High Street, Potterne, Wiltshire SN10 5PY
Tel: 01380 722139

its most unusual feature is a short small-bore rifle range in an area behind the bar. There's also a skittle alley where the Folk Club performs on Monday nights. Many customers come for something to eat, whether it's a sandwich or plough-man's or a main dish such as home-made liver and onions, steak & kidney pie, salmon with béarnaise sauce or lamb shanks braised with red wine and rose-mary sauce. In a separate wing of the building are two attractive letting rooms, a twin and a double; both have a TV and hospitality tray, with bathroom, shower and toilet along the landing which overlook the vine-covered courtyard. The pub has a lawned, terraced beer garden. Ask Derek and Joyce about the ghost!

MARSTON
5 miles S of Devizes off the A360

MAP 3 REF D6

Country roads lead from Potterne to a quiet rural village in open country just west of Worton Common.

A sleepy rural village five miles out of Devizes is the setting for **Home Farm**, a traditional Wiltshire long house whose oldest part traces back to the 15th cen-tury. Joy and Maurice Reardon welcome guests from near and far into their home, where flagstone floors, exposed beams and timbers, low ceilings and deep fireplaces paint the perfect picture of an archetypal English cottage. Joy is keen to expand the overseas trade, and the completion of the barn conversion

Home Farm Barn & Stable Cottage, Marston, Near Devizes, Wiltshire SN10 5SN Tel: 01380 725484

has made this possible, with self-catering accommodation in three bedrooms above a well-equipped open-plan kitchen-diner-lounge. This supplements the two letting rooms (both en suite) in the main house. There is a lovely sitting room for guests, and a beautiful garden with the trimmest of lawns and a large duck pond. Fishing and riding are available nearby.

MARKET LAVINGTON
5 miles S of Devizes on the B3098

MAP 3 REF D6

The 'Village under the Plain' is home to a little museum, in the former schoolmaster's cottage behind the old village school. Displays at **Market Lavington Museum** include a Victorian kitchen and archive photographs.

On the main street of 'the Village under the Plain', **The Green Dragon** is a pub of many facets where Duval and Ann Stroud are the friendly, popular landlord and landlady. The 17th century listed building, brick-built with a Bath-stone porch, is a pub, restaurant and coffee and crafts shop, and also offers B&B ac-

The Green Dragon, 26 High Street, Market Lavington, Near Devizes, Wiltshire SN10 4AG Tel: 01380 813235

commodation in four bedrooms, one with en suite facilities, the others sharing a bathroom. There are seats for up to 50 in the beamed and panelled bar, while 20 can be seated in the restaurant, whose evening menu (Ann does the cooking) includes meaty savoury pies, spicy chicken, grills and home-made sweets. 'For the larger appetite', the Dragon mixed grill manages to put steak, pork chop, sausage, kidney, liver, burger and bacon on a single platter! Games feature strongly here, notably pool, darts, pétanque and the Oxfordshire game of Aunt Sally.

WEST LAVINGTON

MAP 3 REF D6

5 miles S of Devizes on the A360

The famous school was founded in the 16th century by the local lords of the manor, the Dauntseys, who also built the almshouses near the 12th century village church.

Wyneshore House, built some 20 years ago in traditional style, is a handsome brick house in a village setting that is ideal for touring the historic sites of Wiltshire. The lawns and beautiful flower beds are a tribute to the skills of owner Jeannie O'Flynn, who with her husband Terence has been offering high-quality B&B accommodation for the past five years. Elegance characterises the interior,

Wyneshore House, White Street, West Lavington, Wiltshire SN10 4LWE
Tel/Fax: 01380 818180

a notable feature being the main staircase, carved with impressive craftsmanship from a single oak tree. The bedrooms, both twin, have either a private bathroom or private shower room, and guests have the use of a comfortable sitting room, where tea is served on arrival. Home-made preserves, English bacon and free-range eggs are served for breakfast. This is a charming and relaxing home, where visitors return. The Wessex Ridgeway walk from Marlborough to Lyme Regis passes the gates.

CHIRTON

Map 3 ref E6

6 miles SE of Devizes on the A342

Worth a detour to see the handsome Georgian houses and one of the finest Norman churches in the country: of particular interest are the carved doorway, the font and the timber roof.

6 South Wiltshire

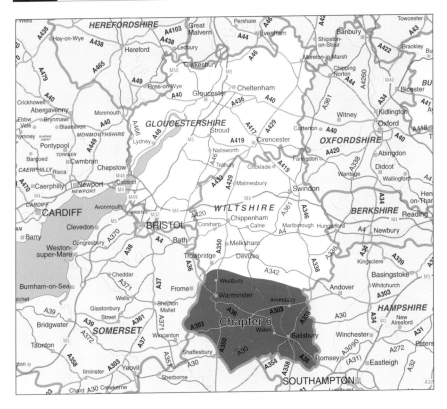

© MAPS IN MINUTES ™ (1998)

Salisbury and South Wiltshire are a part of traditional England with 6,000 years of history and a delight for visitors from all over the world. Salisbury, with its glorious Cathedral, is one of the most beautiful cities in the kingdom, and elsewhere in the region are the chalk downs and river valleys, the stately homes and picturesque villages, the churches, the ancient hill forts and, above all, Stonehenge, one of the great mysteries of the prehistoric world.

WESTBURY TO THE DORSET BORDER

WESTBURY
Map 3 ref D6

5 miles S of Trowbridge on the A350

Westbury, at the western edge of the chalk downlands of **Salisbury Plain**, was a major player in the medieval cloth and wool trades, and still retains many fine buildings from the days of great prosperity, including some cloth works and mills, Westbury was formerly a 'rotten borough' and returned two MPs until 1832. Scandal and corruption were rife, and the **Old Town Hall** in the market place is evidence of such goings-on, a gift from a grateful victorious candidate in 1815. This was Sir Manasseh Massey Lopes, a Portuguese financier and slave-trader who 'bought' the borough to advance his political career.

All Saints Church, a 14th century building on much earlier foundations, has many unusual and interesting features, including a stone reredos, a copy of the Erasmus Bible and a clock with no face made by a local blacksmith in 1604. It also boasts the third heaviest peal of bells in the world.

On the southern edge of town is another church well worth a visit. Behind the simple, rustic exterior of St Mary's, Old Dilton, are a three-decker pulpit and panelled pew boxes with original fittings and individual fireplaces. Just west of Westbury, at **Brokerswood**, is **Woodland Park and Heritage Centre**, 80 acres of ancient broadleaf woodland with a wide range of trees, plants and animals, nature trails, a lake with fishing, a picnic and barbecue area, a tea room and gift shop, a museum, a play area and a narrow-gauge railway.

By far the best-known Westbury feature is the famous **Westbury White Horse**, a chalk carving measuring 182' in length and 108' in height. The present steed dates from 1778, replacing an earlier one carved to celebrate King Alfred's victory over the Danes at nearby Ethandun (Edington) in 878. The white horse is well looked after, the last major grooming being in 1996. Above the horse's head are the ruins of Bratton Castle, an Iron Age hill fort covering 25 acres.

Stan and Rosemary Painter are natural hosts, and a stay in their **Glenmore Farm** is like being with friends. The house, built around 1930, stands half a mile out of Westbury in 70 acres of grounds (it was once at the heart of a working farm) including beautiful landscaped gardens. B&B accommodation comprises three bright, well-decorated bedrooms, two of them with four-poster beds and en suite bathrooms. Guests wake up to lovely views, including the famous Westbury White Horse two miles away, before enjoying a good English breakfast in the dining room. The lounge and conservatory provide ample space for relaxation, and guests are welcome to stroll around the gardens. Stabling and fishing are available by arrangement. The owners will offer self-contained cottage accommodation in the spring of 2000 at the Old Watermill (up to 8 guests) and the Stable (up to 4). AA 4 Diamonds.

Glenmore Farm, The Ham, Westbury, Wiltshire BA13 4HQ
Tel: 01373 865022

WARMINSTER
4 miles S of Westbury on the A350

MAP 3 REF D7

The largest centre of population is a historic wool, corn-trading and coaching town with many distinguished buildings, including a famous school with a door designed by Wren. In addition to the 18th and 19th century buildings, Warminster has a number of interesting monuments: the Obelisk with its feeding troughs and pineapple top erected in 1783 to mark the enclosure of the parish; the Morgan Memorial Fountain in the Lake Pleasure Grounds; and *Beyond Harvest*, a statue in bronze by Colin Lambert of a girl sitting on sacks of corn. Warminster's finest building is the Church of St Denys, mainly 14th century but almost completely rebuilt in the 1880s to the design of Arthur Blomfield. The **Dewey Museum**, in the public library, displays a wide range of local history and geology. To the west of town is the 800' **Cley Hill**, an Iron Age hill fort with two Bronze Age barrows. Formerly owned by the Marquess of Bath, the Hill was given to the National Trust in the 1950s and is a renowned sighting place for UFOs. (The region is also noted for the appearance of crop circles and some have linked the two phenomena.)

On the northern edge of Warminster **Arn Hill Nature Reserve** along public footpaths forms a circular walk of two miles through woodland and open downland.

The Cock Inn, on the edge of Warminster, is a long stone and brick building dating from the early 1700s. The creamwashed exterior is festooned with hanging baskets, and in the roomy bars exposed beams add period character. George and Diane Jones, along with two of their daughters, have made their immaculately-kept pub a very popular place with both Warminster locals and the many visitors to this attractive part of the world. The Cock Inn is a great favourite with sporting locals, with skittles, pool, darts and cribbage among the activities

The Cock Inn, 55 West Street, Warminster, Wiltshire BA12 8JZ
Tel: 01985 213300

in the capacious games room. The pub also sponsors a football team, and the social round extends to discos, karaoke, live groups for functions and regular quiz nights. Good pub food is served lunchtime and evening, and all day at weekends. Sandwiches, burgers, jacket potatoes and omelettes are backed up by rump steak, jumbo hot dogs and the popular suet puddings - lamb & mint, steak & kidney, chicken & leek. Best to book for Sunday lunch. The pub has a beer garden and a large car park.

EDINGTON
MAP 3 REF D6
3 miles E of Westbury on the B3098

The size of the church is evidence that Edington was once a place of consider-able importance. The great priory church was built between 1352 and 1361 by William of Edington, Bishop of Winchester, and its battlements give it the appearance of a fortified palace. A festival of church music is held here every August. Besides being the site of Alfred's thrashing of the Danes, Edington saw violence some six centuries later when, during a rebellion against Henry VI's corrupt government, the Bishop of Salisbury was dragged from his house and stoned to death. **Fitzroy Farm**, open for visits every day except Monday, has workshops featuring local crafts, a plant centre, shops and a café.

IMBER
MAP 3 REF D7
5 miles E of Westbury off the B3098

The part of Salisbury Plain containing the village of Imber was closed to the public in 1943 and has been used by the Army ever since for live firing. The evicted denizens of Imber were told that they could return to their village when the War was over, but that promise was not kept by the Ministry of Defence and the village is only accessible on very rare occasions. A well-marked 30-mile perimeter walk skirting the danger area takes in Warminster, Westbury, Tilshead in the east and Chitterne in the south.

BISHOPSTROW
MAP 3 REF D7
3 miles E of Westbury off the B3414

On and around the A36 road leading to Salisbury are many interesting little villages with notable churches or monuments. One such is Bishopstrow, whose Church of St Aldhelm is a 14th century building on the site of an 8th century original. St Aldhelm, Bishop of Malmesbury, planted his ashen staff in the ground and it grew - hence the name of the village. Inside are a carved oak screen (spot the little mouse) and several monuments to the Temple and Southey families. Will Carling was baptised here. On the parish boundary between Bishopstrow and **Norton Bavant** is **Cromwell's Yew**, where the great man breakfasted in its shade after the Battle of Newbury (1644), perhaps in the company of the fairies who are said to dance round it. At **Sutton Veney**, off the B3095, St Leonard's Church was replaced in 1868 due to subsidence, and only the roofed chancel and the ruins of the nave and transept survive. The churchyard at the replacement St John's contains many graves of Anzac troops who fell in World War l.

CORTON
MAP 3 REF D7
6 miles SE of Westbury on the A36

A peaceful spot in the heart of the upper Wylye Valley. A rider on horseback, sword in hand, is painted on the chimney stack of White Horse House.

Built around 1870, **The Dove Inn** at Corton is a thriving, traditional village pub, tucked away from the nearby A36 in a tranquil Wiltshire hamlet close to the River Wylye. William and Carey Harrison-Allan attract a busy local trade with their superbly kept real ales, crackling log fire and welcoming staff, whilst a highly acclaimed menu prepared by head chef Fraser Carruth entices customers from much farther afield. Fraser is a versatile, creative chef whose dishes

The Dove Inn, Corton, Near Warminster, Wiltshire BA12 0SZ
Tel: 01985 850109 Fax: 01985 851041
e-mail: info@thedove.co.uk web: www.thedove.co.uk

range from lamb's liver & bacon and good old-fashioned fish, chips and mushy peas at lunchtimes, to a full a la carte menu in the evenings offering delights such as giant Dublin Bay prawns wrapped in smoked salmon and bacon and Jock chicken (maize fed chicken stuffed with haggis). For fish lovers, Fraser's Catch of the Day will not disappoint. An excellent wine cellar provides the perfect accompaniment to a memorable meal.

The Dove caters for all occasions from small parties and business meetings to wedding receptions and barbecues in the pub's capacious garden. Four cottage–style en suite bedrooms in a pretty courtyard setting make the Dove Inn an ideal base for touring the beautiful Wylye valley and local historic sites.

CODFORD ST PETER & CODFORD ST MARY MAP 3 REF D7
8 miles SE of Westbury on the A36

Sister villages beneath the prehistoric remains of Codford Circle, an ancient hilltop meeting place which stands 617' up on Salisbury Plain. The church in Codford St Peter has one of Wiltshire's finest treasures in an exceptional 9th

century Saxon stone carving of a man holding a branch and dancing. East of Malmpit Hill and visible from the A36 is a rising sun emblem carved by Australian soldiers during World War l. In the military cemetery at Codford St Mary are the graves of Anzac troops who were in camp here. Anzac graves may also be seen at nearby Baverstock.

The George is a sociable village pub for all the family; it is also a popular stop-off point for visitors and a pleasant base for touring the area. Behind the cheerful white and pink façade a central bar counter serves the public bar, where pool and darts are played, and there is a lounge bar with open log fire and a regular Wednesday evening bingo session. A room at the back has a full-size

The George Hotel, High Street, Codford, Wiltshire BA12 0NG
Tel/Fax: 01985 850270

snooker table. In the restaurant, a wide range of dishes is served, from an all-day breakfast through steaks, fish dishes and vegetarian main courses to a long list of desserts. For guests staying overnight there are three well-equipped bedrooms, two of them with en suite facilities. The George is very much a family business, with Sandra Parrett doing the cooking, son Steven running the social side and daughter Jenny helping with the waitressing. Tables and chairs are set out at the front and in the beer garden at the back.

SHERRINGTON
Map 3 ref D7
8 miles SE of Westbury off the A36

A picture-postcard village with thatched cottages around former cress-growing beds where ducks paddle and cameras click. A castle mound can be seen across

a moat where kingfishers can sometimes be spotted. The Church of St Cosmas and St Damian is one of only four in the country dedicated to these Middle Eastern saints. A notable treasure is a set of Elizabethan and Jacobean wall texts.

STOCKTON Map 3 ref D7
9 miles SE of Westbury on the A36

Another pretty village of chequered flint, thatched and half-timbered cottages. Stockton House, a handsome residence with mullion windows and banded flint stonework, was built by an Elizabethan merchant named Topp. He was also responsible for the elegant almshouses set round three sides of a courtyard a short distance away. A monument to Topp is in the village church.

WYLYE Map 3 ref D7
10 miles SE of Westbury off the A36/A303

Peace arrived in Wylye in 1977, when a bypass diverted traffic from the busy main roads. It had long been an important junction and staging post on the London-Exeter coaching route. A statue near the bridge over the River Wylye (from which the village, Wilton and indeed Wiltshire get their names) commemorates a brave postboy who drowned here after rescuing several passengers from a stagecoach which had overturned during a flood.

The Bell Inn was built as a coaching inn as long ago as 1373, when its position at the junction of two major traffic routes made it an important stopping place. And so it remains today, one of the social centres of a village whose

**The Bell Inn at Wylye, High Street, Wylye, Near Warminster,
Wiltshire BA12 0QP Tel: 01985 248338 Fax: 01985 248389**

traffic problem was alleviated by the opening of a by-pass in 1974. The Bell stands next to the Church of St Mary the Virgin, and as the clappers from an old set of church bells adorn the inglenook fireplace it is easy to see how the pub got its name. That fireplace dominates one end of the splendidly traditional bar, while at the other end a blazing coal fire keeps winter at bay. Outside, there are seats for 60 in the very attractive terrace and beer garden. Keith and Linda Bidwell came here in June 1999 and have instantly done wonders for trade. Keith is a super chef, and his daily-changing menu is always based on fresh, often local, ingredients. A range of traditional ales are served, along with table wines including wine produced at the local Wylye Valley Vineyard. The River Wylye, which runs through the village, is a classic trout stream, and many of the guests staying at The Bell are here for the excellent fly fishing. There are three letting bedrooms, two with en suite bathrooms, the third with adjoining facilities.

Above the village is the little-known **Yarnbury Castle**, an Iron Age hill fort surrounded by two banks and an outer bank. To the west is a triangular enclosure from Roman times which could have held cattle or sheep. From the 18th century to World War l Yarnbury was the venue of an annual sheep fair.

CROCKERTON
Map 3 ref D7
4 miles S of Westbury on the A350

A mile or so south of Warminster is the village of Crockerton on the edge of the Longleat Estate. Also at the western edge is **Shearwater**, a man-made lake created in 1791 by the Duke of Bridgewater, a frequent visitor to Longleat (see below) who was very keen on lakes and canals.

In a lovely village just south of Warminster, **The Bath Arms at Crockerton** is a hostelry with something for everyone. Colin and Melanie Bunn have worked

The Bath Arms at Crockerton, Clay Street, Crockerton, Near Warminster, Wiltshire BA12 8AJ Tel/Fax: 01985 212262

hard in their three years at this fine 17th century pub, building up an excellent reputation for hospitality and good food. It is also a comfortable base for tourists, travellers and anglers (Shearwater Lake is close by), with five well-appointed bedrooms for overnight guests and a Caravan Club-listed park with 12 pitches. Original beams have been retained throughout the bars and the 40-cover restaurant, with prints, photographs and memorabilia contributing to a great period feel. Fish plays a prominent part in the bar and restaurant menus, but there are always other tempting specials, and a good selection of French wines to accompany them. A sundial is built into the wall over the front entrance, but when the sun shines it's time to move into the large beer garden behind the pub.

Potters Hill, on the edge of the Longleat Estate, is the delightful location of **Stoneyside**, an attractive modern single-storey house set in lovely gardens. Mary and Gordon Elkins make their guests feel very much at home, and many of

Stoneyside, Potters Hill, Crockerton, Near Warminster, Wiltshire BA12 8AS Tel: 01985 218149

them return year after year to enjoy the friendly, relaxed atmosphere and the very agreeable surroundings. B&B accommodation comprises two nicely decorated bedrooms, a double with en suite facilities and a twin with a private bathroom. Both have TVs and tea-makers. Guests are welcome to stroll in the gardens or while away a pleasant hour or two in the lounge. Longleat takes pride of place among the local attractions, but it is by no means the only one; Stourhead is only 10 miles away, and there are many local country walks. Mary and Gordon are both very keen walkers and will happily point their guests in the right direction!

LONGLEAT
MAP 3 REF C6
6 miles SW of Westbury off the A362

1999 saw the 50th anniversary of the opening of **Longleat House** to the public. The magnificent home of the Marquess of Bath was built by an ancestor, Sir John Thynne, in a largely symmetrical style, in the 1570s. The inside is a treasure house of old masters, Flemish tapestries, beautiful furniture, rare books.....and Lord Bath's murals. The superb grounds of Longleat House were landscaped by Capability Brown and now contain one of the country's best known venues for a marvellous day out. In the famous **safari park** the Lions of Longleat, first introduced in 1966, have been followed by a veritable Noah's Ark of exotic creatures, including elephants, rhinos, zebras and white tigers. The park also features safari boat rides, a narrow-gauge railway, children's amusement area, garden centre and the largest hedge maze in the world.

STOURTON
MAP 3 REF C8
9 miles SW of Westbury off the B3092

The beautiful National Trust village of Stourton lies at the bottom of a steep wooded valley and is a particularly glorious sight in the daffodil season. The main attraction is, of course, **Stourhead**, one of the most famous examples of the early 18th century English landscape movement. The lakes, the trees, the temples, a grotto and a classical bridge make the grounds a paradise in the finest 18th century tradition, and the gardens are renowned for their striking vistas

Stourhead Gardens

and woodland walks as well as a stunning selection of rare trees and specimen shrubs, including tulip trees, azaleas and rhododendrons. The house itself, a classical masterpiece built in the 1720s in Palladian style for a Bristol banker, contains a wealth of Grand Tour paintings and works of art, including furniture by Chippendale the Younger and wood carvings by Grinling Gibbons. On the

very edge of the estate, some three miles by road from the house, the imposing King Alfred's Tower stands at the top of the 790' Kingsettle Hill. This 160' triangular redbrick folly was built in 1772 to commemorate the king, who reputedly raised his standard here against the Danes in 878.

MERE
MAP 3 REF C8

12 miles SW of Westbury off the A303

A small town nestling below the downs near the borders with Dorset and Somerset. The town is dominated by **Castle Hill**, on which Richard, Earl of Cornwall, son of King John, built a castle in 1253. Nothing of the castle now remains, though many of the stones were used to build Mere's houses. Charles ll broke his journey here when fleeing in disguise after his defeat at the Battle of Worcester. The Church of St Michael the Archangel is an excellent example of High Gothic, and its interior features carved Jacobean pews, an alabaster tablet from 1375, an unusual octagonal font and medieval glass in the south chapel. This is a great area for rambling, and one of the best spots for revelling in the fresh air is **Whitesheet Hill Nature Trail**, with wonderful views and a wealth of plants and insects including some rare chalk-loving butterflies.

A splendidly traditional name for a splendidly traditional pub. The **Butt of Sherry** is a fine old stone building in the centre of the village, very popular with both local residents and visitors to Mere and the many places of interest in the locality. Several societies hold regular meetings here (Wessex Shire Horse Group, Basset Hounds Group) and the pub fields teams in the local pool and darts leagues. Pauline Bashford and her son Dave have been partners here for five years, and Pauline in the kitchen produces excellent snacks and meals that make up the daily-changing blackboard menu. Three real ales, a guest beer and three ciders provide plenty of choice for

The Butt of Sherry, Castle Street, Mere, Wiltshire BA12 6JE Tel: 01747 860352

thirsty customers. The interior of the Butt of Sherry is every bit as characterful as the façade would suggest - old beams, brick or stone walls, an attractive feature fireplace with a woodburner - and out at the back is a little courtyard with hanging baskets, flower tubs and a barbecue.

Adjoining 1880s' cottages in a pretty garden make a lovely quiet, secluded base for a relaxing self-catering break. Ellen K Savage's **Brookside Holiday Cottage**, in the hamlet of Burton among the chalk downs, has four bedrooms and sleeps up to nine guests. Other rooms are a lounge, dining room, kitchen and utility room, toilet and shower downstairs, and a toilet, bath and shower up-

Brookside Holiday Cottage, Waterside, Burton, Mere,
Wiltshire BA12 6BR Tel: 01747 860079 Fax: 01747 861541

stairs. The cottage is centrally heated, but there is also a woodburner in the lounge to provide the warmth and glow of a real fire. Outside, there are large front and back gardens with a patio area and seating round a fishpond and rockery. A playhouse, sandpit, toys and a swing are thoughtfully provided for young visitors. Open all year round for short or long stays, Brookside is ideally located for walking, cycling, painting and nature studies. The facilities of a large village are a gentle walk away at Mere, and there are numerous places of interest within a short driving distance.

EAST KNOYLE
14 miles S of Westbury on the A350

MAP 3 REF D8

Two items of interest here. A simple stone monument marks the birthplace, in 1632, of Sir Christopher Wren, son of the village rector. **East Knoyle Windmill**

is a tower mill on a circular base, without sails and unused for over a century. It offers good views over Blackmoor Vale and has a large grassy area for picnics.

The A350 runs down to **Shaftesbury**, a fine old Dorset border town with plenty for the tourist to see. It stands at the western edge of the **Cranborne Chase and West Wiltshire Downs** Area of Outstanding Natural Beauty. This marvellous part of the world covers almost 1,000 square kilometre and covers parts of four counties.

AROUND SHAFTESBURY

TOLLARD ROYAL
MAP 3 REF D9
6 miles SE of Shaftesbury on the B3081

A historic village atop **Zigzag Hill** in the heart of Cranborne Chase. King John had a small estate and hunted on the surrounding land, then densely wooded. A reminder of those days is the fragmented belt of woodland known as Inner Chase, which covers the downland ridge to the east and west of the village. King John's House is a part stone, part timber-framed residence kept in immaculate condition thanks largely to the efforts of General Pitt Rivers, a Victorian archaeologist who inherited the estate and spent the last 20 years of his life unearthing Bronze Age remains. His collection is now in Salisbury Museum, where a gallery is named after him.

The General's tomb is in the delightful churchyard of Tollard Royal's Church of St Peter ad Vincula (St Peter in Chains). He was also responsible for laying out the nearby **Larmer Tree Gardens**, the original larmer tree being the ancient meeting place where King John would meet his hunting party. The gardens, opened in 1880 and intended for *"the recreation of the people of the neighbouring towns and villages"*, contain a wonderful assortment of exotic features, including Indian-style buildings with Nepalese carvings, a Roman temple and an amphitheatre, all set within superb grounds where peacocks strut and macaws fly free. Open-air concerts are held on summer Sundays, and there's croquet, badminton, an adventure playground, visitor centre and refreshment area.

LUDWELL
MAP 3 REF D8
2 miles E of Shaftesbury on the A30

Near the village is the National Trust-owned **Win Green Hill**, the highest point in Wiltshire, crowned by a copse of beech trees set around an ancient bowl barrow. From the summit there are wonderful views as far as the Quantock Hills to the northwest and the Isle of Wight to the southeast.

ANSTY MAP 3 REF D8
5 miles E of Shaftesbury off the A30

The peaceful village of Ansty is a convenient access point for the hexagonal **Old Wardour Castle**, built in 1392 but badly damaged in the Civil War. The then occupier, Lady Arundell, and a small band of men held a much larger Parlia-

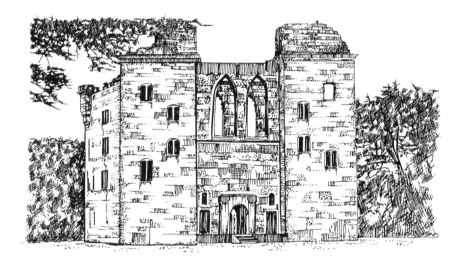

Old Wardour Castle

mentary force at bay for a week. She eventually agreed to surrender when offered favourable terms, but these terms were immediately ignored and the lady put in prison in the castle, whence she soon escaped. The landscaped grounds of the castle include a grotto.

SALISBURY

The glorious medieval city of Salisbury stands at the confluence of four rivers, the Avon, Wylye, Bourne and Nadder. Originally called New Sarum, it grew around the present Cathedral, which was built between 1220 and 1258 in a sheltered position two miles south of the site of its windswept Norman predecessor at Old Sarum. Over the years the townspeople followed the clergy into the new settlement, creating a flourishing religious and market centre whose two main aspects flourish to this day.

One of the most beautiful buildings in the world, **Salisbury Cathedral** is the only medieval cathedral in England to be built in the same Early English style -

apart from the spire, the tallest in England which was added some years later and rises to an awesome 404 feet. The Chapter House opens out of the cloisters and contains, among other treasures, one of the four surviving originals of Magna Carta. Six hundred thousand visitors a year come to marvel at this and other priceless treasures, including a number of magnificent tombs. The oldest working clock in Britain and possibly in the world is situated in the fan-vaulted north transept; it was built in 1386 to strike the hour and has no clock face. The Cathedral is said to contain a door for each month, a window for each day and a column for each hour of the year. A small statue inside the west door is of Salisbury's 17th century **Boy Bishop**. It was a custom for choristers to elect one of their number to be bishop for a period lasting from St Nicholas Day to Holy Innocents Day (6-28 December). One year the boy bishop was apparently literally tickled to death by the other choristers; since he died in office, his statue shows him in full bishop's regalia.

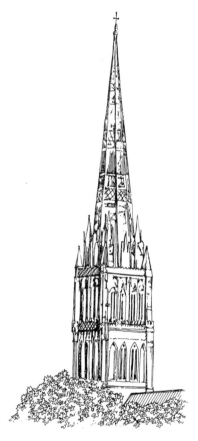

Salisbury Cathedral Spire

The Close, the precinct of the ecclesiastical community serving the cathedral, is the largest in England and contains a number of museums and houses open to the public. **Salisbury Museum**, in the 17th century King's House, is home of the Stonehenge Gallery and the winner of many awards for excellence. Displays include Early Man, Romans and Saxons, the Pitt Rivers collection (see under Tollard Royal), Old Sarum, ceramics, costume, lace, embroidery and Turner watercolours. A few doors away is **The Royal Gloucestershire, Berkshire and Wiltshire Museum** housed in a 13th century building called the Wardrobe, which was originally used to store the bishop's clothes and documents. The museum tells the story of the county regiments since 1743 and the exhibits include Bobbie the Dog, the hero of Maiwand, and many artefacts from foreign campaigns. The house has a riverside garden with views of the famous water meadows. The historic **Medieval Hall** is the atmospheric setting for a 30-minute history of Salisbury in sound and pictures. **Mompesson House**, a National Trust property, is a perfect example of Queen Anne architecture notable for its plasterwork, an elegant carved oak staircase, fine period

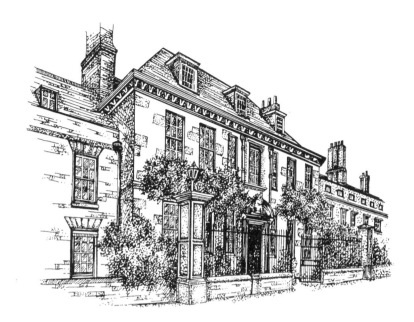

Mompesson House

furniture and the important Turnbull collection of 18th century drinking glasses.
In the Market Place is the **John Creasey Museum and the Creasey Collection
of Contemporary Art,** a permanent collection of books, manuscripts, objects
and art. Also in the Market Place, in the library, is the **Edwin Young Collection**
of 19th and early 20th century oil paintings of Salisbury and its surrounding land-
scape. There are many other areas of Salisbury to explore on foot and a short
drive takes visitors to the ruins of **Old Sarum,** abandoned when the bishopric
moved into the city. Traces of the original cathedral and palace are visible on the
huge uninhabited mound, which dates back to the Iron Age. Old Sarum became

Old Sarum Castle

the most notorious of the 'rotten boroughs', returning two Members of Parliament, despite having no voters, until the 1832 Reform Act stopped the cheating. A plaque on the site commemorates Old Sarum's most illustrious MP William Pitt the Elder.

On the corner of Salt Lane and St Edmunds Church Street stands a delightful Victorian inn called **The Five Bells**. It's very much a family business, with Tony and Pam Clarke at the helm, helped by their son and daughter. Its central location is a great asset, and it draws a truly international clientele as well as local residents. Home-cooked English and Italian cuisine is served daily and the pub is unusual in keeping a range of organic wines. Barbecues in the splendid patio

The Five Bells Inn, Salt Lane, Salisbury, Wiltshire SP1 1EG
Tel: 01722 327022

garden are a regular summer feature, and Salisbury Folk Club meets in the Stable Bar on the third Thursday of every month. The Five Bells is a popular choice for private parties and functions, and also offers very characterful overnight accommodation in two en suite cottage rooms with oak beams and walls dating back over 400 years. Both rooms are equipped with TV, hairdryer, trouser press and tea/coffee-making facilities. Alternatively, you may wish to relax for a week or so (self-catering) just around the corner in the exquisite and tastefully decorated

Town Cottage offering two bedrooms, bathroom, kitchen, sitting/dining room, garden and free car parking - graded 3 diamonds - For full details contact The Five Bells.

AROUND SALISBURY - SOUTH

BRITFORD MAP 3 REF E8
1 mile S of Salisbury on the A338

Lying within the branches of the Wiltshire Avon, Britford has a moated country house and a fine Saxon church with some early stone carvings. An ornate tomb is thought to be that of the Duke of Buckingham, who was beheaded in Salisbury in 1483. Nearby **Longford Castle**, mainly 16th century, houses an interesting collection of paintings.

NUNTON MAP 3 REF E8
2 miles S of Salisbury on the A338

Nunton House is the most notable building in this village in the beautiful valley of the lower Ebble, where some of the best trout in the country are said to live (see under Broad Chalke).

DOWNTON MAP 3 REF E8
5 miles S of Salisbury off the A338

An ancient settlement with Roman, Saxon and Norman links. The Saxons established a meeting place, or moot, on an earlier earthwork fortification, and it was in commemoration of that antique parliament that the present **Moot House** was built on the foundations of the old castle. The building and its garden stand opposite a small 18th century amphitheatre that was built to resemble the Saxon meeting place. In 1955, a Roman villa comprising seven rooms and a bath house was discovered nearby. Downton's old manor house is the former home of the Raleigh family and for many years Sir Walter's brother Carew was the local MP. Every spring Bank Holiday Downton lets its hair down with the Cuckoo Fair, a traditional event providing plenty of fun for residents and locals alike.

LOVER MAP 3 REF F8
6 miles SE of Salisbury off the B3080

In the vicinity of this charmingly-named village is the National Trust's **Pepperbox Hill** topped by an early 17th century octagonal tower known as **Eyre's Folly**. Great walking, great views.

AROUND SALISBURY - WEST

NETHERHAMPTON
MAP 3 REF E8
2 miles W of Salisbury on the A3094

A small village with a lot of character, and a good base when visiting Salisbury races. The racecourse is one of the oldest in the country, racing having taken place since the 16th century. There are 14 race days (all Flat) between May and September.

The small village of Netherhampton, just west of Salisbury, has one of the most delightful pubs in the whole region in the pretty, cottage-like shape of the 16th century thatched **Victoria & Albert**. Harriet Allison and Pam Bourne, owners since April 1998, attract a mixed local and tourist clientele with a winning combination of genuine old-world atmosphere, good drinking, great food and lively music nights. Inside the pub (even the doorway has a thatched roof) the scene is charmingly traditional, with open fires, beams and horse brasses, while

Victoria & Albert, Netherhampton, Near Salisbury, Wiltshire SP2 8PU
Tel/Fax: 01722 743174

to the rear is a charming garden with a pond, waterfall and fountain. Food is served every lunchtime and every evening from a menu of classic snacks, light meals and generous main courses. Desserts offer the chance to be really indulgent with the likes of treacle sponge or Alabama chocolate fudge cake. Children and dogs are welcome, and a separate family room is set aside from the bar.

Brian and Margaret Hayter opened **Coombe Touring Park** in 1981, since

Coombe Touring Park, Coombe Nurseries, Race Plain, Netherhampton, Near Salisbury, Wiltshire SP2 8PN Tel/Fax: 01722 328451

when they have developed a very popular site that attracts caravaners and campers from all over Europe. The landscaped site, which has 50 pitches for touring caravans and tents, with additional space in the summer, lies next to Salisbury racecourse and offers terrific views across the Chalke Valley. This is a quiet, peaceful spot, with no club, bars, disco, fruit machines or video games. What it does have is all the amenities that a well-run site needs, including electric hook-ups, a recently renovated shower and toilet block, Calor gas and Camping gaz, a shop (summer only), play area, telephone box, post box, laundry and washing lines, battery charging and chemical disposal points. Recommendations include RAC, AA 4 pennants, ANWB, ADAC.

The golf, the racing and the country walks for which the area is renowned have a rival attraction in Ken and Pat Mirfin's **Flowerland Garden Centre**, which is located next to the new livestock market. Flowerland has been here for 50 years, opened by Ken's father, who delivered plants to the local district in his

Flowerland Garden Centre, Netherhampton, Near Salisbury, Wiltshire SP2 8PR. Tel: 01722 743206

van. The centre, which still supplies many local needs, now covers some six acres, including extensive greenhouses and a large shop area. Quality bedding plants from their own nursery are the speciality, and there is a wide stock of flowers, plants, shrubs and trees, along with terracotta and ornamental pots, garden sundries, books and gifts. All in all, a great place for a stroll and a browse; access is easy, and there's a large car park.

WILTON
MAP 3 REF E8

3 miles W of Salisbury on the A30

The third oldest borough in England, once the capital of Saxon Wessex. It is best known for its carpets, and the **Wilton Carpet Factory** on the River Wylye continues to produce top-quality Wilton and Axminster carpets. Visitors can tour the carpet-making exhibition in the historic courtyard then go into the modern factory to see the carpets made on up-to-date machinery using traditional skills and techniques. Alongside the factory is the Wilton Shopping Village offering high-quality factory shopping in a traditional rural setting.

 Wilton House is the stately home of the Earls of Pembroke. When the original house was destroyed by fire in 1647, Inigo Jones was commissioned to build its replacement. He designed both the exterior and the interior, including the amazing Double Cube Room, and the house was further remodelled by James Wyatt. The art collection is one of the very finest, with works by Rembrandt, Van Dyke, Rubens and Tintoretto; the furniture includes pieces by Chippendale and Kent. There's plenty to keep children busy and happy, notably the Wareham Bears (a collection of 200 miniature costumed teddy bears), a treasure hunt quiz and a huge adventure playground. There's a Tudor kitchen, a Victorian laundry and 21 acres of landscaped grounds with parkland, cedar trees, water and rose

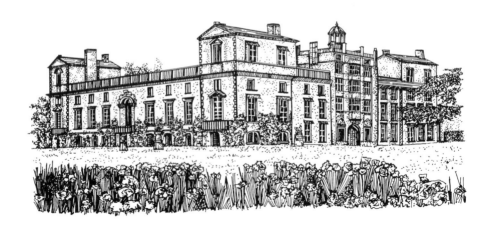

Wilton House

gardens and an elegant Palladian bridge. During World War ll the house was used as an operations centre for Southern Command and it is believed that the Normandy landings were planned here. Open daily late March-end October.

The Church of St Mary and St Nicholas is a unique Italianate church built in the style of Lombardy by the Russian Countess of Pembroke in 1845. The interior is resplendent with marble, mosaics, richly carved woodwork and early French stained glass.

A central position in historic Wilton makes **The Six Bells Inn** both a very popular locals' pub and an attractive choice for tourists and travellers to take a break. The 200 year-old pub has three comfortable beamed bars that provide a choice of mood and atmosphere, and a restaurant that overlooks the colourful

The Six Bells Inn, 14 North Street, Wilton, Wiltshire SP2 0HE
Tel: 01722 743553

courtyard. Co-owners Sandra Gadbury and Paul Gardner, both with long experience in the catering industry, offer a warm, personal welcome and interesting menus that combine bar classics and speciality light bites (including sandwiches with tempting fillings like brie with crispy bacon) with main courses like seafood pasta, Thai-style chicken with saffron rice or lamb's liver with a thyme, honey and port wine sauce. The inn is a popular venue for small functions, and the enterprising owners organise regular theme nights and evenings of music and dancing. A pool team and a cribbage team fly the flag in the local leagues.

BROAD CHALKE
Map 3 ref E8
7 miles W of Salisbury off the A354

A Saxon village where the family of the 17th century diarist John Aubrey had a small estate. Aubrey was a warden at the parish church and lived in the Old Rectory. He also a keen angler and wrote of his beloved River Ebble: *"there are not better trouts in the Kingdom of England than here"*.

FOVANT
Map 3 ref D8
8 miles W of Salisbury on the A30

The **Fovant Badges** are badges carved in the chalk hillside by troops during World War l. They include the Australian Imperial Force, the Devonshire Regiment, 6th City of London Regiment, the London Rifle Brigade, the Post Office Rifles, the Royal Corps of Signals, the Royal Wiltshire Yeomanry, the Wiltshire Regiment and the YMCA. The badges are visible from the A30.

DINTON
Map 3 ref E8
9 miles W of Salisbury off the A30

Two National Trust properties to visit near this lovely hillside village. **Little Clarendon** is a small but perfectly formed Tudor manor house; **Philipps House** is a handsome white-fronted neo-Grecian house with a great Ionic portico. The work of the early 19th century architect Jeffrey Wyattville, it stands in the beautiful grounds of Dinton Park.

TEFFONT MAGNA
Map 3 ref D8
9 miles W of Salisbury on the B3089

A stream runs beside the main street of this charming village, and the houses are reached by a series of little footbridges. Along the minor road which connects Teffont Magna with the A303 is **Farmer Giles Farmstead**, a 175-acre working farm with a wide variety of farm animals which can be seen at close quarters. Visitors can milk a cow, bottle-feed a baby lamb, look at the interesting and instructive display on the history of farming, play in the adventure area or take a stroll around this lovely stretch of downland.

AROUND SALISBURY - NORTH & NORTH WEST

The lovely Wylye Valley has a great deal to offer the visitor in terms of both scenery and history in and around a string of delightful villages.

SOUTH NEWTON
3 miles NW of Salisbury on the A36

MAP 3 REF E8

A short drive into the country from Salisbury takes the motorist to South New-ton and the hospitality that awaits there. A little further north, in the larger community of **Great Wishford**, is an unusual sign on the churchyard wall that records the price of bread at various times in the past 200 years. Each year on Oak Apple Day, 29 May, the villagers exercise their ancient right to cut and gather timber in nearby **Grovely Wood**. Later in the day the party moves to Salisbury's cathedral green to dance carrying bundles of sticks.

Three 17th century cottages in the beautiful Wylye Valley northwest of Salis-bury were sympathetically combined to create **The Bell Inn**, a most delightful pub that retains many of the best original features. Shaun Cooper and Chantal Phillips are very proud of their lovely home and offer guests a high standard of hospitality, with top-quality home-cooked food and comfortable accommoda-

The Bell Inn, South Newton, Near Salisbury, Wiltshire SP2 0QD
Tel: 01722 743336 Fax: 01722 744202

tion. There's plenty of seating space in the bar and restaurant, and when the weather is kind, the courtyard and beer garden come into their own. Black-boards proclaim the day's bill of fare, which runs from filled baguettes and ploughman's platters to main-course specials such as lamb and vegetable curry or steak braised in red wine. Guests staying overnight have the use of three en suite bedrooms, two doubles and a twin. The pub's resident darts teams include some crack county players, so take them on at your peril! The Bell is closed Tuesday lunchtime.

STAPLEFORD
6 miles NW of Salisbury

MAP 3 REF E7

One of a number of delightful unspoilt villages including the three Langfords and **Berwick St James**, where the grid of the medieval board game Nine Men's Morris can be seen on a stone bench in the church porch. At Stapleford there was once a castle belonging to Waleran, chief huntsman of William the Conqueror.

'Free House, Restaurant and Accommodation' - **The Pelican Inn**, on the A36 Warminster-Salisbury road, is a fine old inn of many attractions, not least of which is a large garden with a frontage on the River Till. Marion and Chris Pitcher have a friendly greeting for one and all; families are very welcome, and there's a special children's menu and a play area. Chris is in charge of the kitchen,

The Pelican Inn, Warminster Road, Stapleford, Near Salisbury,
Wiltshire SP3 4LT Tel: 01722 790241

producing a fine range of dishes for both bar and restaurant menus; daily specials and traditional favourites make excellent use of local ingredients. A peaceful and very comfortable overnight stay is provided in five superbly equipped double bedrooms of the highest quality, with en suite shower and toilet, TV, radio, hairdryer, trouser press, iron and well-stocked fridge. All the rooms are on the ground floor and two are suitable for family occupation. No smoking and no pets in the rooms. The inn's name commemorates the ship (later called the Golden Hind) in which Sir Francis Drake set sail in 1575 on a round-the-world voyage. A painting and a model of the ship can be seen in the bar.

STEEPLE LANGFORD
MAP 3 REF E7

7 miles NW of Salisbury on the A36

One of a trio of settlements characterised by chequered flint houses and thatched brick cottages: Steeple Langford, Little Langford and Hanging Langford.

The crock of gold at this particular **Rainbows End** is overflowing with delights that attract a wide cross-section of trade, both local and passing. Babs Compton is the popular, hands-on owner; she's been in the business for 25 years and knows exactly what her customers want. She really enjoys cooking and has excellent, long-serving staff to help her. The pub has two bars, one with darts and pool, and an 80-seat restaurant with its own bar where a long menu

**The Rainbows End, Steeple Langford, Near Salisbury,
Wiltshire SP3 4LZ Tel: 01722 790251**

combines pub classics with some less usual dishes such as lamb samosas, prawn fritters, chicken Wellington and a trio of marinated pork steaks - one peppered, one curried, one Chinese-flavoured. Real ale quaffers have a choice of half a dozen brews, mostly local, and wine drinkers also have plenty to choose from. There are lovely views over the Wylye Valley from the restaurant and from the two letting bedrooms, both with en suite facilities; one is a double, the other a twin, and both can accommodate an extra bed for family use. This delightful place is host to four darts teams and a pool team, and on Sunday nights brains click into gear for the weekly quiz. Ample car parking space; beer garden with a play area.

SHREWTON

MAP 3 REF E7

10 miles NW of Salisbury on the A360

A village at a point on the southern Salisbury Plain where the A360, up from Stonehenge, joins several B roads. A good place to pause on a trip to Stonehenge and Woodhenge.

Jackie and Tony Clift, both locals and very much involved in community life, are the hosts at **The George**, a friendly pub on a corner site at the north end of the village. The 17th century building, which once incorporated its own brewery, has a large, comfortable and very cheerful bar with an exceptional range of

The George Inn, London Road, Shrewton, Near Salisbury, Wiltshire SP3 4DH Tel/Fax: 01980 620341

beers, open fires and a wealth of old photographs and local memorabilia on the walls. Outside is a covered terrace that leads to an attractive beer garden with a colourful abundance of hanging baskets, tubs and shrubs. The ace in the pack at The George is Jackie's superb cooking, and the cosy 26-cover dining room is a very popular eating place. Jackie's steak and kidney pie is the stuff of legends, with a reputation that has spread far beyond the county limits, and other favourites include salads, omelettes, steaks and the Sunday roast, as well as a wide choice of lighter bites. The George - just three miles from Stonehenge - is one of those special places where everyone feels comfortable, from ladies on their own to family groups, and it has a great social side, with an annual beer festival, quiz

nights in winter and teams in the local football, darts, cribbage and skittles leagues. The skittles league is actually run from the pub, whose skittle alley doubles as a function room.

TILSHEAD MAP 3 REF E7
14 miles NW of Salisbury

On the eastern edge of the Imber Range Perimeter Path (see under Imber), with Horse Down to the west and West Down to the east. Stick to the marked perimeter path and always observe the country code: "Take nothing but Photographs, Leave nothing but Footprints, Kill nothing but Time".

Hanging baskets and window boxes make a cheerful sight at the **Black Horse Inn**, and the scene inside is no less welcoming. Jan and Martin Price have extensively renovated the 300 year-old building while keeping all its period character and atmosphere. Flagstone floors, ancient beams and handsome panelling paint a traditional picture in the bars and in the 20-cover restaurant,

**Black Horse Inn, High Street, Tilshead, Near Salisbury,
Wiltshire SP3 4RY Tel: 01980 620104**

which was originally used as a honeymoon cottage. All-time favourites on the menu include home-cooked Wiltshire ham, curry of the day, steak & ale pie and sizzling grills. A blackboard lists a daily-changing choice of specials. Accommodation, in a converted stable block, comprises four double bedrooms, all with

en suite facilities and all boasting lovely views of the countryside. The pub has a busy local trade, with teams for skittles and darts, and is also a popular venue for functions and receptions, either in the function room (believed to be the old village schoolroom) or outside in the very large beer garden, which has seats for 100+ and a play area for children. Ample off-road parking.

Brades' Acre Touring Park, on the A360 between Salisbury and Devizes, is a very attractive and popular site that is open all year round. Owned for 18 years by George and Judith Brades, it welcomes caravaners and campers into what has rightly been described as 'more a caravan garden than a park'. It is indeed a

Brades' Acre Touring Park, Tilshead, Near Salisbury, Wiltshire SP3 4RX
Tel: 01980 620402

very pretty, peaceful spot, with a nice combination of open spaces and shady trees, and it's an ideal base for a leisurely tour of the many places of interest within easy reach. The 1½-acre site has accommodation for 23 caravans on level or near-level pitches with closely cut grass, and amenities on site include electric hook-up points, shower rooms with separate dressing areas and toilets partly tiled and fully carpeted! The village shop and post office are 100 yards away, and the village pubs are a short walk down the road.

WOODFORD VALLEY MAP 3 REF E7
6 miles N of Salisbury off the A345

A seven-mile stretch between Salisbury and Amesbury contains some of the prettiest and most peaceful villages in the county, among them **Great Durnford**

with its Norman church and restored mill, **Lake**, with an imposing Tudor mansion, and **Middle Woodford**, where the internationally renowned **Heale Garden and Plant Centre** lies within the grounds of 16th century Heale House in an idyllic riverside setting. This is another place where Charles ll took refuge when fleeing after the Battle of Worcester. The garden has a superb collection of plants, shrubs and roses, a water garden, a Japanese teahouse and the elegant Nikko Bridge.

AMESBURY
Map 3 ref E7
8 miles N of Salisbury on the A345

Queen Elfrida founded an abbey here in 979 in atonement for her part in the murder of her son-in-law, Edward the Martyr, at Corfe Castle. Henry ll rebuilt the abbey's great Church of St Mary and St Melor, whose tall central tower is the only structure to survive from the pre-Norman monastery. A mile to the north of Amesbury, the A345 passes along the eastern side of **Woodhenge**, a ceremonial monument even older than Stonehenge. It was the first major prehistoric site to be discovered by aerial photography, its six concentric rings of post holes having been spotted as cropmarks by Squadron Leader Insall in 1925. Like Stonehenge, it seems to have been used as an astronomical calendar. When major excavation was carried out in the 1920s, a number of neolithic tools and other artefacts were found, along with the skeleton of a three-year-old child whose fractured skull suggested some kind of ritual sacrifice.

Two miles west of Amesbury at the junction of the A303 and A344/A360 stands **Stonehenge** itself, perhaps the greatest mystery of the prehistoric world, one of the wonders of the world, and a monument of unique importance. The

Stonehenge

World Heritage Site is surrounded by the remains of ceremonial and domestic structures, many of them accessible by road or public footpath. The great stone blocks of the main ring are truly massive, and it seems certain that the stones in the outer rings - rare bluestones from the Preseli Hills of west Wales - had to be transported over 200 miles. Stonehenge's orientation on the rising and setting sun has always been one of its most remarkable features, leading to theories that the builders were from a sun-worshipping culture or that the whole structure is part of a huge astronomical calendar....or both. The mystery remains, and will probably remain for ever.

AROUND SALISBURY - NORTH EAST

LAVERSTOCK
MAP 3 REF E8
1 mile N of Salisbury off the A30

Laverstock is on the northern edge of Salisbury, virtually part of the city.

There's never a dull moment at **The Duck Inn**, where something special is going on most nights: Wednesday is quiz night, every Friday there's a meat draw, Sunday is karaoke night and there are regular themed food nights and live music nights. Jason and Julie Turner are the energetic young licensees at this grand old pub, parts of which are thought to date back to the 14th century. The

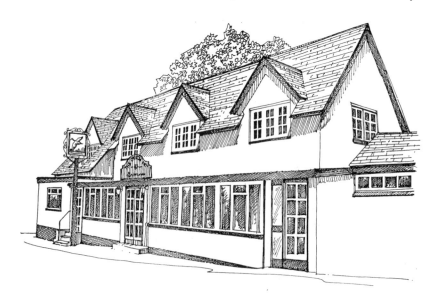

**The Duck Inn, Duck Lane, Laverstock, Near Salisbury,
Wiltshire SP1 1PU Tel: 01722 327678**

cosy lounge bar with open fire is the ideal setting to enjoy a meal, with many dishes home-made, including traditional Sunday lunches. The public bar has a pool table, darts and jukebox and a friendly, lively atmosphere. At the back is a beer garden with plenty of seats and a play area for children. The pub stands in the middle of Laverstock about 1½ miles east of Salisbury city centre.

STRATFORD-SUB-CASTLE
Map 3 ref F8
2 miles NE of Salisbury off the A343

Old Sarum may be the most impressive mound around but it's certainly not the only one. Three miles east of Old Sarum is the Iron Age hill fort of **Figsbury Ring**; above it, the bleak expanse of Porton Down, a top-secret military establishment and also a uniquely undisturbed conservation area where the great bustard has staged a comeback. This large, long-legged bird was once a common sight on the Plain and is incorporated in Wiltshire's coat of arms.

ALLINGTON
Map 3 ref F7
7 miles NE of Salisbury off the A338

One of many attractive villages in the pretty Bourne Valley. Just below it is another, Idmiston, whose Church of All Saints is built with alternate bands of Chilmark and Hurdcott stone, giving the arcades a pleasing striped effect. Note the medieval carvings, the roof bosses and the gargoyles.

The Old Inn, in a hamlet eight miles from Salisbury, is equally popular with locals and passing trade. There's a great atmosphere in the turn-of-the-century building, whose beamed bar has a pool table and dart board; the inn fields four

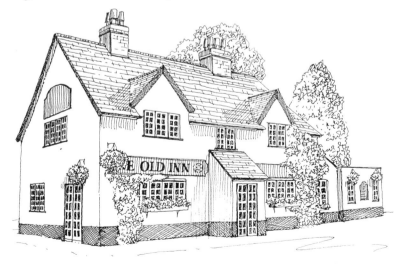

**The Old Inn, Tidworth Road, Allington, Near Salisbury,
Wiltshire SP4 0BN Tel: 01980 610421**

darts teams and a pool team, and the social side extends to quiz nights on Sunday and live music night once a month. There are seats for 30 or more for lunchtime bar meals, all cooked to order using fine fresh produce. Steak & vegetable pie, chicken chasseur and gammon with parsley sauce are among the specialities, and one of the desserts is called Split Decision - a home-made plain sponge with warm custard poured over one half and a last-second choice of warm syrup or warm jam over the other half! The inn has a garden and plenty of parking space.

NEWTON TONEY MAP 3 REF F7
8 miles NE of Salisbury on the A338

Another agreeable spot on the Bourne, and a good base to set out for the short trip up the road to **Cholderton Rare Breeds Farm Park** set in beautiful countryside and a major attraction since opening to the public in 1987. Its attractions include Rabbit World, tractor and trailer rides in peak periods, pig racing (cheer on your fancy in the Pork Stakes) a woodland adventure playground, nature trail and cafeteria, where clotted cream teas are a speciality. The farm park is also home to a wide variety of endangered farm animals.

Noel and Anne Cardew bought the **Malet Arms** in July 1999, having lived in the lovely quiet village of Newton Toney for nine years. The traditional look of the Grade ll listed building is enhanced in the bar by beams, old prints and lots of memorabilia: no games, no music - just a great atmosphere. Outside is a walled garden with seats for 20 and another little 'secret' garden. It's a very popular place with the local residents and is developing a widening circle of

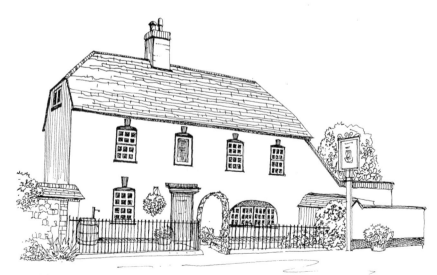

The Malet Arms, Newton Toney, Near Salisbury, Wiltshire SP4 0HF
Tel: 01980 629279 Fax: 01980 629459

regulars with its excellent food. The menu in the 30-cover restaurant is far from run-of-the-mill with such dishes as Mediterranean vegetable bruschetta, grilled smoked haddock fishcakes with a hint of cumin, and blackened chicken strips with sautéed okra, green leaves and sour cream. It's always good to see a savoury alternative to the sweet desserts, and the Malet Welsh rarebit is an excellent way to round off a meal. For guests staying overnight the Malet Arms offers two comfortable bedrooms in a separate cottage 150 yards from the pub.

CHOLDERTON
MAP 3 REF F7
9 miles NE of Salisbury on the A338

The **Red House Hotel** and conference centre is a family run concern not far from Stonehenge. A large and impressive establishment it was used as and officers' mess during the Aecond World War. Offering superb business or family accommodation, the hotel boasts 30 high-standard en suite rooms, each with tea and coffee making facilities remote-control TV, direct dial telephone with Internet access, king-size beds and power showers. With a challenging, short 18-

The Red House Hotel, Parkhouse Corner, Cholderton, Salisbury,
Wiltshire SP4 OEG Tel: 01980 629542 Fax: 01980 629481
website: www.redhousehotel.co.uk

hole golf course and a gourmet Bistro restaurant, with a reputation to exceed expectations, this hotel delivers the kind of accommodation only an independent hotel can - outstanding value and sumptuous dining in super surroundings. The Red House Bistro with its country farmhouse atmosphere and top-quality fresh foods offers an attractively priced menu of dishes that include noisettes of' lamb, medallions of pork, sesame-crusted chicken, pan-fried trout and beef stroganoff. A fine selection of well-chosen wines complement the gourmet dining.

TOURIST INFORMATION CENTRES

Locations in **bold** type are open throughout the year

Gloucestershire

Cheltenham Spa Tourist Information Centre
77 The Promenade, Cheltenham Spa, Gloucestershire GL50 1PP
Tel: 01242 522878 Fax: 01242 255848

Cirencester Tourist Information Centre
The Corn Hall, Market Place, Cirencester, Gloucestershire GL7 2NW
Tel: 01285 654180 Fax: 01285 641182

Coleford Tourist Information Centre
High Street, Coleford, Gloucestershire GL16 8HG
Tel: 01594 812388 Fax: 01594 832889

Cotswold Tourist Information Centre
Hollis House, The Square, Stow-on-the-Wold, Gloucestershire GL54 1AF
Tel: 01451 831082 Fax: 01451 870083

Gloucester Tourist Information Centre
28 Southgate Street, Gloucester, Gloucestershire GL1 2DP
Tel: 01452 421188 Fax: 01452 504273

Newent Tourist Information Centre
7 Church Street, Newent, Gloucestershire GL18 1PU
Tel/Fax: 01531 822468

Northleach Tourist Information Centre
Cotswold Heritage Centre, Fosseway, Northleach, Gloucestershire GL54 3JH
Tel: 01451 860715 Fax: 01451 860091

Stroud Tourist Information Centre
Subscription Rooms, George Street, Stroud, Gloucestershire GL5 1AE
Tel: 01453 765768 Fax: 01453 755638

Tetbury Tourist Information Centre
33 Church Street, Tetbury, Gloucestershire GL8 8JG
Tel/Fax: 01666 503552

Tewkesbury Tourist Information Centre
Tewkesbury Museum, 64 Barton Street, Tewkesbury,
Gloucestershire GL20 5PX Tel: 01684 295027 Fax: 01684 292277

Winchcombe Tourist Information Centre
The Town Hall, High Street, Winchcombe, Gloucestershire GL54 5LJ
Tel: 01242 602925

Wiltshire

Amesbury Tourist Information Centre
Redworth House, Flower Lane, Amesbury, Wiltshire SP4 7HG
Tel: 01980 622833 Fax: 01980 625541

Avebury Tourist Information Centre
The Great Barn, High Street, Avebury, Wiltshire SN8 1RF
Tel: 01672 539425

Bradford-on-Avon Tourist Information Centre
34 Silver Street, Bradford-on-Avon, Wiltshire BA15 1JX
Tel: 01225 865797 Fax: 01225 868722

Chippenham Tourist Information Centre
The Citadel, Bath Road, Chippenham, Wiltshire SN15 2AA
Tel: 01249 706333 Fax: 01249 460776

Corsham Tourist Information Centre
Tourist Information Point, Arnold House, High Street, Corsham,
Wiltshire SN13 0EZ Tel: 01249 714660

Devizes Tourist Information Centre
Cromwell House, Market Place, Devizes, Wiltshire SN10 1JG
Tel: 01380 729408 Fax: 01380 730319

Malmesbury Tourist Information Centre
Town Hall, Market Lane, Malmesbury, Wiltshire SN16 9BZ
Tel: 01666 823748 Fax: 01666 826166

Marlborough Tourist Information Centre
George Lane Car Park, Marlborough, Wiltshire SN8 1EE
Tel/Fax: 01672 513989

Melksham Tourist Information Centre
Church Street, Melksham, Wiltshire SN12 6LS
Tel/Fax: 01225 707424

Mere Tourist Information Centre
The Square, Mere, Wiltshire BA12 6JJ
Tel: 01747 861211 Fax: 01747 861127

Salisbury Tourist Information Centre
Fish Row, Salisbury, Wiltshire SP1 1EJ
Tel: 01722 334956 Fax: 01722 422059

Swindon Tourist Information Centre
37 Regent Street, Swindon, Wiltshire SN1 1JL
Tel: 01793 530328/466454 Fax: 01793 434031

Trowbridge Tourist Information Centre
St Stephens Place, Trowbridge, Wiltshire BA14 8AH
Tel/Fax: 01225 777054

Warminster Tourist Information Centre
Central Car Park, Warminster, Wiltshire BA12 9BT
Tel: 01985 218548 Fax: 01985 846154

Westbury Tourist Information Centre
The Library, Edward Street, Westbury, Wiltshire BA13 3BD
Tel/Fax: 01373 827158

Wootton Bassett Tourist Information Centre
Cascade, 117 High Street, Wootton Bassett, Wiltshire, SN4 7AU
Tel: 01793 853860 Fax: 01793 840052

INDEX OF TOWNS, VILLAGES AND PLACES OF INTEREST

Stanton 87
Snowshill Manor 88
Stanton Court 88
Stanway 87
Stanway House 87
Stapleford 206
Staunton 12
Buckstone 12
Far Harkening 13
Long Stone 13
Near Harkening 13
Suck Stone 12
Steeple Ashton 149
Samuel Hey Library 149
Steeple Langford 207
Stert 175
Ridgeway 175
Stinchcombe 50
Melksham House 50
Piers Court 50
Stancombe Park 50
Stockton 188
Stourton 191
Stourhead 191
Stow-on-the-Wold 91
Sheep Street 91
Shepherds Way 91
Toy and Collectors Museum 92
Stratford-sub-Castle 213
Figsbury Ring 213
Stretton-on-Fosse 96
Stroud 55
Old Town Hall 55
Stratford Park 55
Subscription Rooms 55
Sudeley 86
Sudeley Castle 86
Sutton Benger 127
Sutton Veney 185
Swindon 116
Coate Water Country Park 117
Great Western Railway Museum 116
National Monuments Record Centre 117
Railway Village Museum 116
STEAM 116

T

Teddington 74
Teffont Magna 204
Farmer Giles Farmstead 204
Templars Fir 123
Temple Firs
Wilts & Berks Canal 123
Tetbury 41
Chipping Steps 41
Market House 41
Tetbury Police Museum 41
Tewkesbury 70
Battle of Tewkesbury 72
John Moore Countryside Museum 71
Milton Organ 71
Tewkesbury Abbey 71
Thornbury 36
Thornbury Castle 36
Tilshead 209
Tirley 73
Toddington 87
Gloucestershire-Warwickshire Railway 87
Tollard Royal 194
Larmer Tree Gardens 194
Zigzag Hill 194
Tormarton 39
Tortworth 47
Tortworth Chestnut 47
Trowbridge 148
Twigworth 70
Nature in Art 70

U

Uley 52
Coaley Peak 52
Hetty Pegler's Tump 52
Nympsfield Long Barrow 52
Owlpen Manor 52
Uley Bury 52
Upavon 165
Upleadon 29
Church of St Mary the Virgin 29
Upper Lydbrook 4

INDEX OF PLACES TO STAY, EAT, DRINK & SHOP

		Map Ref	Page No

Accommodation

Pubs, Inns & Wine Bars (cont.)

		Map Ref	Page No

Specialist Shops & Activities

Tea Rooms, Coffee Shops & Cafes

THE HIDDEN PLACES
ORDER FORM

To order any of our publications just fill in the payment details below and complete the order form *overleaf*. For orders of less than 4 copies please add £1 per book for postage and packing. Orders over 4 copies are P & P free.

Please Complete Either:

I enclose a cheque for £ made payable to Travel Publishing Ltd

Or:

Card No: ☐☐☐☐ ☐☐☐☐ ☐☐☐☐ ☐☐☐☐

Expiry Date: ☐☐☐

Signature: ...

NAME: ...

ADDRESS: ...

...

...

POSTCODE: ...

TEL NO: ...

Please send to: Travel Publishing Ltd
7a Apollo House
Calleva Park
Aldermaston
Berks, RG7 8TN

THE HIDDEN PLACES
ORDER FORM

	Price	Quantity	Value
Regional Titles			
Cambridgeshire & Lincolnshire	£7.99
Channel Islands	£6.99
Cheshire	£7.99
Chilterns	£7.99
Cornwall	£7.99
Devon	£7.99
Dorset, Hants & Isle of Wight	£7.99
Essex	£7.99
Gloucestershire & Wiltshire	£7.99
Heart of England	£7.99
Hereford, Worcs & Shropshire	£7.99
Highlands & Islands	£7.99
Kent	£7.99
Lake District & Cumbria	£7.99
Lancashire	£7.99
Norfolk	£7.99
Northeast Yorkshire	£6.99
Northumberland & Durham	£6.99
North Wales	£7.99
Nottinghamshire	£6.99
Peak District	£6.99
Potteries	£6.99
Somerset	£6.99
South Wales	£7.99
Suffolk	£7.99
Surrey	£6.99
Sussex	£6.99
Thames Valley	£7.99
Warwickshire & West Midlands	£6.99
Yorkshire Dales	£6.99
Set of any 5 Regional titles	**£25.00**
National Titles			
England	£9.99
Ireland	£9.99
Scotland	£9.99
Wales	£8.99
Set of all 4 National titles	**£28.00**
		———	———
		———	———

For orders of less than 4 copies please add £1 per book for postage &
packing. Orders over 4 copies P & P free.

THE HIDDEN PLACES
READER COMMENT FORM

The *Hidden Places* research team would like to receive reader's comments on any visitor attractions or places reviewed in the book and also recommendations for suitable entries to be included in the next edition. This will help ensure that the *Hidden Places* series continues to provide its readers with useful information on the more interesting, unusual or unique features of each attraction or place ensuring that their stay in the local area is an enjoyable and stimulating experience.

To provide your comments or recommendations would you please complete the forms below and overleaf as indicated and send to: The Research Department, Travel Publishing Ltd., 7a Apollo House, Calleva Park, Aldermaston, Reading, RG7 8TN.

Your Name:

Your Address:

Your Telephone Number:

Please tick as appropriate: Comments ☐ Recommendation ☐

Name of *"Hidden Place"*:

Address:

Telephone Number:

Name of Contact:

THE HIDDEN PLACES
READER COMMENT FORM

Comment or Reason for Recommendation:

..

..

..

..

..

..

..

..

..

..

..

..

THE HIDDEN PLACES
READER COMMENT FORM

The *Hidden Places* research team would like to receive reader's comments on any visitor attractions or places reviewed in the book and also recommendations for suitable entries to be included in the next edition. This will help ensure that the *Hidden Places* series continues to provide its readers with useful information on the more interesting, unusual or unique features of each attraction or place ensuring that their stay in the local area is an enjoyable and stimulating experience.

To provide your comments or recommendations would you please complete the forms below and overleaf as indicated and send to: The Research Department, Travel Publishing Ltd., 7a Apollo House, Calleva Park, Aldermaston, Reading, RG7 8TN.

Your Name:

Your Address:

Your Telephone Number:

Please tick as appropriate: Comments ☐ Recommendation ☐

Name of *"Hidden Place"*:

Address:

Telephone Number:

Name of Contact:

THE HIDDEN PLACES
READER COMMENT FORM

Comment or Reason for Recommendation:

...

...

...

...

...

...

...

...

...

...

...

...

THE HIDDEN PLACES
READER COMMENT FORM

The *Hidden Places* research team would like to receive reader's comments on any visitor attractions or places reviewed in the book and also recommendations for suitable entries to be included in the next edition. This will help ensure that the *Hidden Places* series continues to provide its readers with useful information on the more interesting, unusual or unique features of each attraction or place ensuring that their stay in the local area is an enjoyable and stimulating experience.

To provide your comments or recommendations would you please complete the forms below and overleaf as indicated and send to: The Research Department, Travel Publishing Ltd., 7a Apollo House, Calleva Park, Aldermaston, Reading, RG7 8TN.

Your Name:

Your Address:

Your Telephone Number:

Please tick as appropriate: Comments ☐ Recommendation ☐

Name of *"Hidden Place"*:

Address:

Telephone Number:

Name of Contact:

THE HIDDEN PLACES
READER COMMENT FORM

Comment or Reason for Recommendation:

...

...

...

...

...

...

...

...

...

...

...

THE HIDDEN PLACES
READER COMMENT FORM

The *Hidden Places* research team would like to receive reader's comments on any visitor attractions or places reviewed in the book and also recommendations for suitable entries to be included in the next edition. This will help ensure that the *Hidden Places* series continues to provide its readers with useful information on the more interesting, unusual or unique features of each attraction or place ensuring that their stay in the local area is an enjoyable and stimulating experience.

To provide your comments or recommendations would you please complete the forms below and overleaf as indicated and send to: The Research Department, Travel Publishing Ltd., 7a Apollo House, Calleva Park, Aldermaston, Reading, RG7 8TN.

Your Name:

Your Address:

Your Telephone Number:

Please tick as appropriate: Comments ☐ Recommendation ☐

Name of *"Hidden Place"*:

Address:

Telephone Number:

Name of Contact:

THE HIDDEN PLACES
READER COMMENT FORM

Comment or Reason for Recommendation:

..

..

..

..

..

..

..

..

..

..

..

..

MAP SECTION

The following pages of maps encompass the main cities, towns and geographical features of Gloucestershire and Wiltshire, as well as many of the interesting places featured in the guide. Distances are indicated by the use of scale bars located below each of the maps

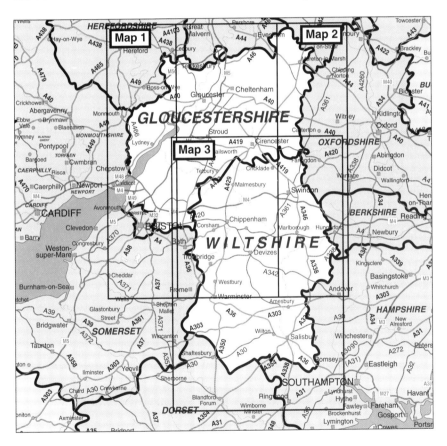

© MAPS IN MINUTES ™ (1998)

Map 1

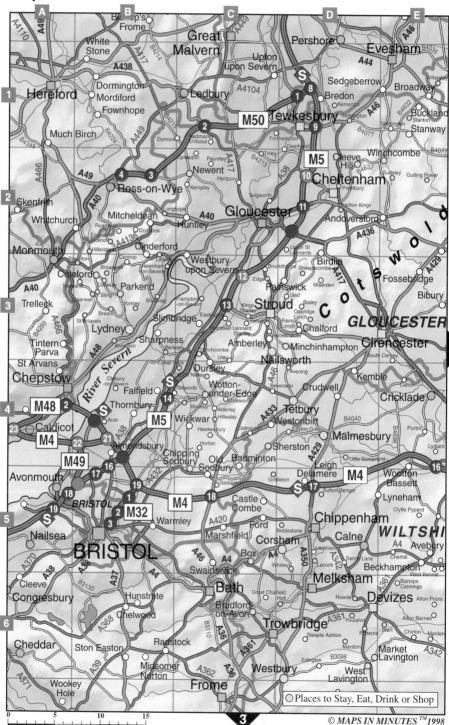

© MAPS IN MINUTES ™1998

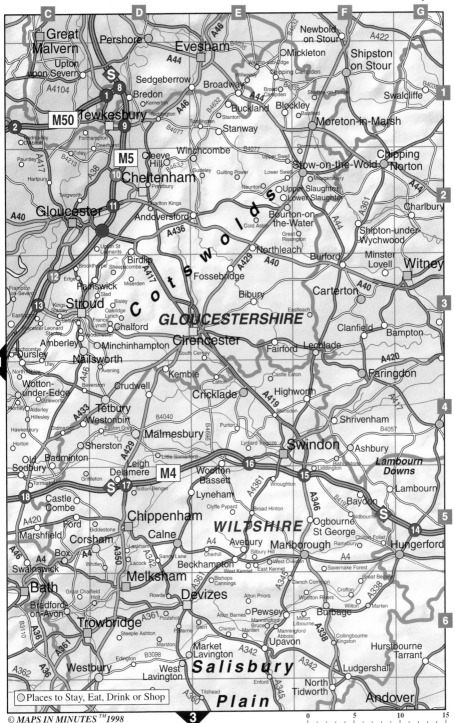

Map 2

Map 3

© MAPS IN MINUTES ™1998

Cirencester · Chalford · Clanfield · Bampton · Amberley · Minchinhampton · Fairford · Lechlade · Nailsworth · South Cerney · Castle Eaton · Faringdon · Dursley · Kemble · Latton · Highworth · Shrivenham · Ashbury · Wotton-under-Edge · Crudwell · Cricklade · Swindon · Tetbury · Westonbirt · Malmesbury · Purton · Wickwar · Sherston · Little Somerford · Wootton Bassett · Lambourn Downs · Lambourn · Chipping Sodbury · Badminton · Leigh · Delamere · Lyneham · Baydon · Old Sodbury · Castle Combe · Chippenham · Calne · Avebury · Marlborough · Ogbourne St George · Hungerford · Corsham · Box · Lacock · Beckhampton · Cherhill · Silbury Hill · Swainswick · Bath · Melksham · Devizes · Pewsey · Burbage · Bradford on Avon · Trowbridge · Market Lavington · Upavon · Radstock · Westbury · West Lavington · Ludgershall · Frome · Warminster · Salisbury Plain · North Tidworth · Andover · Chitterne · Durrington · Amesbury · Longleat · Crockerton · Shrewton · Middle Wallop · Chicklade · Wylie · Wilton · Lopcombe Corner · Hindon · Chilmark · Wincanton · Gillingham · Salisbury · Romsey · Shaftesbury · Ludwell · Whitsbury Down · West Wellow · Fontmell Magna · Cranborne · Fordingbridge · Brook · Cadnam · Buckland Newton · Blandford Forum · Verwood · Ringwood · Lyndhurst · Milton Abbas · Wimborne Minster · Ferndown · New Forest

WILTSHIRE · **DORSET**

○ Places to Stay, Eat, Drink or Shop

0 · 5 · 10 · 15